VOICES OF COLOR

Phoebe Farris-Dufrene

VOICES OF COLOR

ART AND SOCIETY IN THE AMERICAS

HUMANITIES PRESS

NEW JERSEY

First published in 1997 by
Humanities Press International, Inc.
165 First Avenue, Atlantic Highlands, New Jersey 07716

Library of Congress Cataloging-in-Publication Data
Voices of color : art and society in the Americas / edited by Phoebe
 Farris-Dufrene.
 p. cm.
 Includes bibliographical references and index.
 ISBN 0–391–03991–1 (cloth). — ISBN 0–391–03992–X (paper)
 1. Art and society—America. 2. Artists and community—America.
 3. Minority artists—America. I. Farris-Dufrene, Phoebe M.
 N72.S6V63 1996
 700'. 97—dc20 96–18039
 C I P

Printed in the United States of America

10 9 8 7 6 5 4 3 2 1

CONTENTS

ACKNOWLEDGMENTS

Preparation for this book began in 1992 when I solicited various publishers, artists, and scholars to participate in its formation. Calls for papers were sent to artists/scholars through connections with periodicals, academic conferences, written correspondence, and word-of-mouth networking. The audience I contacted had some type of affiliation with the visual arts/mass media, with communities of people of color/marginalized groups, and critical engagement with the often overused terms "the other" and "difference."

From those initial calls eleven writers responded with essays. Trying to keep an open, flexible mind, I accepted all of them with their varying views of aesthetics, ideologies, and culture. I thank the following contributors for their provocative and insightful positions: Nadema Agard, Ana Mae Barbosa, Carl Briscoe, Robin Chandler, Michi Itami, jan jagodzinski, Cliff Joseph, Janice Tanaka, Freida High, Regina Vater, and Sana Musasama.

Compounding the search for authors is the always more difficult task of securing a publisher. Humanities Press, with its commitment to fusing creativity, scholarship, and social awareness, believed in me and in this project. Keith Ashfield, president of Humanities Press, supported me with his intellectual insight, editing skills, patience, and endurance. Many thanks to him and all the Humanities Press staff, especially, editorial manager Cindy Kaufman-Nixon.

At Purdue University, colleagues across disciplines supported me in my efforts. Leonard Harris for our long discussions and heated arguments on philosophy and aesthetics; Lewis Gordon for recommending Keith Ashfield and Humanities Press, and for advising me on the contractual technicalities involved in publishing; Dennis Ichiyama for granting me a sabbatical to complete the necessary research to finish this anthology, as well as two other books I am writing; and especially Marcella VanSickle who has been typing my manuscripts and managing/filing all my computer disks since my arrival at Purdue. Without her patience with my semiliterate computer skills, this book and my other writings would have been published at much later dates.

I deeply appreciate the artists and writers whose works precede mine. Their influence and inspiration assisted my understanding of challenging intellectual terrains and enabled me to articulate my ideas more forcefully. I hope this book inspires future thinkers of all backgrounds, especially the marginalized voices.

This book reflects progressive responses to searching questions about the arts, aesthetics, criticism, the creative processes, and their engagement or

lack of engagement with such issues as race, ethnicity, class, gender, the environment, and nationhood. Issues about art evoke feelings of pleasure, joy, and power, as well as anger, despair, and hopelessness. If our voices do not interrogate, challenge, or alter the status quo of the art world, what is the point of speaking?

As Carol Becker states in her book, *The Subversive Imagination: Artists, Society, and Social Responsibility* (New York: Routledge, 1994), confusion exists about where art fits in society, its functions, and what it should emphasize. Becker asks questions such as what is political art and who determines that? Which communities should art engage, and who has the authority to define community? How, why, or should artists be responsible to the worlds they inhabit?

I hope this collection of essays will add to the dialogue of cultural criticism and serve as one of the many intellectual catalysts for activism and change. As all the contributors to this volume explore new visions of art and society in the Americas, we create voices and power, voices of dissent, voices of liberation, voices of love, voices of compassion, voices of healing, and voices of connectedness to this land, this sacred fertile earth (ATTAN AKAMIK).

Lastly, I am deeply indebted to the Native American community of friends, artists, scholars, family, and the spirit world. Through their paintings and lectures, Juane-Quick-To-See Smith and Kay Walkingstick expand my awareness of Native American art, identity, and feminism. Carl Briscoe, with his Red/Black warrior spirit, helps me in the ongoing struggle for intellectual, cultural, and political liberation. In particular, I am grateful for the mentorship of Jack Forbes, a fellow Powhatan and the director of Native American Studies at the University of California, Davis; his breadth of knowledge on cultural issues affecting indigenous peoples in the Americas is astounding.

Special thanks to my mother, Phoebe Mills Lyles, for choosing to bring me into this world despite the obstacles involved and for sharing with me her love of poetry and the written word in general. Despite severe health problems, she joined me on visits to the Powhatan-Renape, Pamunkey, and Mattaponi Reservations to pay respect to our ancestors and survivors. My daughter, Sienna Captola Farris, journalist, film critic, and creative writer, also makes those trips with me to powwows and reservations. In spite of racist, external pressures to deny, suppress, and/or ignore her Native American heritage, Sienna perseveres, sometimes quietly, usually forcefully.

The ability to conceptualize and form *Voices of Color: Art and Society in the Americas* or any other creative endeavor is ultimately made possible by a higher power, called by many names. Thank you Great Spirit.

AHO,
PHOEBE FARRIS-DUFRENE

FOREWORD:
AN EXTRA HEARTBEAT

The emperor is in drag, the spook who sat by the door has stood up, and the cigar store Indian owns the casino.

—Robin Chandler

The "multicultural scene" in the Americas is constantly changing. Since the 1960s, the preoccupation among the various cultural communities in the United States has been communal discovery and solidarity, sometimes taken to the brink of nationalism and simultaneously threatened by pending assimilation. In the mid-1980s, the "politics of identity" began to be more carefully scrutinized and the word "*multicultural*" soon came under attack from the Right as an ideology rather than a way of life. I have always preferred the terms *intercultural* and *cross-cultural* but it was irritating, to say the least, to find "*multiculturalism*," which had previously meant all groups working together—including Caucasians—suddenly confined in a straitjacket of "political correctness" (another term distorted from its original meaning, which was poking fun at the overearnest within the Left). Clearly, a number of people found themselves threatened by the alliances being formed among those working hard to do the right thing.

By the early 1990s, thanks to an increasingly sophisticated analysis within the increasingly diverse field of cultural studies, there was a broader and more intercultural focus, as well as a growing (and, sadly, often justified) exclusion of Caucasians from the multicultural fold. Today, we have arrived at what has been called the "third space," "third text," or "third stream" of a decolonized hybridity. It is here that *Voices of Color* enters the fray. Phoebe Farris-Dufrene has put together a provocative range of essays that further illuminates this hybrid state. Whereas none of the writers is disavowing her or his own community, each is often most concerned with the complexities of an identity that cannot be viewed from a single vantage point. This collection of twelve essays is, in the best sense, all over the place. Whether they are culturally "mixed-bloods," have lived and worked in differential global locations, or draw their inspirations from world culture, these artists

and scholars know where they stand. They, and others, are creating a centerless world in which every margin is permeable and, in the process, becomes what we might have called a center, except that it is now a multiple rather than a singular phenomenon. (I use the term "multicentered" in the context of people's relations to places.) And they are in a good position to describe those places to the rest of us.

These essays include personal reminiscences and scholarly disquisitions on questions of difference, of inclusion and exclusion, and of representation—the most urgent issue for visual artists who are charged not only with representing themselves, but everyone everywhere as well. Edward Said has written of the violence inherent in all representation. I have said elsewhere that white people have got to give up their assumed task of representing everyone. The goal, anyhow, is not just representation (which can be done *to* the object as well as *by* the subject), but reproduction, which can only be done by the subject.

Hybridity is often seen as a threat to hard-won communal cohesion. The trangression of "racial" or cultural barriers is neither easy nor accepted in many quarters. Yet culture and the arts should be powerful formers and transformers of identity. Regina Vater writes bravely in this book that "in one way or another, we are all blacks in Brazil." She describes (and prescribes) a "psychodrama of reconnection" operating through African music, the subversive "colonization of the body by a cadence and a beat" that has eased Europeans all over the world out of their "rigidity" and helped to "plant a different mind-set in the second half of the twentieth century in the United States" Veter's allegorical work *Comigo Ninguém Pode* serves as a talisman for such beneficent transgression, with its strips of Xeroxes showing thousands of faces of all colors, genders, ages, and classes.

Cliff Joseph also cites music ("Jazz, the greatest art form America has produced") as a healing device, an African gift offering "added depth, breadth, and power" by the arts of Latinos, Asians, and Native Americans. Speaking for an art that engages directly with society, he worries that too often art is "a defense against concern, a defense against commitment." Carl Briscoe, too, thinks that "art as social capital, a metaphysics tied to U.S. identity, appears indifferent to race, sex, and oppression." There is a huge literature written over the last fifty years by artists and scholars whose lives contradict this opinion; but it is true that within the cultural mainstream, political committment and activism are still looked upon as foreign to aesthetic success. Fusion of these so-called opposites is another kind of hybrid many of us have worked hard to achieve.

Hybridity is a fact for some people and wishful thinking for others. Residents of that third space find themselves pulled in different directions. Living on the hyphen or the cutting edge is inevitably uncomfortable, and it is

probably not much consolation to these people to know that they represent the unstable reality of a large part of the global population. Michi Itami, for instance, talks about the "irony of being American"—an irony that is felt by all of us but has different flavors from the viewpoints of Asian Americans (legally excluded for decades, illegally and unjustly interned during World War II), or Latino Americans (historically imported as cheap labor when profitable, then deported on political whim), or African Americans (brought here against their will, still not enjoying full citizenship), or Native Americans (internal exiles at home but evicted, still constantly battling for sovereignty). For Caucasians who do not identify with the dominant culture, the irony is compounded by apparent complicity.

Itami concludes that "focusing on the discriminatory attitudes and prejudice of some individuals *disempowers* the person of color," while Janice D. Tanaka quotes filmmaker Loni Ding on the absence of people of color from the media: "It is somehow not enough that we've lived among a group of people, and see them every day in life. Something essential is missing when that existence is not also a confirmed public existence." From another angle, jan jagodzinski points out that "geographic identity—a strong sense of land and place—remains the dominant metaphor for the definition of the aboriginal self in North America despite the dissipating power of dislocation by the media." And Robin M. Chandler warns; "we always run the risk of fortifying the old culture with neomythologies that continue to invade the private space of others."

Apparent contradictions surface constantly in this book and make it a reflection of the millennial conditions under which we all live. Within feminism, as well, there are many different angles, some new ones introduced as white women belatedly learned to listen to women of color. The two indigenous women writing here, for instance, emphasize wholeness: Phoebe Farris-Dufrene contends that "women of color are reluctant to accept a political framework that would divide instead of unify their communities"; and Nadema Agard, with her work on the "four directions," male and female, stresses the "'and' and nature of my native teachings." Brazilian feminist Ana Mae Barbosa points out that "the great multicultural challenge in Brazil is social-class prejudice."

> Diaspora identities are those which are constantly producing and reproducing themselves anew, through transformation and difference. (Stuart Hall).

Sana Musasama, who has worked all over the world, refers to "relatives not by blood but relatives by community." And Freida High writes about the similarities rather than the differences in the "art as struggle" of Chicanos and African Americans operating in social interstices and transgressing bor-

ders. Her adoption of the literary term "chiasmus" is particularly appropriate to discussions of hybridity: "Chiasmus refers to the action of two parallel phrases meeting and crossing, thus producing a shift in the meanings of those phrases."

Given the plethora of ethnic wars and internal divisions taking place around the globe at this moment, most of the writers in *Voices of Color* are more interested in healing the wounds, bringing together rather than rending apart. Some of them can be accused (as I have been) of "essentialism." So what. I'm not so sure we really do "live in a postmodern world" (as jagodzinski assumes). Maybe only academics are seeing through postmodern glasses; glasses and theoretical descriptions off, it's the same old world that must be changed "by any means necessary," and although deconstructivist strategies work in some areas, essentialist affirmation works in others. It is not a matter of one or the other, as this book makes clear.

The extra hearbeat (Musasama's phrase) is that beat we can all dance to.

LUCY R. LIPPARD

1 / The Political Effects of Contemporary Art: Cultural Diversity and the Myth of Art in Popular Culture

Carl E. Briscoe Jr.

The point . . . is to be critical in transformative ways of any theory or practice that unjustifiably restricts freedom or promotes exclusion. . . . What we need is a theoretical and sociopolitical praxis sufficiently fluid to recognize and respond to racisms' renewals and to articulate broad principles of renewable and revisable social relations committed to resisting the emergence and refinement of racist thinking and practice.

—David Theo Goldberg, *Racist Culture*

Providing an analytics of an idea illuminates the idea's relations of power: its effects in a material culture and its use in framing the culture's national identity. I argue here that the use of art in popular culture disguises the politics of identity in a phantasm of diversity. Art as a commodity in late capitalism produces desire and manipulates prohibitions by exploiting racial and sexual differences, without moral or ethical responsibility. Race and sex are primary symbols to which are affixed the secondary symbolic values: moral, amoral, dirty, clean, pure, primitive, criminal, lazy, bestial, aggressive, and so forth. Even though interpretations for primary symbols are in flux, according to Joel Kovel, "secondary symbols [that] prove particularly fruitful for the representation of primary symbols . . . become enduring parts of a culture."[1]

Artistic forms (e.g., music, graphics, computer imaging, dance, theater, sculpture, jazz) are used in popular culture to exploit these "enduring" cultural attachments to race and sex. The purpose is strategic in that desire and prohibitions, human feelings capable of gross distortion because of their

1

subjectivity, tend to have a binary relationship with the primary symbols of race and sex. For the black community, Spike Lee's movie *Jungle Fever* illustrates how desire is produced in a racist society. Currently, when a black man dates a white woman, black people euphemistically refer to this as "jungle fever."

Whereas desire involves wanting, a feeling that can be exploited limitlessly, prohibition involves restraints—consciously, unconsciously, culturally, or hegemonically imposed. Desire can effect prohibitions, and prohibitions can effect desires. The market economy can engage this space called "diversity" (which is associated with egalitarianism, equality in principle, multiculturalism, the melting pot, etc.), an idea that has no historical reality in the United States, by producing both desire and prohibitions in a venue (i.e., popular culture) that appears neutral. This neutral space, in itself, becomes a commodity in which all taboos attached to primary symbols can be deflocked. Given the monopoly of visual and audio media in determining public reality, art's neutrality creates the illusion of inclusion and delimits diversity to the cellulose sound bites epitomized by MTV. According to Martha Rosler, "art sometimes produces social lectures uncomfortably resistant to interpretations, containing complex significations and seeming to embody uglification and threat."[2]

What, then, is art in the late capitalist United States, given these conditions of existence? The political effects of selling racial heterogeneity in a racist, capitalist patriarchy will be the subject of this chapter. I examine the effects of commodification in contemporary popular culture on the black community, in addition to providing a tertiary examination of Native American art commodification, suggesting that the inability to create civilization in the United States means that it must appropriate it from other cultures. In order to efface the dialectic of this appropriation (limit the migration and eventual transformation), the art object must be strategically relocated (disassociated or disassembled) from the art producer.

The contemporary use of art seems to be decentered from its historical representation. Art—as the profundity of a moment, as beauty undefinable in any other way except by the creative genius of the artist, or, as bell hooks describes it, as "the expressive creativity of a soul struggling to self actualize . . . a realm where every imposed boundary could be transgressed"—has no use in late capitalism.[3]

The rules of art have shifted. With the emergence or production of popular culture, the ability to bound the thinkable, "achieved by tolerating debate . . . within proper limits," defines art's use.[4] Popular culture, according to Stuart Hall, is a political space "allowing us to see [the experiences of popular communities] as expressive of a particular subordinate social life that resist its being constantly made over as low and outside."[5] As popular culture

becomes the dominant form of world culture, its artist substance is appropriated for use by the market economy. In popular culture, art for art's sake takes the form of economic and social capital. According to Donald Kuspit, "Art that helps create the illusion that capitalism has a human face is highly valued by it. Such art becomes part of capitalism social as well as economic capital."[6]

This "artist space," which is thought to be "more democratic," allows privileged classes to submerge themselves "in identities suggested by skin color or ethnicity without acknowledging their superior access to knowledge and power."[7] Art, as a sign of transcendence, inclusion, and diversity, disguises the political effects of normalizing racial animus and producing essentialist ethnic profiles in the commodification of racial body. While rap artists debate the purity of rap forms, revolt becomes style, critical intervention becomes stagnant sophistry, and politics becomes reactions to unauthorized penetrations of the social morality. The bottom line is that contemporary art forms are allowed to transcend normal boundaries, provoking desire and titillating prohibitions. But there are structural limitations. Only within this designated space called "popular culture," where art from the margins has equal access and equal opportunity, is this transcendence allowed; and this is by no means permanent. Permanent acceptance of difference would neutralize desire and prohibition: in market terms, the use value created by fictionalized mimetic accounts of experience at the margins. Commodification requires a "binary differentiation" from the civilized other to produce a contested terrain, such that what appears to be inclusion and heterogeneity is actually dislocation and rearticulation, created in a space that serves the rationality of market economy.[8]

The racial subject, whether Native American, African American, or Latino, is produced by discourses that sustain the other as separate from the national culture. Art history is not and has not been absent in producing discourses that sustain these discursive underpinnings. Primitive art is, after all, a categorical distinction in the art discipline. The 1984 Museum of Modern Art (MOMA) exhibition on primitivism displayed attempts to place such discursive terms into grand theory. According to David Theo Goldberg, "As consumptive demands of the public are met in galleries, the museums' mediation of social science shapes ideology, just as ideological dimensions in the practices of social sciences open it to the possibility of such mediation."[9]

In Edward Said's book *Orientalism*, the Orient became known by the proliferation of works from Western authorities chronicling their views of difference. The Orient, as it became known to Western subjects, was produced by travelogues, historians, anthropologists, art historians, and others who added substance to predetermined limits defined by the relationship of identity and difference. To use Michel Foucault's definition of resemblance, the Orient

"has a model . . . an original element that . . . presupposes a primary refer-ence that prescribes and classes."[10] Popular culture is a composite of art forms, rooted in popular experiences and resisting the subordinate status these experiences have been designated.

I remember reading once that some traditional people interpreted human goodness in terms of the amount a person gave of what he or she possessed. This may very well be the oogenesis of philanthropy as a virtue. Regardless, virtue is a value scripted into the U.S. identity by culture makers: artists, novelists, politicians, and so on. Today, the artist is produced by the phi-lanthropist. The philanthropist transforms the value of art and the artist's magic into capital: dead stored labor—something totally different from its original form. Likewise, virtue, a value traditionally associated with giving, is now associated with wealth, that is, "the virtue of a man who has taken so much that he can afford to give back in return."[11] Similarly, the word "art" signifies something different from its uses or practices in the contem-porary United States.

The capitalist, racist, patriarchial United States is structured by strict binary codes of do's and don't's appearing in the form of rules, values, mor-als, ethics, and norms that uphold the ideological sanctity of its "national culture."[12] The interpretive capacity of these rules symbolically represents good or right, in a structured dichotomization of good versus evil, or right versus wrong. Rules of interpretation aid in conditioning a kind of carceral control (control over the body through the juncture of social norms and legal sanctions) needed for efficiency ratings in a technological mode of production, but they also provide the illusions necessary to sustain the metaphysics of a reflexive glaze. In the recent Disney production of *Pocahontas*, the personification for moral "right" was embodied in John Smith, the ob-ject of Pocahontas's love. The fact that Pocahontas was twelve years old was left unsaid. Good was reified over and over again in ideas hardly ger-mane to a capitalist culture. Disney's production leads the audience to be-lieve that conscientious Pocahontas is devoted to her people's welfare. The fact is that Pocahontas didn't stay with her people, as the movie intimated ("My responsibility is here"). She died in England of smallpox at the age of twenty-two, after John Rolfe married her, an event that dubiously ended the war with the Powhatans. Disney is selling the idea of social responsibil-ity to poor, underemployed, unemployed people, while corporations export millions of their jobs to maximize profits, devastating neighborhoods and entire towns, conditioning the possibility for reactionary politics.

The ideological foundation upon which this takes place is rationalism. In the book *Yurugu*, Marimba Ani says that rationalism is merely Western ide-ology, that is, interpretations emerging from a specific worldview. In addi-tion to Ani's position, research indicates that the idea of being rational, or

having the capability to think rationally, has historical antecedents in the production of racism.[13] Racism is a method of exclusion that uses the idea of race as a criterion. One can conclude, therefore, that the idea of being rational is intricately tied to the use of race as an exclusionary mechanism.

The existence of race—and its corollary, the practice of racism—is at least partly substantiated through a preponderance of discourses with attending epistemological rationales capable of seducing the social body into believing that subordination is normal, or at least reasonable.[14] Evidence of this is clear in the support given by the social body to laws, social and psychological theories, historical revisions, and social taboos that have legitimized racial difference within the binary format of Western rationalism. The racial animus experienced by blacks, Native Americans, and Latinos is a direct result of what Martin Luther King Jr. called the "drum major instinct," that is, the desire to be first, contextualized in social, legal, and psychological prohibitions. The Rehnquist court's ruling that Georgia's Eleventh District must be redrawn to omit race as a "predominant" factor, according to Salim Muwakkil, "disregard[s] historical context for . . . the conservative ideology of race neutrality." How does this strategy normalize subordination? Race neutrality is a political reaction to affirmative action, equal opportunity, and desegregation, essentially laying claim to a new day of racial equality. Under the pretext that race is no longer a factor in political representation, laws set up to create this condition can now be dismantled. They can be dismantled under the equal protection clause of the Fourteenth Amendment, originally legislated to guarantee the rights of African Americans. Racism is merely a form of oppression concocted to guarantee a superordinate position for the group controlling the limits of the idea. In a society intersected by race and gender bifurcation, where individualism is rewarded if it increases capital, race has a use value. Franz Fanon tells us that in a racist society the racist is normal. A postulate to Fanon's position might read: Race as a mechanism of subordination guarantees that the interest of the national culture is normal. The neutrality of art provides a useful segue for this obfuscation.

By definition, the word "art" connotes a site of tolerance, ambiguity, cultural freedom, and ethnic diversity. This is what I mean by neutral: The word "art" is a sign, signifying a formulaic interpretation that embraces the former as metaphors. According to Kovel, interpretations formulated in the idea retain their inference when they are positive reflections of cultural identity. Normal perceptions associated with the idea reflect and represent cultural identity. Therefore, art, as representative of a neutral terrain, can also be the site of a unifying discourse, delimiting insurgent discourses for appropriation as national ideology.

One of my clearest recollections of this phenomenon was Richard Nixon

giving the peace sign on national television while sanctioning state terror-ism in Iran, South Africa, and the United States. Nixon and Spiro Agnew represented the antithesis of this peace culture. The peace sign, which per-meated popular culture through paintings, graffiti, murals, movie themes, clothing, songs, and dance; essentially signified a crisis of legitimization, a desire for change, and an end to capital accumulation by military engage-ment. It has been said that the United States has the unique ability to merchandise dissent. Once appropriated by institutional leadership, the sign no longer stood for resistance; instead, it represented what Fanon called "national culture." Serious rap music, critical of fraudulent and coercive forces operating in the black community, came under serious attack by music distributors, social commentators, and political leadership. Rap that embel-lishes a material world, that is sexually exploitive, degrading to black women, apolitical, or just purely entertaining, crosses into "the industries where culture enters directly into the circuits of a dominant technology—the circuits of power and capital."[15] Commodification, however, uses popular experience to provoke desire and prohibitions. Black groups that employ rap apolitically, such as Hammer, Salt 'n' Peppa, and En Vogue, aid in the production and the fabrication of a nuanced, uncritical, contextualized appearance of diversity.

The television and movie industry capitalizes on this neutral space by interdicting social reality. TV and films are the cheapest forms of entertain-ment, making the poor and the middle class major supporters, and a tar-geted market. Many themes generated by these art forms set parameters for thought on social issues.[16] For example, ensuring that the bad guys always lose establishes the idea that crime doesn't pay, which in turn enforces political dogma associated with hard work and enlarged police powers. More important, and far more useful, is the fact that a concrete profile begins to develop in the minds of those who depend on these devices for vicarious exploration of the real, and oftentimes unknown, world.

This begs the question of artistic responsibility. The plethora of police/ crime stories on television and in film objectifies blacks as criminals. White-collar crime, conversely, is laden with intricate plots and real-life charac-ters. Lost in the fashion and glorification of rugged individualism is the fact that this form of crime costs taxpayers far more than petty crimes com-mitted by blacks. On the other hand, blacks and other people of color are well represented in the crime-fighting units protecting U.S. institutional integrity. In this cellulose art world, a close examination of high-ranking officers reveals a disproportionate number of people of color. The message being sent clearly makes it legitimate for blacks to see other blacks not as victims, but as perpetrators messing everything up for decent black folk. This same dynamic was seen in South Africa. Blacks from tribes were em-ployed by the South African Defense Force to murder, infiltrate, and brutalize

their own struggling people, in the name of vague words such as "decency," "morality," "freedom," and "justice." Functionally, police are paid to maintain the integrity of the state. Structurally, their choices are limited. A black law enforcement agent must enforce the oppressor's laws or lose the ability to reproduce. By enforcing the law, he or she participates in constructing the limits of right, moral integrity, and justice, making it normal by example to protect the interests of those committing the oppression. When blacks aren't cast as criminals, they are placed in some netherworld where race is insignificant or neutral. The twofold effect of distorting/producing reality through film and television is that it makes oppression more insidious, and, because on the average people watch TV and film more than they labor, it also controls the public perception of national culture. The commodification of art taken from popular experience advances a false sense of liberation. The artist creates this by giving the object a value that appeals to desire, on the one hand (such as desiring sneakers), while on the other hand, real power is unavailable and unreachable (i.e., the sneakers become symbolic). The commodification of art is a rational mechanism for system maintenance where art in late capitalism, according to Rosler, "sometimes produces social lectures uncomfortably resistant to interpretations, containing complex signification and seeming to embody uglification and threat."[17]

Art as social capital, a metaphysics tied to U.S. identity, appears indifferent to race, sex, and oppression, but is it? Evidence that the Other is at least tacitly represented can be found in the cellars of Western museums. Or is this another deception? Is there a predatory need to covet art from other cultures, as carnivores do with fresh kills, and or is this just a "rationalized abstract pursuit which aims at the progressive accumulation of the media of exchange"?[18] There seems to be some of the former working with some of the latter. The labels attached to art from the margins somehow become associated with art from the past: primitive art, tribal art, native art, heathen art, and precivilized art. Once again, the sign of inclusion reinforces exclusion.

Rosa Luxemburg says of primitive accumulation that all "noncapitalist social units" that obstruct the accumulation of capital must be annihilated in order for "the culture of capitalism" to proceed. This process, a necessary condition of domination, must also annihilate the artistic content of a cultural formation. I believe that this is a continuous process, changing form at various socioeconomic and political ruptures. Not only must creative, intellectual, social, and mental faculties undergo transformation to paint the oppressors' view of the world, but artists' objects must be disassociated from their producers to sustain racial beliefs. This is all very rational from Marimba Ani's perspective. Sustaining the normative interpretation of the

word—its deferred meaning—disguises the relationship of power between the dominator and the dominated. The appearance of art for art's sake can be retained in the product by rendering the producer an object of social, anthropological, or scientific discourse.

Primitive accumulation, in the sense that art forms from the native population are stripped, separated, and then appropriated, involves a dual process. First, the producer must be alienated from his or her work. The native must negate his or her art as he or she negates self. Once the art is valueless to the artist and the people represented by the art, the oppressor can transform the art into capital by marketing its marginality in various self-reflecting categories (minority, diversity, multiculturalism).

In the contemporary, racist, capitalist United States, any art form from the margins is creative capital for the producers of popular culture. A dead culture loses its creativity and must steal from those it oppresses. As commodities, dance, sports, music, styles, cinema, slangs, and body parts retain their culture identity while provoking both desires and prohibitions for many uses. The Mapplethorpe exhibit, for example, set off a range of reactions. It was an easy target for reactionary political interest. The eroticism of homosexual penetrations involving black bodies suddenly became the quintessential representative of the public's investment in the National Endowment for the Arts. Sagging, a style of dressing where the pants hang off the buttocks displaying coordinated underwear, is admonished in social institutions, while on TV and in movies it gives cultural favor to an otherwise clear reality.

While producing in the public space an appearance of inclusion, strategically selected icons shape the public's perception of the black community. Appropriation combined with primitive accumulation separates the human bases of production from the art object. Rap was black music to most whites, until their children started buying records and white groups attempted to imitate them. 2 Live Crew's foray into First Amendment issues is significant in that the protest was led by white women under the banner of morality. The picture they conveyed (white mothers against violence and dirty language) metaphorically signaled an attack on the "lovely white." Carefully staged and carefully engineered reproduction of popular experience relies heavily on desire and prohibition by exploiting sex and race.

CONCLUSION

Racial and sexual taboos are thematically chosen by advertising executives to assist in selling cultural icons. Everything from jean ads to chewing gum ads is specifically designed to stimulate sexual desire. The same is true for race. Art is essential in making racial taboos palatable to the public, yet capable of stimulating enough desire to sell a product.

Delimited to this artistic space, it appears that racial hybridizations are positively altering the existing hegemony. The appearance of inclusion can be negotiated by exclusionary methods that extol the egalitarian virtues of liberal democracy. A simplistic example demonstrates the possibility: A majority vote of 51 percent would exclude 49 percent. Although the entire population was included in this vote, the process implicitly excludes. Similarly, the inclusion of racial icons in visual media, as representations of cultural difference—an idea contextualized as politically neutral—could confound political reality. In other words, virulent exclusion could continue under the appearance of inclusion. What we see as entertaining in dance, music, and theater could very well exploit the black body. In the context of a color-blind society, this distorts the picture. It distorts how really segregated and brutally racist the United States is to its most loyal subjects. By exploiting the virtues of racial difference within the context of national identities such as diversity, multiculturalism, or the melting pot, any racial icon can be substituted for the idea. These icons not only represent the idea, but also substitute for the practice implied by the idea, signifying a reality that at best is a cellulose illusion. The appropriation of art by the national culture and the transformation of its form extend the limits of marginality.

Designating the art of national minorities as art from the margins denotes a causal relationship between the art product and specific social pathologies, which neutralizes substantive acceptance. Accepting the others' art as an altruistic penance or as an attempt to own or savor part of a primitive past completes the cycle of separation between the artist and the object. Often this is disguised by critical interventions. These further disengage the artists and their creations, for such interventions bear witness to freedom of speech. These are quickly offset by competing positions resulting in a resolution (we agree to disagree) ultimately reifying diversity as a metaphysical character of U.S. democracy. The popular concept of difference, therefore, is produced in the identical simulacrum that maintains race as an idea. Control and use being necessary assents of modern man (a category historically identified with white, Western subjects) condition the possibility of conflating race and difference.

NOTES

1. James Kovel, *White Racism: A Psychohistory* (London: Free Association Books, 1988), p. 102.
2. Martha Rosler, "Place, Position, Power, Politics," in Carol Becker, *The Subversive Imagination: Artists, Society, and Social Responsibility* (New York: Routledge, 1994), p. 57.

3. bell hooks, *Art on My Mind: Visual Politics* (New York: New Press, 1995), introduction.
4. Noam Chomsky, *Necessary Illusions* (Boston: South End Press, 1989), p. 105.
5. Stuart Hall, "What Is This 'Black' in Black Popular Culture?" in Michele Wallace, *Black Popular Culture*, (Seattle, WA: Bay Press, 1992), p. 26.
6. Donald Kuspit, *Signs of Psyche in Modern and Postmodern Art* (New York: Cambridge University Press, 1995), p. 286.
7. Becker, *The Subversive Imagination*, pp. 56, 66.
8. David Theo Goldberg, *Racist Culture* (Cambridge: Blackwell, 1993), p. 188. Goldberg uses the concept "periphractic space" to indicate "spatial circumscription . . . the primary mode by which the space of racial marginality has been articulated and reproduced."
9. Ibid., p. 159.
10. Michel Foucault, *This Is Not a Pipe*, ed. and trans. James Harkness (Los Angeles: University of California Press, 1982), p. 44.
11. Kovel, *White Racism*, pp. 114, 115.
12. Franz Fanon, *Wretched of the Earth* (New York, Grove Press, 1963), pp. 167–189. My idea of national culture stems from this reading in Fanon. Culture is not static; instead, it is constantly struggling to become. Culture is also a reflexive device, a mirror of specific agency. Given the need for new markets in capitals, national culture also implies mechanisms of authority, domination, and violence deployed to maintain a superordinate relationship.
13. See Goldberg, *Racist Culture*, pp. 1–40; J. M. Blaut, *The Colonizer's Model of the World* (New York: Guilford Press, 1993), pp. 94–135; Marimba Ani, *Yurugu* (Trenton, NJ: African World Press, 1994), pp. 289–308; Michel Foucault, *The Order of Things* (New York: Random House, 1970), pp. 50–76.
14. Salim Muwakkil, "Down by Law," *In These Times*, vol. 19, no. 18 (24 July 1995): 20–22.
15. Hall, "What Is This 'Black' in Black Popular Culture?" p. 26.
16. Chomsky, *Necessary Illusions*.
17. Rosler, "Place, Position, Power, Politics," p. 57.
18. Kovel, *White Racism*, p. 114.

Reaching In and Taking Out: Native American Women Artists in a Different Feminism

Phoebe Farris-Dufrene

FEMINISM AND CULTURE: THE DOMINANT PERSPECTIVE

In the United States, issues of race, sex, and class dominate societal patterns. This is largely the result of historical experiences and contemporary racial biases impacting people of color. Legacies of Native American genocide and removal to reservations, African slavery, and women's equality issues continue to affect contemporary U.S. society and also extend into the art world and related domains such as academia and the mass media. The art world's power structure, however, prefers to ignore issues of race, sex, and class, only occasionally acknowledging them as having relevance with respect to background or context. The art power brokers (critics, art historians, dealers, patrons, and elite artists) assume that only one norm exists, a norm that is universal, ahistorical, androgynous, classless, and nonracial; in other words, male, upper-class, and Western. Lise Vogel acknowledges the art world's evasion of contemporary social issues: "The apparent backwardness of the art world with respect to all social issues including that of feminism is no accident, and the relative timidity of the feminist art movement reflects the reality of this art world."[1].

Cassandra Langer also acknowledges the timidity of women in the arts, including self-professed feminists.[2] Because intellectualism has been defined and limited by a patriarchal Western hierarchy, many women in the arts use self-censorship to secure grants, to exhibit, and to achieve an illusory concept of status.

Feminist artists who want to challenge the status quo of the art world have many questions to ask: What is a feminist perspective in the arts? What do feminist artists, critics, and historians do? In general, what are

11

women artists doing? What are so-called feminist artists doing?[3] Langer suggests that feminists in the art world engage in a struggle to combat the "covertly restrictive" art world and transform it through sexual, spiritual, and ritual endeavors.[4]

To date, the few transformations that have taken place in the contemporary art world are superficial: Black artists are given exhibition space in February in deference to Black History Month; female artists are highlighted in March during Women's History Month; and Native American artists are exhibited in November during Native American Heritage Month. The remaining nine calendar months are usually the exclusive domain of safe, noncontroversial, apolitical, form-over-content, art-for-art's-sake, mainstream Euro-American male artists.

Feminist artists and critics with consciousness are working toward an understanding of racism, classism, and sexism. However, more than any other "ism," racism continues to dominate U.S. discourse, including so-called radical sexual politics or feminism. According to Langer, "some white feminists are frightened by the consciousness that groups they see as disparate (African-American, lesbians, Asians, Hispanics, Latinas, and Native Americans) are taking over their movement."[5]

Vogel criticizes the emphasis on reform that is prevalent in the women's art movement, the view that change can be achieved within the existing capitalist art structure. Instead of the prevailing debate on a female aesthetic versus a male aesthetic, Vogel argues for the development of a more covertly political art that rejects current reward systems in the contemporary art establishment. A rejection of the art establishment involves a rejection of distinctions such as "high" art and "low" art and language that seeks to exclude rather than include. Prevailing terms and values keep outsiders on marginal edges of the dominant culture, especially artists of color. Vogel does not blame solely men for ideologies that marginalize; she discusses discriminatory practices of Western feminists whose biases are caused by their own conditioning in regard to sex, class, and race.

Langer voices the need for inclusion of differences as well as similarities, which would enable the feminist movement to attract women of all colors and classes. Abolishing sexism and other isms is an ongoing struggle that necessitates using feminist theories in all art disciplines, including art criticism, art history, studio art, and education.

It is with these issues in mind that I sought to explore Native American women artists and their relationship to feminism. I am a Powhatan from a mixed-blood family of artists who is interested in how Native American women artists reach into the past and also reach out to future generations, taking on the responsibility of using the arts to call attention to and preserve ATTAN AKAMIK (our fertile earth).

FEMINISM AND CULTURE: WOMEN OF COLOR

Recently, feminists from the dominant culture have engaged in self-criticism that questions their previous embrace of universal categories and concepts that obscured differences among women.[6] This self-criticism involves responding to minority, poor, and Third World critiques of Western feminist theory. Mainstream feminists are becoming more aware that women of color are involved in coalition politics with one another, and with men of color, to confront domination that affects both sexes. "Black women want to be liberated along with Black men. Latin-American women want to be liberated along with Latin-American men. They are all in the prisons, whether they are women or men."[7]

Expressing similar concerns, African American feminist writer bell hooks stresses the importance of understanding the ways "racism and sexism are interlocking systems of domination which uphold and sustain one another."[8] Although many feminists still fail to see them as joint issues, hooks urges feminists of all colors to explore connections between racism and sexism as ways of working toward a less violent and more just society. Solidarity between black women and other women of color is addressed in many of hooks's writings.[9] She promotes an invitation to dialogue that includes constructive criticism. However, hooks acknowledges that solidarity among people of color (women or men) is often hard to maintain because of internalized racism and internalized sexism, by-products of colonialism, as well as of Western cultural traditions.

In addressing cultural decolonization, hooks cautions against rejecting everything that seems to maintain connection with the colonizing culture. She refutes the idea that Western culture is the location where the discipline of aesthetics began.[10] It is only one location, not THE location. Nonelitist aesthetics can be interdisciplinary, sensitive to political issues such as feminism, and reach a broader audience that allows for cultural inclusion instead of cultural exclusion. Nonelitist aesthetics challenges assumptions that "the other," "difference," "minority," and "women" are synonymous with "lack" and "deprivation."[11]

In academia and the contemporary art world, feminists of color reject using one critical paradigm for evaluating art. Hooks advocates that professors in cultural studies, the humanities, and the arts radicalize their students so they will think more critically, reject racial/sexual/class domination, and become actively involved in resistance against colonialism and imperialism.

Progressive scholars and artists engaged in critical discourse on racism and sexism must vigilantly guard against social control by the media, the art establishment, and academia—controls that co-opt, neutralize, and make fads out of feminism and multiculturalism. As hooks warns: "If we do not interrogate our motives and the direction of our work continually, we risk

furthering a discourse on differences and otherness that not only marginalizes people of color but actually eliminates the need for our presence.[12]

NATIVE AMERICAN VIEWS ON FEMINISM

In contrast to the negative stereotyping of Native American women as timid, subordinate to men, and docile—a stereotype perpetuated by the dominant culture's use of media and constructions of Western anthropology, history, and rightist/leftist politics—Native American women always have been involved in indigenous resistance to colonization and genocide.[13] Traditional Native American societies were not and are not "sexist" or "chauvinist," although that charge has been leveled against Native American men by contemporary feminists. On the contrary, native societies try to achieve a balance between male and female principles in nature, religion, and spirituality.

Native American women currently involved in resistance to genocide and colonialism view their struggle as a joint concern with the men of their respective nations. Like women from other "minority" groups, Native American women experience oppression and discrimination more from their racial origins than from their gender identification. In M. Annette Jaimes's essay in her edited collection *The State of Native America*, she quotes and paraphrases many Native American women who feel that the women's liberation movement would divide Native American people and divert Native American women into participating in their own colonization through alignment with women from the dominant, colonizing culture.[14]

Instead, many Native American women prefer to reestablish traditional Indian women's warrior societies that were abolished by Christian missionaries or to form/join new Indian women's societies such as the Northwest Indian Women's Circle and the Indigenous Women's Network (IWN). These organizations draw their strength from traditions inherited from grandmothers and great-grandmothers and view themselves as supportive of their men in a common struggle for liberation of the land and people. Feminism is seen by some native women as similar to capitalism and Marxism, a Euro-supremacist ideology with imperialist implications. Feminism often is regarded as a form of cultural imperialism because feminists from the dominant culture have co-opted Indian spiritual practices such as shamanism into their art and performance pieces.[15]

African American women, Asian American women, Chicanas, and Latinas share many of the same criticisms of Euro-American feminism. Women of color are reluctant to accept a political framework that would divide, instead of unify, their communities. This rejection and ambivalence is viewed by many Native American women as a bridge to form alliances with other women of color to fight racial, cultural, and gender oppression.

NATIVE AMERICAN ART: CURRENT TRENDS AND THE CONTEMPORARY WOMAN ARTIST

When Native American art is studied as part of art history or explored in the studio, the past is usually emphasized. Romantic misconceptions of Native Americans, as nontechnological Stone Age artisans, dominate the literature, thereby reinforcing the tendency to dismiss the evolving contemporary Native American culture.[16] In the hundreds of Native American languages, there is no word that comes close to the Western definition of "art." American Indian art is seldom "art for art's sake." Both traditional and contemporary thinking do not separate art and life or draw comparisons between what is beautiful and what is functional. Art, beauty, and spirituality are intertwined in the routine of living.

Centuries before European settlers arrived on Turtle Island (the indigenous name for North America), Native American women were producing art in the form of basketry, pottery, quillwork, weaving, and leather painting. Women dug clay for their pots, gathered reeds and skins for painting. Indigenous women developed a sensitivity to colors and textures found in nature and related designs to the space and form on which they were placed. Working communally, Native American women learned their crafts from grandmothers, mothers, and aunts.

During the past five hundred years, Native American artists have been exposed to non-Indian concepts of art and artists' roles in the dominant society. In varying degrees, Native American artists assimilated systems of non-Indian aesthetics. Contemporary Native American artists in the United States have continued to explore both art traditions that were developed during reservation confinement as well as newer, experimental art concepts. Contemporary Native American art often functions as social criticism by using content that expresses alienation from Western culture.

Many Native American artists, whether their work is abstract in form or more representational, create art that has a social context. Native American women artists such as Pena Bonita (Apache/Seminole) had to confront male art professors who did not want their students to express any political content in art. After graduating from Hunter College in New York City, Bonita followed her own instincts and now often incorporates Native American history into her paintings. She depicts Native American women warriors in some of her paintings, women who were committed and made ultimate sacrifices for their people. In an interview in *Turtle Quarterly*, Bonita described a female warrior whose head was cut off, stuck on a pike, and paraded around by imperial armies during King Philip's war in the 1700s.[17]

Images of Native American women created by non-Indians usually reinforced stereotypes of "Indian Princesses" or "Earth Mother."[18] Shelly Niro

(Mohawk), a photographer, is part of an expanding group of Indian women artists who refute these stereotypes by creating images that show a broader range of contemporary Native American women's experiences.[19] Using family members, Niro photographs humorous, playful scenes of Indian women without the required beads, feathers, and buckskin dresses.

Jean La Marr (Pauite/Pit River), in a monoprint titled "They're Going to Dump It Where?!," describes an image of resistance in her portrait of a contemporary Native American woman.[20] The print is concerned with the issue of a nuclear facility in the sacred Southwestern Native American site Diablo Canyon.

The Native American woman artist with the most national/international exposure currently is Jaune Quick-To-See Smith (Salish-Flathead). As an artist, curator, lecturer, and political activist, she is a role model for many Native American artists, both male and female. Her abstract paintings, which incorporate sign language, glyphs, and pictograms, are often concerned with environmental issues affecting native lands.[21] Jaune Quick-To-See Smith rejects the opinion that Native American artists working within mainstream Euro-American aesthetics are "inauthentic." She states that "dying cultures do not make art. Cultures who do not change with the times will die."[22]

Native American women artists also are involved in newer art forms such as performance art. The New York—based group Spiderwoman Theater is composed of three sisters, Lisa Mayo, Gloria Miguel, and Muriel Miguel, of Cuna/Rappahanock-Powhatan ancestry. They use humor to poke fun at "plastic shamans," New Age Indian workshops, and "wanna-bee" Indians. Nadema Agard (Powhatan), a visual artist, art educator, and museum professional, creates multimedia works that evoke symbols of Native American womanhood (see Chapter 8). Other women artists of Powhatan ancestry, part of an extended family of artists, include myself, photographer and art therapist/art educator; Georgia Jessup, painter and ceramicist; and Rose Auld-Powhatan, painter and printmaker. Jessup's oil painting *Downtown* is part of the permanent collection of the National Museum of Women in the Arts in Washington, D.C.

I cannot discuss here all the Native American women artists who are currently impacting the contemporary art world. Native American women artists with varying visions, such as Emmi Whitehouse, Kay Walkingstick, Felice Lucerno-Giaccardo, Jane Ash Poitras, Nora Naranjo, Gail Tremblay, Joanna Osburn-Bigfeather, and Hulleah J. Tsinhnahjinnie, just to mention a few, are dealing with issues such as the environment, genocide, native spirituality, racism, and feminism. Kay Walkingstick's (Cherokee) work is a way of unifying the double life of living in an Indian and non-Indian world, a way of representing two kinds of knowledges of the earth. Walkingstick's new work uses copper to represent the economic urges underlying the rape

of the earth. Whitehouse (Navajo) creates abstract vessel and plant forms that represent the abstraction of Navajo attitudes and philosophies.[23] Native American women are confronting controversial topics with artistic vision in all the myriad styles and formats of the Native American and nonnative world.

IMPLICATIONS FOR ART EDUCATION

Despite regional and tribal diversity, there exists a spiritual unity among Native Americans that is manifested in the arts. The creative process in which artists transform visions is viewed as part of life's great mystery. That is why Indian art often is intertwined with religion, philosophy, and healing. Native American artists continue to be involved in processes that establish and renew relationships among humanity, nature, and the animal world. Native American aesthetics has survived colonialism, slavery, racism, sexism, and rapid technological changes.[24] Native American women always have been an integral part of this creative vision and continue to contribute to Indian aesthetics independently, in collaboration with other women, and in tandem with Native American men.

Where does the art of Native American women belong in a so-called pluralistic, postmodern, poststructuralist world? In the various "post-ism" worlds, the concept of identity is undergoing profound changes, as is the concept of high/fine art versus low/popular art. Native American women artists and intellectuals, along with Native American men, are in the process of developing new definitions of Native American art and redefining Native American ethnic heritages.

In contemporary cultural contexts in which multicultural, cross-cultural, gender, and diversity issues are explored, Eurocentrism still prevails. Non-European artists are either scarcely considered or relegated to the last chapter in the latest book on art criticism, history, or aesthetics. The term "mainstream art," as it is used in contemporary U.S. and Canadian books and art journals, usually ignores art by U.S. or Canadian minorities, especially Native American artists, male or female.

Art educators concerned with these multicultural issues, who are attempting to introduce Native American art into curricula, find few sources. Fortunately, feminist writers such as Georgia Collins and Renee Sandell,[25] Charlotte Rubinstein,[26] and myself have written texts that include contributions of Native American women artists. These writings are examples of feminist works that have tried to be inclusive, rather than exclusive.

However, this is not enough. The ultimate challenge is for Native American men and women to write their own cultural histories. Native American artists, critics, and audiences of both sexes have responsibilities to control

their imagery, the Native American commercial market, Native American art history and art criticism, and administration of Native American art galleries and museums. Native American artists who, like myself, travel to culturally diverse Native American communities help expand evolving Native American aesthetics. Interaction with eastern tribes such as the Powhatan, Lumbee, Shinnecock, Narraganset, Houma, Haliwa-Saponi, Piscataway, Leni-Lenape, Pequot, and Mohegan, which are usually ignored in literature on contemporary Native American art, can help in the revitalization of those cultures.

Native American feminist artists view their roles as partnerships with Native American men, partnerships with other oppressed women of color, carriers of their matrilineal legacies, and artists with consciousness. Native American feminist artists understand the relationship between sexism and racism; as cultural bearers, we link our art with pressing issues such as genocide, environmentalism, and spirituality. Native American women artists reach into the past and also reach out to future generations, taking responsibility for using the arts to call attention to and preserve ATTAN AKAMIK.

NOTES

1. Lise Vogel, "Fine Arts and Feminism: The Awakening Consciousness," in Arlene Raven, Cassandra Langer, and Joanna Frueh, eds., *Feminist Art Criticism: An Anthology* (New York: HarperCollins, 1988), p. 22.
2. Cassandra Langer, "Against the Grain: A Working Gynergenic Art Criticism," in Raven, Langer, and Frueh, eds., *Feminist Art Criticism*, pp. 111–132.
3. Vogel, "Fine Arts and Feminism."
4. Cassandra Langer, "Feminist Art Criticism," *Art Journal*, vol. 50, no. 2 (1991): 21–28.
5. Ibid., p. 25.
6. Jani Sawicki, *Disciplining Foucault, Feminism, Power, and the Body* (New York: Routledge, 1991).
7. Samella Lewis, *The Art of Elizabeth Catlett* (Claremont, CA: Hancraft Studios, 1984), p. 102.
8. bell hooks, *Yearning, Race, Gender, and Cultural Politics* (Boston: South End Press, 1990), p. 59.
9. See ibid., as well as bell hooks, *Black Looks, Race, and Representation* (Boston: South End Press, 1992).
10. hooks, *Black Looks*.
11. hooks, *Yearning*.
12. Ibid., p. 132.
13. M. Annette Jaimes, "American Indian Women: At the Center of Indigenous Resistance in North America," in M. Annette Jaimes, ed., *The State of Native America: Genocide, Colonization, and Resistance* (Boston: South End Press, 1992), pp. 311–344.
14. Ibid.

15. Ibid.
16. Phoebe Dufrene, "Exploring Native American Symbolism," *Journal of Multicultural and Cross-Cultural Research in Art Education*, vol. 8, no. 1 (1990): 38–50.
17. Tim Johnson, "New York Native Pena Bonita," *Turtle Quarterly*, vol. 2, no. 3 (1988): 6–11.
18. Allan Ryan, "Postmodern Parody," *Art Journal*, vol. 51, no. 3 (1992): 59–65.
19. Ibid.
20. In Lucy Lippard, *Mixed Blessings: New Art in a Multicultural America* (New York: Pantheon Books, 1990).
21. Ibid.
22. Ibid., p. 28.
23. Joseph Traugott, "Native American Artists and the Postmodern Cultural Divide," *Art Journal*, vol. 51, no. 3 (1992): 36–43.
24. Dufrene, "Exploring Native American Symbolism."
25. Georgia Collins and Renee Sandell, *Women, Art, and Education* (Reston, VA: National Art Education Association, 1984).
26. Charlotte Rubinstein, *American Women Artists from Early Indian Times to the Present* (New York: Avon Books, 1982).

3 / The Irony of Being American

Michi Itami

I am an artist of Japanese American heritage (third generation) who experienced internment, as did many Japanese-Americans during World War II, and who teaches at the City College of New York of the City University of New York, perhaps the most culturally diverse university in the United States. The makeup of the student body of the City College of New York incorporates fifty-two language groups, and many of the students are the first college-graduates-to-be in their respective families. The experience of teaching there is incredibly enriching, and I appreciate what I am learning from my students at the same time that I am teaching them printmaking and art. I am director of the Graduate Studio Program as well.

I feel obliged to first tell you about my experiences and evolution as an artist. In the past, my own work had been largely abstract. The tone and ambience of the work was largely Japanese. I say this because the Japanese in the past have eschewed direct representations of nature and usually have represented their visions of nature in stylized and abstracted ways. A moving phenomenon, such as a wave in the ocean existing in time and in constant motion, is better represented in abstract form.

In 1989, I got involved with computers and this has influenced the current direction in my artwork. I began to realize that one could make art from *anything*. The artist is no longer curtailed by one's drawing or representational skills. In addition, above all else, the issue of what is relevant to you became *most* important. My father left me a treasure trove of photographs from his past and his family. I had used them before in photo-etchings, but the size and scope was limited. I felt compelled to tell his story visually. In fact, when the government informed me that I was to receive a "redress" payment for being interned during World War II, I was at first quite ambivalent and upset. But when I thought of making a piece about my father and about our being interned at Manzanar, one of the largest internment camps located on wasteland near Bishop, California, I accepted the money with the intention of making these pieces. I bought a high-end computer

20

with part of the money and used it to create art related to the experience. In one of the pieces, I placed the letter from President George Bush that accompanied the redress payment next to the piece and called it *The Irony of Being American* (Figure 3.1).

The Irony, as it is nicknamed, includes three views of my father—one at sixteen years of age in Japanese dress, one at twenty-three in a double-breasted suit, and one at twenty-seven in his U.S. Army uniform—superimposed transparently over the background of Manzanar. The photograph of Manzanar was taken by Ansel Adams when he was a young photographer in the employ of the U.S. government.[1] Adams was told to take photographs of the camp, but he was ordered to leave out the barbed wire and the guard towers. He took many of the photographs from the guard towers hoping that intelligent people would ask from what vantage point these photographs were taken.[2] Adams bequeathed the photographs to the Library of Congress, and they are part of the public domain.

Most recently, I have been making multimedia pieces using more of my father's photographs. I have also used photographs of my mother, who, like my father, was also raised in Japan. Both my parents are *Kibei-Nisei*, which means they were born in the United States but raised in Japan. Before World War II, it was possible to live in a city such as Los Angeles and not speak English. As a result, I did not learn English until I was seven years old. My mother and I learned English together.

My father got us out of the internment camp by volunteering for the United States Army. A year after the war began, the U.S. government asked Japanese Americans to volunteer for the U.S. Army, although they could not guarantee citizenship rights for them. In fact, the government had proven that citizenship carried no rights by incarcerating Americans of Japanese descent. Because my father was fluent in both English and Japanese, he was chosen to teach language in the Army in Savage, Minnesota.[3] We all moved to Minnesota. My father was asked to go to Washington, D.C., to form a government publication library of Japanese materials; as a result of his efforts, he was awarded the Legion of Merit, the highest noncombat medal. From there my father went to the South Pacific, and at the end of the war he was appointed the head interpreter of the Tokyo War Crimes Trials. My mother and I were among the first American dependents to go to Japan in 1947. My memories of Japan at that time have fueled much of my work.

I feel very fortunate to be a visual artist, as we have another tool to aid us in communication. Artists of all kinds of media, whether it be music, dance, or visual art, have always had the benefit of their unique talents that supersede racial and ethnic difference. I think that at this particular time, artists can contribute most uniquely by informing the larger society about their own particular ethnic/racial cultural history.

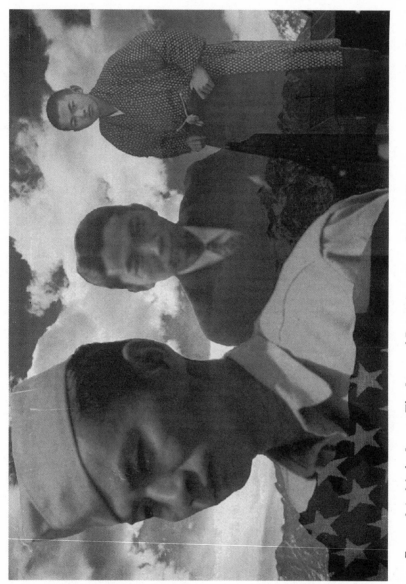

Figure 3.1. Michi Itami, *The Irony of Being American*, 51″ × 36″, computer-generated collage photograph and 22″ × 29″ lithograph. Prizewinner in the "Twenty-fourth Annual Works on Paper" show, San Marcos, Texas, 1994.

Recently, when I was waiting to be called for duty on a jury in New York City, I was impressed with the fact that in a large jury-pool room, where more than two hundred people were waiting to be called, Amy Tan's *The Kitchen God's Wife* was being read by four of them. I think that educated people everywhere are looking to be informed about other cultural experiences. The success of movies such as *The Wedding Banquet, Farewell, My Concubine,* and *Bandit Queen* further illustrates my point. The proliferation of ethnic-food restaurants in major cities is another instance of the growing appreciation of ethnic diversity.

In the United States, we share a common history in that we all came from other places. Because of this, we all have much to contribute to the storehouse of shared experience; we need to investigate our own pasts, the history of our mothers and fathers and their parents, to fully appreciate and understand how we have shared similar tribulations. At the same time, we need to acknowledge the differences of our various backgrounds. I know that when I read Toni Morrison's *Beloved*[4] and Maya Angelou's many books and poems, I am struck by the similarities of human need and desire, rather than by the differences.

Often people of color feel the need to make objective art as opposed to nonobjective abstract art that is perceived as mainstream art; perhaps it is because they are re-creating their presence and history for the larger world to see and acknowledge. Bell hooks, in her *Art on My Mind: Visual Politics*, says that "cameras gave to black folks, irrespective of class, a means by which we could participate fully in the production of images."[5] She further states:

Across class boundaries black folks struggled with the issue of representation. This issue was linked with the issue of documentation; hence the importance of photography. The camera was the central instrument by which blacks could disprove representations created by white folks. The degrading images of blackness that emerged from racist white imagination and that were circulated widely in the dominant culture (on salt shakers, cookie jars, pancake boxes) could be countered by "true-to-life" images.[6]

When I look back at my own childhood in Minneapolis during World War II (my mother and I stayed in Minneapolis while my father went to Washington, D.C., with the Army), I realize that the overwhelming image for me, as represented in magazine ads and movies, was that of Veronica Lake. As a little girl playing with friends, "dressing up" in evening gowns my mother had found in a thrift store, we posed with one leg peeking out from the folds of the garment in a Veronica Lake pose, hair hanging over one eye. Not being blond was a major setback in my own self-image, as it must have been for many others. Although I had just experienced being

incarcerated in a "relocation camp" a few years before, that had not left as strong a mark on my sense of who I was as did not having the possibility of looking like Veronica Lake.

Only in the years since deconstruction and the analysis of the authorship of history has there emerged an interest in the history and reality of others from different cultures. Fortunately, this interest expands our collective knowledge of the world and is more interesting. However, I think that rather than point out the other as the white, male-dominated, patriarchal society, it is important to not condone this society's actions but to try to understand what motivates people to follow this attitude. We all came to America as immigrants, whether it was one or two hundred years ago. People rarely leave their native countries unless forced due to discrimination, as with our earliest immigrants, the Puritans, or to economic duress, as with the Irish during the potato famine in their native land. Because of this history of dislocation from our native countries, we all have a tremendous need to belong to a larger whole. In the past, I think that need to assimilate, to be "American," has kept us from investigating our distinct pasts and our own ethnic traditions.

The desire to belong to a group has its comforts, but underlying this need is fear: fear that without group support, we are vulnerable to attack; fear that we as individuals lack the talent or strength to survive on our own; fear that a group of people we do not understand will supersede us economically and deprive us of our sense of status and our means of livelihood. How often have we seen fear motivate irrational behavior? Since most of us are prey to fear at some time in our lives, it should be an emotion we learn to confront and understand. However, we do not have to be ruled by fear; we can realize that each of us affects one another and that atrocities such as the Holocaust and the internment camps do not have to happen if more of us are brave and refuse to line up with the majority.

In the realization that we live in a society in which racism exists, what can we do about it? Focusing on the discriminatory attitudes and prejudice of some individuals *disempowers* the person of color. It is necessary, instead, to pinpoint the problem and use means to correct it if possible; but to spend one's creative energies and time complaining is counterproductive and fruitless. It is important to step outside of oneself and objectively look at one's own actions to see if one is acting positively or negatively. Every encounter with another person, whether they be friend, enemy, or neutral party, is an opportunity to interact positively. Ultimately, the only means we have to address the problems of society and create a larger multicultural world with equal opportunities for everyone is through a personal commitment to change. A friend and associate whom I have come to respect very much in our work together for the Committee on Cultural Diversity of the

College Art Association (CAA), Moira Roth,[7] told me that when she is asked to serve on a panel, she always asks what the makeup of the panel is in terms of diversity. If the panel has no one of color, she replies that it is not possible for her to participate in panels that do not represent a culturally diverse reality. The organization of the panel may be an innocent act, and it may never have occurred to the moderator that this would be an issue. However, Moira's actions serve as a reminder and represent a proactive stance.

The CAA's Committee on Cultural Diversity distributed a nineteen-page bibliography of books and videos on cultural diversity at the 1995 CAA conference in San Antonio, Texas, in response to several requests for help from the CAA in establishing a multicultural curriculum. Consequently, we organized a panel called "Working Models in Action" for the 1996 CAA conference in Boston, for which Joe Lewis served as moderator. We put out a call for submissions wherein artists and administrators would relate their experiences with actual working programs that were multicultural. Despite the fact that the CAA newsletter has a very wide readership, there were no proposals that featured "working models." Proposals were submitted, but they again talked about what they *wanted* to do, what reading lists and programs they *would* offer. No one who actually had a working program submitted a proposal. Does that mean that there are so few?

For artists of color, I would like to say that it is important for us to be involved in the larger art world and its activities. I know that it is tempting to say that our own art is all that matters and that it is not "our bag" to be involved with such things. Some even think that it is "not cool" and proof that you are not "really" an artist if you do involve yourself. Prior to coming to New York, I felt much the same way; but, New York, with all its complexity and dense layering of economic and social status and concomitant discrimination, made me aware of the power structure in the world. I am not the first to state that *every act is political; all artwork is political.* The hierarchy of what is considered "good art" and what is not, what is suitable for a museum and what is not, is all political. When I say "political," I am using the word in larger terms than just "who you know." By this, I am not saying that you must include a person of color's work in a show if you do not think it is at the same level of the work of other participants, but I am saying that if you are committed to change it is your obligation to search for work done by "others" to be included in the show. This is not about so-called affirmative action, which in itself as a concept can be degrading. Affirmative action as a program is complex and needs to be discussed more fully in another venue. But it *is* about being aware of the lack of multiethnic representation and addressing it. It is important to search for qualified minority people and invite them to participate and compete in the broader world.

In turn, I challenge culturally diverse people to participate in larger forums

and become active. It is not enough to voice criticism: It is imperative for one to participate, to be proactive, and to create opportunities for other people. I am active in several Asian groups, and for one of them, Godzilla: Asian American Arts Network, I am on the steering committee. As a group, we have picketed the Whitney Museum of Contemporary Art and the Guggenheim Museum for their lack of Asian representation in their collections and shows. We have also organized and presented exhibitions and workshops at Reed College in Portland, Oregon, and at Artists' Space in New York. The membership of Godzilla is multicultural within its Asian identification: There are artists from Japan, China, Taiwan, Korea, the Philippines, Thailand, Burma, and India. Their work represents the whole range of artwork in the art world, from sculpture and painting to installation and performance.

I also support and serve on the board of Art in General, a nonprofit gallery and art center in lower Manhattan directed by Holly Block. The board is multiethnic, and exhibitions and events at Art in General encompass the whole gamut of the population of the art world. Art in General is very forward-looking in that it hosts video viewing nights as well as guest lectures, exhibitions, and community outreach projects, among other activities, staffed and directed by artists.

Participation in these groups broadens my sense of the realities of our complex world. Fear arises from not knowing, fear of the unknown. When I occasionally meet people from segregated suburbs who tell me that they do not know anyone who is African American, I can tell by the way they are looking at me that it is the first time they are conversing with an Asian as an equal. I feel empathy for their condition. No wonder they are afraid; their experience has been so limited. We must act to broaden their experience.

In 1967–1968, when my ex-husband, who was an English professor, received a Fulbright teaching grant, I returned to Japan with him and our two daughters who were then six and three years old. I felt the experience of living in Japan, where the majority of people were nonwhite and where the culture was distinctly different from America, was an important experience for our daughters. I think the experience was empowering because they realized that their background is an actual culture and not just some picture-postcard place. One realizes that people of color in the United States, where the majority is truly different in color and looks, can inadvertently come to feel that their difference is a negative thing. However, living in another country, even when it is one's culture of origin, makes one realize at the same time how "American" we are.

What is truly "American" is to adopt an attitude of activism to ensure the ideals of fair play and equal opportunity for everyone. This is the responsibility of everyone, regardless of color or ethnic background. Part of

Figure 3.2. Michi Itami, *Sadame*, 22" × 30", computer-generated lithograph, 1993. Image of artist's mother at age eighteen combined on the computer with one of the artist's paintings and then color separated digitally. Original printed by Devraj Dakoi at Robert Blackburn's Printmaking Workshop, New York, under the auspices of a Professional staff congress-CUNY research grant. Prizewinner in the "Arcade" digital-to-print show, University of Brighton, England April 1995.

that activism is to relate our own personal stories and histories through our different media and inform one another of the complexity of our nation. Multiculturalism encompasses *everyone*; all of us have a story to tell, and understanding and empathy are increased when we share our stories.[8]

NOTES

1. John Armor and Peter Wright, Manzanar, commentary by John Hersey, photographs by Ansel Adams (New York: Times Books, Random House, 1988).
2. Ibid.
3. Loni Ding has made an interesting video about the Japanese American soldiers who trained to serve in the South Pacific interrogating Japanese prisoners of war in the battlefield. Loni Ding, *The Color of Honor: The Japanese American Soldier in World War II*, 90 mins., Vox Productions, 2335 Jones Street, San Francisco, CA 94133, 1989, video.
4. Toni Morrison, *Beloved* (New York: Alfred A. Knopf, 1987).
5. bell hooks, *Art on My Mind: Visual Politics* (New York: New Press, 1955), p. 57.
6. Ibid.
7. Moira Roth teaches at Mills College in Oakland, California, where she holds the Trefethen Chair. She is the author of numerous books and articles and has been on the board of the CAA since 1993.
8. For further, related reading and resources, see Loni Ding, *Nisei Soldier: Standard Bearer for an Exiled People*, 30 min., Vox Productions, 2335 Jones Street, San Francisco, CA 94133, 1984, video; Karen Higa, *The View from Within: Japanese American Art from the Internment Camps, 1942–1945* (Los Angeles: Wright Art Gallery and the Japanese American National Museum, c. 1992); bell hooks, *Teaching to Transgress: Education as the Practice of Freedom* (New York: Routledge, 1994); Lucy R. Lippard, *Mixed Blessings: New Art in a Multicultural America* (New York: Pantheon Books, 1990); and Ronald Takaki, *A Different Mirror* (Boston: Little, Brown, 1993).

4 / At Face Value

Janice D. Tanaka

As a third-generation Japanese American videomaker and activist, I was born and raised in an area adjacent to south-central Los Angeles. Having spent the 1980s working in corporate video, I wanted to create politically progressive work as an independent filmmaker, but the racially charged L.A. riots of 1992 brought a halt to my motivation. The concept of grassroots political organization using media as a vehicle for social change seemed to be a frivolous endeavor in the context of L.A.'s serious social, economic, and political problems. The riots also became my catalyst to reanalyze issues of race, class, and gender. I needed to break out of my two-decades-long career in public relations and gain new perspectives on what it meant to be a politically responsible mediamaker of color in the United States. So I made a midlife career change, taking a temporary job as a visiting professor at Indiana University. Subsequently, I was offered a permanent position at Purdue University in West Lafayette, Indiana. It was here that I sought to examine how right-wing thought develops for native Midwesterners. I wanted to see how the prospect of ethnic diversity, gender equity, and sexual preference affected the status quo of this homogeneous society.

At the beginning of my first year at Purdue, my very presence seemed to threaten some people. I saw deep roots of intolerance in this small Indiana town, even though a majority of the white, Christian population hid their ignorance under saccharin-sweet friendliness. For the first time, I became "the little Oriental girl" to the clerk at the local Sam's Club. People constantly asked me where I came from, and when my answer, "Los Angeles," did not satisfy them, they inevitably trapped themselves with their next question, "Where are your parents from?" When my answer to that, "Los Angeles," was still unsatisfactory, I felt myself getting irritated. What angered me most was their final sigh of relief when they got "Japan" as a reply for the birthplace of my grandparents.

Quickly, I learned what Asian Americans in the Midwest had gone through during their lives. Many simply assimilated, claiming that they had no real

29

problems, no qualms, no issues of being different. Upon closer examination of their interracial relationships, however, I discovered, for example, that they had never been introduced to the parents of their white girlfriends or boyfriends, and as interracial couples, they were not served in some restaurants.

The greater Lafayette area has a unique demographic profile. The official university town is West Lafayette, considered to be more upscale, with large numbers of professors and students served by major retailers. Separated by the Wabash River is Lafayette, a blue-collar town comprised of light industry such as the Alcoa Aluminum plant and the Staley Steel Company. The Japanese, a recent and transient population of workers who came in the 1970s as a result of the opening of the Subaru-Isuzu plant, were the largest Asian group in the town. Even then, I was a curiosity to the Asian and Asian American students coming in and out of my office in the Communication Department. Many of them were second-generation Chinese or Koreans. There were also several first-generation immigrants who had been raised in the United States. One common theme surfaced in our discussions. As a professor teaching television, they asked me: "Where are the films and videos related to our experiences?" "Isn't there anything specific to the Midwest, a piece broad enough in scope to tell the stories of different Asian groups, both immigrants and those of us born here?"

These questions echo the issue Loni Ding, veteran Asian American producer and educator, raises.

> It is somehow not enough that we've lived among a group of people, and see them every day in life. Something essential is missing when that existence is not also a confirmed public existence. The subtext of media absence is that the absent group "doesn't count," or is somehow unacceptable. And psychologically we know it affects our sense of self, our feeling of being agents who act upon the world.[1]

As a result of hearing so many stories of racial bias and discrimination against Asians, I decided to commit myself to a politically active agenda that included using media to effect change. In Los Angeles, I felt the situation was hopeless. In Indiana, I was more optimistic about the change that I could potentially effect with independent and alternative films and videos. Renee Tajima, coproducer of Who Killed Vincent Chin?, called independent works "socially committed cinema" free from network interference.[2] Many of my predecessors in Asian American media had gained national track records and received government grants creating such pieces. Pioneering Asian American filmmakers of the 1970s and 1980s, such as Steven Okazaki, Loni Ding, Chris Choi, and Renee Tajima, had set the standard for Asian American media, which was "characterized by diversity shaped through national origin and the constant flux of new immigration flowing from a westernizing

East into an easternizing West."[3] They were also tied by "a common experience of western domination."[4] I held on to these concepts and looked at those preceding me as models.

In order to depict the realities of life for immigrants in the Midwest, I decided on a format of personal stories that would be narrated by people representing three groups: Koreans, Chinese, and Japanese. Documenting real people meant that their stories could not be discarded as figments of my imagination. "'Ordinary people,'" says Loni Ding, "of no particular position—not heros, stars, celebrities, scoundrels, criminals, or monsters—are yet capable of doing extraordinary things. Individually and collectively they can have the power to engage us: to hold our interest, draw us nearer, fascinate, instruct, and charm us."[5] Indeed, the stories told to me had all the dramatic elements needed to create a vivid picture of Midwest racism.

Tony Yamasaki was the first subject interviewed for the documentary. He was the local proprietor of a Japanese restaurant in town. He and his wife, Kazue, reminded me of my grandparents, who had toiled all their lives to survive in the United States. Needless to say, the Yamasakis worked from early morning until late at night, over one hundred hours a week, to pay off their mounting debt. I began to understand how difficult it was to make it in the restaurant business in a place such as Lafayette. When I met Tony and Kazue, their lease had run out, and they were in the midst of complicated negotiations with city health and safety officials. My first shoot was at the grand opening of Tony's new restaurant called Kokoro, or heart and soul. During the event, Tony delivered a touching speech about his dislike of hate crimes. He told his guests a dramatic story of a man walking past his door every day shouting, "Jap, go home." While looking through the camera's eyepiece, I realized that media can empower immigrants such as Tony and Kazue to stand up for their civil rights.

Then I selected the story of Carrie and Courtni Pugh, adoptees from Korea. We met at the inaugural Asian Pacific Network of Indiana meeting. Having had a childhood and young adulthood full of racially motivated incidents, they were very concerned about the quality of life for Asians in Indiana. I was impressed by their breadth of knowledge about Asian American communities, particularly events and issues dealing with the East and West Coasts. They had educated themselves by combing the latest Asian American magazines and newspapers and were heavily involved in the Midwest Asian American Student Union.

I came upon the third subject for my tape when I attended a meeting of the Asian American Association, a student group on campus. One of the speakers sharing his story of growing up in the Midwest was Johnny Choi. I was at once struck by his fascinating accent that was a combination of African American and Chinese. He had come to Chicago's Chinatown when

Figure 4.1. From *At Face Value*, Tony and Kazue Yamasaki, Lafayette, Indiana.

Figure 4.2. At the *At Face Value* premiere, 15 April 1995, Lafayette, Indiana. From left to right: Janice D. Tanaka, Johnny Choi, Carrie Pugh, and Courtni Pugh.

he was nine and later moved to the suburbs, where he played high school football. His accounts of racist attitudes by his coaches were much too compelling to ignore, and along with the fact that it was unusual to find an Asian playing varsity ball, I thought Johnny defied the stereotype. He represented a new, refreshing type of role model for young Asian males.

Midway through production, the Ku Klux Klan announced plans to rally on the steps of the Lafayette courthouse. Footage of this event provided the ideal backdrop for the content of my video and became the cornerstone of the finished documentary.

Having modeled myself after independent media producers and directors such as Duane Kubo and Eddie Wong, founders of Visual Communications, I learned that documentary filmmaking was a cooperative process. To truly understand and visualize the depth of people's stories, I had to spend time with them. Working at a progressive media collective like Visual Communications, I had the privilege to be invited into the homes and lives of people such as Philip Vera Cruz, Filipino American labor organizer; Samoan community leader Foe Alo and his family; June Kuramoto, musician, teacher, and founding member of the band Hiroshima; and many others. I danced with the *pinoys*, the old Filipino men who hung out at the community center. I ate at family pig roasts hosted by the Samoan elders. And I sat around the dining table eating *senbei*, or Japanese rice crackers, at June Kuramoto's house talking about being *Sansei* (third generation) in America. Becoming a part of people's lives allowed me to gain their trust, internalize their experiences, and translate them onto the screen. As a result, in *At Face Value*, the three stories are distinct; yet woven together, they reveal great personal sacrifices needed to survive in the hostile Midwest.

The first round of interviews brought with it a few surprises. Tony and Kazue talked candidly about their lives. They were more open and honest than I had anticipated. Tony, who was a recent naturalized citizen, told of his attempt to commit suicide because he was much too individualistic for Japanese society. As an American, he thought he would be able to celebrate his uniqueness. In Lafayette, being different only exposed him to blatant racism.

Carrie and Courtni Pugh had arranged for me to shoot at their parents' house in a small town called Bremen, just outside of South Bend. Not knowing much about the patterns and numbers of Korean adoptions, I was expecting to find an eclectic, modern home reflecting a cross-cultural environment. I was surprised to find that the Pugh residence was pure homespun America. I immediately recognized the problem associated with growing up without an ethnic identity. Carrie and Courtni were not exposed to any symbols or artifacts of their Korean history and background. One visual element that became a part of the final tape was that of a Chinese restaurant logo in

their hometown of Bremen. It was a line drawing of a stereotypical Chinese man with a hat and long queue flowing from his head. This kind of depiction was prevalent in the early 1900s. I couldn't believe that in 1995, an image like this was still in use.

With the bulk of the shooting completed, I began the most time-consuming part of production: editing. My first cut was a searing critique of white male domination in our own small town. Little did I know I would pay a high price for my political message. I became the target of harassment by students and the subject of ridicule by insensitive administrators and staff members at Purdue. At the time, I was teaching a television editing workshop under the naive assumption that times had changed and diverse views were tolerated by the average U.S. college student. To the contrary, overt and covert hostile behavior began to manifest itself in the classroom and studio as a response to my work. The most blatant reaction came when I shared a rough cut of the segment about Tony, the sushi chef, with my class. They were less than receptive because Tony happened to have a heavy accent. One student in particular voiced his racism with a mocking "Ah, so!" Here, even a polite facade of political correctness did not exist. Apparently, being white and male still carried with it the pompous privilege to dehumanize what postmodernist theorists call the "other." My work, its subject matter, and my whole point of tolerance were lost.

I struggled to complete the editing of the tape. The story of the Pughs was cut in several different ways. With their many twists and turns, different combinations of quotes were needed to fully tell their story. I was able to weave the complex threads of their lives from their early years of harassment by other children to their trip to Korea and their later years as activists. I became intrigued by the issues surrounding adoption of nonwhite children from other countries who end up in white homes. I wondered what type of misrepresentations were given to women who gave up their kids. Did they realize life in America could pose problems for their children?

Johnny Choi's story illustrated the complicated relationship of Chicago's Chinatown and its Cantonese roots meeting head-on with the newer Taiwanese community. I used footage that Johnny shot on his home video camera of his football practice and games that made references to the stereotyping with labels such as the "Great Wall."

The Ku Klux Klan footage provided an interesting insight into why civilian militia groups are on the rise. With their love of guns and delusions of white supremacy, the Klan appeals to the white youth in rural communities through a cleverly waged public relations campaign that depicts the members with a new 1990s' image of being "clean, normal citizens." The local press bought into their lies by running several articles showing pictures of wholesome Klansmen in their three-piece suits.

Figure 4.3. At *Face Value* premiere, 15 April 1995, Lafayette, Indiana. Becky Wong and Janice D. Tanaka

At Face Value premiered at a benefit screening for the Asian American Network of Indiana, a fledgling civil rights organization working with the local and statewide press. I was encouraged by the heartfelt reception. The mayor of West Lafayette was gracious enough to comment that the tape really helped open her eyes to a problem she knew little about.

The process of making *At Face Value* and my own experiences living in the Midwest have changed the way I think. Large social movements, such as the fight for civil rights and for women's equality, have bypassed the heartland of the United States. The same is true for the fundamental principles of equality and freedom. In the Midwest, the young adults of the 1990s view the fight for civil rights as a past concept to be preserved as only a small part of U.S. history. They have, and will always have, the majority rule. When they are faced with people like Tony Yamasaki, Carrie and Courtni Pugh, and Johnny Choi in their neighborhoods, they look upon them as threats. It is my hope not only to chip away at these negative stereotypes, but more important, to empower Asian Americans with media images that provide us with a sense of self, as productive citizens with a place in this country that must be examined beyond just our face value.

NOTES

1. Loni Ding, "Strategies of an Asian American Filmmaker," in Russell Leong, ed., *Moving the Image: Independent Asian Pacific American Media Arts* (Los Angeles: UCLA Asian American Studies Center and Visual Communications, Southern California Asian American Studies Central, Inc., 1991), p. 47.
2. Renee Tajima, "Moving the Image: Asian American Independent Filmmaking, 1970–1990," in Leong, ed., *Moving the Image*, p. 10.
3. Ibid., p. 12.
4. Ibid.
5. Ding, "Strategies of an Asian American Filmmaker," p. 48.

5 / The New Movement of the Center: A Theoretical Model for Future Analysis in Art Worlds

Robin M. Chandler

As an artist-apostate, one could say that art worlds are in desperate need of change either from within or by the spawning of new traditions, institutions, and human beings. The last category is critical. If artists fail to become better human beings, future art worlds will also fail in their mission to inspire, heal, uplift, and guide. If artists are not as self-critical of themselves as they are of the constraints of expressive freedom in every nation, the destiny of art will gradually dim and decay.

Some of us have arrived at the shores of art's global projects late in the evening of its crises. Many more were defined into these issues by the very nature of identities of race and gender that were politicized through dramatic events such as slavery and the slave trade, holocausts, internment, land removals and conquest, and histories of gender oppression and class struggle. These are powerful histories to overcome. Some of us seek to actively dismantle old shibboleths, while others are being dragged, kicking and screaming, in to a New World being forged by the discontent and greed.

We all arrived at the threshold of the art world in similar disarray. Yet, however we came to this site of chaos, conflict, competition, collapse, and contradiction, we exist as "architects in partnership" at a historical moment that we may redesign based on a new set of principles. For good or for bad, the metaphor of civic and artistic citizenship is being felt outside the traditional loop—in Bosnia and Dublin, in Zaire and south-central Los Angeles, in Sydney, in South Africa, in Salvador, Brazil, in Bombay, in Bismarck, North Dakota. The centers of the globe are no longer the traditional enclaves of Paris, New York, and Hong Kong, long the economic hearts of the world. Now the heartbeat of art worlds pulsates from nontraditional

38

centers of activity where artists have survived repression, censorship, disenfranchisement, exclusion, exile, imprisonment, and even death.

No practitioners more so than artists are equipped with perilous war stories about how they have navigated and survived in their profession.

As creative people, artists are in the midst of a great paradigm shift. We are at the threshold of a new century. The relational desires of the class struggle and nationalism remain a shivering menace to the globalizing unities needed for the construction of a new art world. The politics of empire would have us believe in the limits of theoretical inquiry and its linkages with social change and responsible citizenship. The global economic community is a political enterprise constituted by the same art world elites. Its antiquated sense of empire will stop at nothing to rekindle the flames of mean-spirited debates about multiculturalism, feminism, revisionism, spirituality, reformation, interdisciplinarianism, syncretism, and any issue that mediates power. These forms of "difference" are, at the first tier, associated with the multiple identities of race/ethnicity, nationalism, gender, age, class, and formal education, religion, and sexual preference. However, at the second tier, they are the powerful forces of those who settle for a virtual reality of false materialism against those who demand a reality of virtual peace.

Those who have struggled against ideological warfare in the art world through spiritually based praxis have learned many important lessons; on the up side, that art is not above life, not transcendent, and certainly not "pure," since the individuals who produce it remain untransformed. We have learned that the most functional art is, in fact, defined by its consensual submission to reflecting life as it was, as it is, and as it might become. Exclusionary practices, patriarchy, nepotism, cronyism, and provincialism are only a few of the abnormalities of an old culture dying in the wake of what is being born. The art world, as it is presently constructed, expires with the old culture. A new generation whose definitions of the purposes of art and the role of artists drastically challenge the art world on the battlefield of art production is now in operation but not yet at center stage.

Moving away from the claustrophobic and cobwebbed arena of "*art for art's sake*," many artists took with them the dream that a magical site of transformations could exist, one that had no doors, windows, walls, floors, or ceiling. The epistemological site of the old culture from which we fled replicated itself with some of the same theories, canons, methods, and practices, such as gender inequalities within nationalistic struggles or racial hierarchies within feminist praxis. The failure to adequately face sexism within nationalist agendas or racism within women's pursuit of equal opportunity has nearly drained our capacity to speculate, let alone act upon, the inevitability of peace. The neomythologizing strategies of first-tier concerns haunt our organizing capacities in the art world. We respond, as artists, to the

exclusions by creating discrete art worlds: feminist art, African American art, Native American art, gay and lesbian art, tribal art, and institutes of Third World consciousness. The project of many of these currents is a claim to forms of new classicism organized around "cultural" centrisms. While these may offer exposure to a new cadre or generation of elites, many of whom disdain mastery of craft in lieu of stardom, they serve only to further expose the feebleness of that old culture that seeks regeneration in the bodies of the young. The spiritual foundation of the new culture awaiting birth has yet to be a matter of public debate in the art world and for good reason. Many of us are embarrassed to admit a lack of readiness for the individual transformation that must set such debates in motion. The emperor is in drag, the spook who sat by the door has stood up, and the cigar store Indian owns the casino. As artists, we were led to believe that interior decoration of the art world "house" with first-tier multiple identities would represent a new vision of the world, one that included women, people of color, and the poor. In its place we have a revised art world as a vanishing wilderness of soon-to-be extinct species who achieve the questionable status of specimens of material culture. Enthralled with those human objects of material culture, we worship our new cultural/art heroes and heroines until the next wave of human artifacts presents itself.

The "difference" dilemma in art worlds is far more complex than we imagined. The cultural freedoms often associated with liberation struggles in the arts mean that, in some countries, art breeds self-censorship, while in Western countries, the threat of commodification and commercialization is a seduction of containment. In some Middle and Eastern countries, that autonomy of thought and action in artistic life must always bend an obsequious knee to postmodern clones. Convention rather than innovation often characterizes the art that is permitted (financially supported/government-sponsored) to rise to the top. We rarely get to see some of the most important work being done until it is made palatable for elite consumption with its dissemination and interpretation controlled by the entrepreneurial elites of the old culture.

From a more basic position, artist agency means that if artists do not compose, choreograph, construct, film, paint, and perform as well as administer, interpret, and encode their own texts, and mediate their own markets and audiences, than those tasks will continually be usurped by those who ride the backs of artists. Rarely has artist agency achieved new ways of knowing unless it has been connected with a more transcendent purpose, an application to real conditions of existence that must be altered—the threat of death, imprisonment, or poverty. Implementing first-tier affirmations may control outward forms of intolerance; but underneath, the plagues of the old culture thrive. Retaining more women or people of color in the art

world may or may not guarantee progress in the art world, especially if that art world is one with which we no longer wish to identify. Perhaps the ideas of progress and civic community demand revisions of their own. The Athenian female persona may diversify the marketplace, but she may do so in defense of patriarchy, traditionalism, and the status quo. Alone, this strategy is doomed. Hand in hand with other strategies, however, it has a chance for meaningful change in the ways we do business in the art world.

The strategy presented in the concept of a *"New Movement of the Center"* is, in part, a view from the briar patch. It is a self-reflexive moment in which we discover that artistic genius is not a matter of gender or race unless those identities are linked with spiritual agency—the power to make good things happen, even in bad times. In that self-reflexive moment, the artist discovers that the content-form-performance conundrum is a vital, interanimating vortex in which theory and praxis define a discourse of nonmateriality with physical culture, with society and consciousness. Art demands to know where it is being driven, propelled by the accelerating energies of the times. The *New Movement*, for the first time in the history of art as a movement, wants a map of future art worlds not only as an assurance that history will not repeat itself, but also as a means of enhanced vision in the darkness of materialism.

Artists are migrating away from the stigmata left from anti-art and anti-intellectual regimes of nationalism. They are saying that there is no life without desire; that there is a desire for a syncretized politics of aesthetics in which art practice and political action can produce not only great art, but an admirable humanity. The *New Movement of the Center* is an analytical model that describes the globalism, technologism, and intergenerational domain in which we find ourselves at the close and opening of centuries, a means for understanding future art worlds. The model avoids ideological reproductions and formulae proselytized by the culture centrisms of temporal rule(rs). Hovering on the edge of darkness, the old cultures of power overemphasized social systems rooted in celebrity, fame, exceptionalism, genius, social types, autonomy, and class and gender hierarchies. Most continue to reproduce themselves through vast, chaotic markets, economic determinism, nationalism, materialism, and the degradation of the body and nature. The preservation of art worlds in the modern West has been a major site of conquest and exploitation.

As intellectuals read the written text, compile ethnographies, tour the non-Western terrain, and make art out of the charred remnants of these quests, we always run the risk of fortifying the old culture with neomythologies that continue to invade the private space of others. In spiritual terms, the task is to recognize the self-privileging that occurs when we make the cultural capital of others our own in our artwork. The interposition of feminism

and cultural centrisms is a frequent flyer into these regions. For at least a century, a kind of hypermodernism has flourished in the imagination of those artists enticed by strategies of resistance to the nineteenth century's "cult of true womanhood" and "scientific racism." Artists continue to lose themselves in these projects even at the close of the twentieth century. Among artists of color, there is a type of cultural dissonance that emerges out of deconstruction politics that can be both a decoy and a cesspool. The Du Boisian legacy, as a basic theory of cultural politics, has grown deep roots in the language of identity. Some artists are often focused on romance and nostalgia, a looking backward, while others are searching forward in the emptiness for a more basic spiritual outlook as a means of preparation for things to come. If artists of color and women have learned anything from the old culture it is that the new emphasis on the lived histories of the excluded has been a fertile epistemological field that has invented and theorized a whole new set of kinships. Definitive forms of reason and memory have developed in these new creational worlds, and they have been developing, most definitely, within a "center" of their own. While the *Movement* of the center is new, the center itself has been evolving for the last one hundred years.

The infrastructure of art worlds, modern and traditional, involves a patronage, legitimation, and screening common to different national contexts. The acceleration of shifts in art production and consumption has also increased. Not long ago, the choice of style, medium, theme, and one's identity operated to screen out new genres, women, and artists of color. In these times, those agendas have been appropriated by entrepreneurial elites (art consultants, art historians, curators, galleries and dealers, museums, etc.) who define art's investment potential. It is as if one cannot market work unless it is about an artifice of shifting identity. Elites control not only the monetary, acquisitional, and exchange value of art production, but the hyperinflated artist icons who star in an endless parade of artist minstrelsy as well. The explicit message is that only art that replicates the ideological commodification of gender, cultural difference, or social type in all of its flamboyant and idiosyncratic manifestations will be sanctioned and glorified. This translates into a supply art politics steered by what elites who have money and power want to look at and experience as art, not necessarily artists or everyday people. Sadly, it may not be in the practical interests of the wealthy to support the establishment of more spiritually based forms of art and art production. That necessitates a dramatic social and individual change in how we define our humanity as artists. Historically, these processes have become treaties of convenience that lead to new reservations, plantations, and a domestic service to the halls of bourgeois tastes.

Questions of inclusion are not recent to the debates on difference. I can

remember the darkened halls of slide lectures on what was preemptively titled "world art history" in my undergraduate years. The meaning conveyed by the absence of work by women, people of color, and non-Westerners was self-evident: Quite simply, the "world" is defined by those with the power to stake its boundaries. Invisibility and anonymity continued in the course texts that devoted one page to the Mexican muralists, authors of one of the first and most profound globalizing influences of the twentieth century; preliterate societies (the entire planet outside of Europe) "naturally" were allocated a sparse field in the front of the text; and we saw little of the great Asian or Amerindian cultures that had flourished for millennia.

Hypermodernism has been content to draw upon the vitalizing and dynamic impulse of non-Western cultures for the energies that would stimulate new styles of art in the West. These appropriations assisted the postcolonial projects often resulting in the commodification of traditional cultural ways of knowing. With African sculpture, Japanese formalism, and Mexican narrative painting neatly packaged for consumerism these days, there has been little time to adequately evaluate the ways in which European art (relatively speaking, a new kid on the block) might even fit into a more comprehensive overview of "real" world art. Its role and place would be diminished significantly in a new paradigm of inclusion. Art, as a discipline, has not evolved all that differently from science and its revolutions—perhaps a mixed blessing. Preoccupation with indigenous creators of material culture and their artistic manifestations is old-fashioned ethnography, a colonial pattern of conquerors followed by missionaries and intellectuals.

The dilemma of naming "what is art" and taking those names seriously in the art world is a task for the *New Movement of the Center*. The womanist, brown or black gaze can appreciate a Bearden, a Vermeer, the Kano school of sixteenth-century Japan, or a well-made Martinez pot and its approaches to representation. Yet dealers, collectors, and the markets they comprise often abhor themes that address degeneracy, political repression, and violence against the body when such are depicted by those subjected to these atrocities. It always comes down to who owns the sandbox.

We are witnessing a collectivization of the struggle for globalized art worlds, art worlds whose spiritual conscience demands a link between art and politics, an art that advocates on behalf of the human condition. It will not be enough that artists address these themes in their work. Artist agency will build these newly engaged art worlds as they have done in the past in various nationalized contexts from Chile to China to South Africa. These worlds will not be built by entrepreneurial elites, nor by social historians, nor aestheticians, curators, or the new breed of public intellectuals. Art worlds will be built by the hands of art itself, from the studio where the life of art begins. The interrogation of freedom and individual rights and the

responsibilities that go along with global citizenship are a directive of the new movement, a movement not constituted by media-hyped stars, but by artists participating in the nominal and routine activities of their craft as they find ways to use art to liberate and renew human agency.

Nurtured in a violent world, the *New Movement of the Center* is not pre-occupied with annihilation and redemption, but with the creative will of the twenty-first century. The principles of this movement assert the oneness of humanity because of its diversity, the equality of men and women, and spiritual solutions to economic problems as we reconcile science, technology, and the arts. These principles are gradually being implemented not by partisanry, but by a loosely configured set of artists whose credentials rest in their commitment to this new paradigm of a new culture of humanism. Individuals and artists take the name "artist" seriously at the close of the old century. The massive walkouts of National Endowment for the Arts panelists, the redirection of major theoretical projects that redress First Amendment rights, public protests on every continent—all these point to a mandate for social action. One of most important credentials is that of a spiritual and geographical shift from a point of personal interest to a global baseline. The shifting sites of operation are not in the United States and Europe, but below the equator and to the east.

Sorting through the international debates of our times demands new models of thought. The *New Movement of the Center* is the spiraling effect of globalization, interdependence, ethical chaos, cultural diffusion, and technology. It is the coalescing of actors and philosophies around these new principles that privilege human life above political agendas. The future of the *New Movement* implies a reorganization of social systems (including art worlds) which thrive on conflict, competition, and privilege. The transformation of worldviews and the elimination of all forms of prejudice, particularly racism, will redefine cultural difference in spiritual terms. Identity will no longer be a masking device to avoid the confrontation with personal change. One can be gay and racist or black and sexist in the *New Movement of the Center*, a site where such anomalies can be purged without recrimination.

The *New Movement of the Center* is a harsh and demanding breeding pool for artist-citizens who desire world solidarity, envision art as an act of worship, avow deference to artists, and understand that only transformed individuals can build new institutions.

The theory of a *New Movement of the Center* is purposely broad enough to embrace cultural centrisms, religious positions, new technologies, creative people who work in traditional modes in less technologically developed communities, and views of women as they emerge from vastly different human societies. The principles suggest an epistemological pathway on which

artists may communicate, navigate, plan, and execute the tasks associated with rebuilding art worlds. The lexicon suggested here is designed to accommodate the work of art across all production media, particularly those in their infancy. The concepts—multiple identities, artist performance practice, lived histories, the dramatic event—involve new ways of knowing our humanity and learning socially responsible patterns of living.

Artists should be encouraged by what the global art world will look like in the future, as well as by what is going on now. The tenacity with which artists of the current generations are devoting themselves to new movements of the center is inventive, experimental, and catalytic, even when it is rooted in materialist notions of power. What will eclipse any new movements in art is the possibility that the values of materialism—indiscriminate over consumption, individualism, loss of spiritual purpose—will merely reproduce old societies with an aesthetic face-lift. The shareholders in art production of the future, those who will control the means of production, will navigate on the information superhighway instead of on the telephone or fax; they will have Web pages on the Internet where their work will be exhibited, performed, and promoted, instead of high-rent, high-profile galleries and museums; and they will be competent businesspeople as well as artists. Mastery of technique will no longer mean how well you can draw, compose, or choreograph but, rather, how good you are at assessing trends, analyzing markets, and networking on collaborative works, projects, and institution building.

New business enterprises will emerge out of artists' needs to redefine space and identify resources and new materials. Whereas movements in art in the twentieth century have been political, apolitical, and reactionary, in the twenty-first century one's survival as an artist will be determined less by identity and social position and more by rethinking spiritual approaches to problems in art whether they are personal, interpersonal, professional, or societal.

Carpe diem as you walk the path of the human being.

NOTES

This chapter is a revised version of a paper delivered at the Eighty-first Annual College Art Association Conference panel entitled "Feminism/Gender Studies: Taking Names Seriously," Seattle, Washington, February 1993.

6/ Reflections on the Inescapable Political Dimensions of Art and Life

Cliff Joseph

The debate persists among publicized critics, curators, dealers, producers, directors, critical spectators, and artists themselves as to what is authentically "art". The argument will continue and will shift, as value systems shift with the winds of time. How, then, do the foregoing opinionated viewers respond to the voice that loudly asserts from the center of the crowd, "All art is political!"?

Gaining the attention of all the stunned disputants, the speaker continues: "All art is political because art is created by people, and all people are political." A brief murmur is heard from the crowd, and then silence descends again, awaiting the speaker's elaboration. "Many people like to deny that they are political, but being political is an inescapable essential in being human, demanding responsible lifelong expression. So, in creating art, we are expressing ourselves politically. For example, we're offering a concept, stating a point of view or a preference, declaring a judgment, expressing a feeling. All that—together with our choice of medium, style, form, content—is exhibited to our viewers, read by our readers, performed for our audiences to be critiqued, appreciated, panned, praised, ridiculed, accepted, rejected, or exploited based on their likes, dislikes, ideals, beliefs, projections, and needs. Who can be aware of such complex grounds for people's assessment of art and still deny that all art is political?"

Hearing a stir from a small part of the crowd, and sensing by the silence of the great majority of listeners that the point hadn't been fully understood by them, the speaker goes further: "Those who represent the arts establishment are painfully aware of the political power of art that speaks out against their exploitation of creativity and takes a stand against the injustices that fuel the affluent world's market culture system—the most widely protested among them being racism, sexism, poverty, and environmental

46

pollution, and the list could go on until we stop at the ultimate insult awaiting the command to rise from nuclear silos. Art created to didactically expose these injustices and inspire people's proactive response in protest stands on the constructive side of the political dialectic that calls upon the people to confront and engage the principalities and powers in a struggle to bring about fully liberating change. But to be effective, to be most powerful and empowering, this kind of political art must never lose its magic." For as Ernst Fischer asserts in *The Necessity of Art*:

> True as it is that the essential function of art for a class destined to change the world is not that of making magic but of enlightening and stimulating action, it is equally true that a magical residue in art cannot be entirely eliminated, for without that minute residue of its original nature, art ceases to be art.[1]

The implication is that if art loses the magical power to be truly art, it loses the power to be constructively and effectively political.

When the arts establishment condemns these creative protests as too political and therefore nonart, it simultaneously embraces and declares the status quo–serving works and performances it considers suitable to its exploitative purpose to be "high art." In this way, despite some occasional token face-saving exceptions that it has perhaps felt morally obliged to make, it closes the doors of "respectable" culture to the political expressions with which it disagrees and finds threatening to its authority, while keeping the doors open to art that, regardless of form and technique, in content induces tranquility, titillation, romantic sentimentalism, appeal to decorative passions, and intellectual and cultural pompousness—all of which serve as distractions from the serious human concerns upon which art has the power and responsibility to focus.

As such, the establishment hopes to avoid the polemic that challenges its judgmental authority and its refusal to recognize that the cataclysmic dangers threatening our age are far greater than those that such cogently explicit commentators as Goya and Daumier, whose work it exploits, lived through. The arts establishment distances itself from the political substance of the works of these artists that reflect their protest of the injustices of their time, refusing to acknowledge the link between their oppressive time and ours.

Artists and their art must bring to light the fact that, globally, humanity is dominated by a value system that favors destructive technology, material wastefulness, and dangerous disregard for the ecological principles upon which all life on our planet depends for health and survival. As we approach the twenty-first century, those of us who call ourselves socially concerned artists must responsibly challenge the dominant powers through our art and

our politically relevant social action. Such challenge must be undertaken boldly and will often call for what must be done sacrificially, to set an inspiring and empowering example for people to follow as they seek the courage to struggle for liberating social change.

The dominant powers' fear of such confrontation and struggle on a mass scale increases their determination to neutralize and control the power of art through co-optive schemes and whatever other means they deem necessary to achieve the desired effect. Some in the arts community fall prey to the lure of material wealth and lose themselves in the wilderness of competitive economic striving and a place in the arts establishment's lucrative mainstream. The choice they make is political, and the art they produce for that purpose is political. Then there are those of us who express our political choice by keeping the light of creative protest focused on the crucial conflicting issues of our time. Our arms, as we take on the responsibility of engaging the powers of privilege and oppression, are the creative tools of our visual, literary, and performing arts; our armor, the spirit of solidarity. And we must be well aware of our vulnerability to the deadly and determined forces arrayed against us: ideologically, culturally, financially, politically, militarily, and to a disturbing degree, religiously. In their pathological drive toward fulfillment of Orwellian prophecy, these forces have brought humanity to the brink of global nuclear suicide. They make up a formidable alliance against the life-affirming alternatives that the arts represent and must engage them in struggle to realize.

The most valid counterforce available for our struggle to overcome these oppressive and destructive powers is art: art as music, art as dance, art as drama, art as poetry, novel, film, graphic and plastic expression, and as positive self- and other-actualizing lifestyles. Although much of the struggle will be experienced existentially as each individual attempts to deal with problems of personal repression, changing the broader social aspects of an oppressive culture and its dehumanizing effect requires a deliberate collective effort that must essentially be politically creative and creatively political.

In another account of the political intrinsic in art, artist and art historian José A. Argüelles states in *The Transformative Vision,*

> capitalism and communism, the two components of dialectical materialism, cannot exist or be defined without each other. Both are intellectual symptoms of the same disease—the belief that matter is the only knowable reality and that ego, a concatenation of material energies, is the only knower of this reality. Since this belief system entails an explicit denial of psyche, the art it fosters, no matter how technically refined, can have no deeper significance than propaganda or purely sensory entertainment. Anything else will be judged retrogressive, rebellious, or mad. Under these conditions, regardless of the artist's intention, art will be

political, for it is inevitably interpreted under materialistic standards as consciously supporting or rejecting the prevailing economic system. . . . Because of the pervasiveness of materialistic values there is no escaping the political interpretations that art inspires.[2]

To the extent that we are products of Western culture, regardless of our ancestral roots, we are caught in an imbalance of history, dominated by techne and the legacy of industrial structures.

The 1960s brought a striving for alternative values. The spiritual awareness of the East, surviving colonialism and internal corruption, brought us in touch with transformative levels of understanding. Within our own borders, we rediscovered the respect for natural forces in the efforts of Native Americans to maintain their cultures. Idealism became a major theme, as many struggled for a just and peaceful world.

Somewhere between the dichotomy of East and West, the dichotomy of psyche and techne, stood the African American, cut off from ancestral land and material culture, bringing new art forms to the world, expressions of urgent psychic survival—"devil's art." Here was an expression of a people so intimately dominated by an alien culture that the quiet integration of life forces, the subtle interplay of yin and yang, was totally insufficient to counter the oppression of their history. Born in the existential reality of an African people seeking itself in white America, blues and jazz have been integrated into the rock and disco rhythms of the wider youth culture, reflecting the more universal necessity of a subversive energy.

For it is subversion upon which salvation depends most urgently today. Art today, particularly urban art, is aggressive, oppositional, and unsettling to the established order. Actor and comedian Eddie Murphy, for example, for all his superficial vulgarity, is ultimately life-affirming, a surrealist, jolting our surface consciousness with deeper truth. The poetry of blues and jazz abounds with surrealistic images, while a rock group, calling for liberation from the senselessness of existing structures, called itself the Police. It is increasingly urgent to recognize the vital links between culture and the artistic expression of oppressed peoples. Historically, the impact of such expression, reaching us most profoundly through the unconscious, has brought sustenance within culture and opportunities for insight and growth to all.

Through music, dance, drama, poetry, novel and playwriting, and the visual arts, blacks have contributed to the artistic and cultural growth of America, portraying their country in its truest light to their fellow citizens and the world. Jazz, the greatest art form America has produced, grew out of African American roots to enrich the musical reservoirs of human expression throughout the world. The art of Hispanics, Asian Americans, and Native Americans has added depth, breadth, and power to the expression of universal spirituality.

The incessant corruption of the ruling culture, however, makes heritage difficult to maintain. American blacks, for the most part, do not listen to jazz preferentially. Latino (as well as black) youths play disco and rap on their portable radios, too often ignoring the rich African elements of salsa. Some Latino and Native American people turn their crafts into meaningless commercial objects as they struggle to survive. With this same urgency, many African American painters produce works indistinguishable from those of their white colleagues.

In more recent history, however, efforts for creative response to the social, economic, and political ills of the United States and the world grew and became more focused. In the 1950s and 1960s, street musicians in black and Hispanic communities celebrated ethnic power and pride and mourned the inevitable tragedies of oppression, in a context of sharing and caring.

Sixties' rock music articulated white youth's awareness of its own oppression as it protested war, economic injustice, and alienation from the accepted values of the industrial age. Western folk music fused with blues and sometimes Eastern harmonies, seeking a more universal truth.

In the 1970s, significant statements on urban reality were made in subway graffiti. Quality of expression was frequently policed within the culture as graffiti artists sought to eliminate inferior work. For the sensitized mind, much of the work was aesthetic, relevant, and essentially affirming of mental health and the need for positive change.

Then came electric boogie, popping, and break dancing, countering the confusing and steadily failing models of adult authority in a world of unparalleled hypocrisy, corruption, and apocalyptic threat.

These art forms held the potential for mastery, fulfillment, and unity. Sadly, however, the "dream-deferred" has left us today with regressive expression, destruction, and hopelessness. Street culture today has few new answers for its salvation. Our only defense against drugs and moral corruption is a futile effort to reinforce dying structures. Illusion hides the profound nature of our impotence.

Much has been lost. And the danger of continued loss is tied not merely to the shrinking art funds, but to the frayed fabric of our deteriorating communities as well.

While art that denies the essential challenges of our time prospers on the investment market, too little relevant art finds meaningful connection to the less privileged classes. For if creative expression is to flourish, the relationship between artist and audience must be nurtured.

Such nurturance evolves naturally in simpler times, but in today's world, public effort is needed. Such effort has precedence in our history. During the presidency of Franklin D. Roosevelt, for the first time in U.S. history, thousands of artists were paid by the government to work productively and

develop their art. Musicians were paid for playing in community bands, and writers were hired to write local or state histories. There was money for public murals and for teaching children to sketch and paint. Such generous government support for the arts, particularly as it affected artists of the lower economic class, was not given without careful assessment of the investment's potential return in cultural, capital, and political assets. In order to secure that investment, care was taken to provide the broadest range of opportunities to the most deserving among artists, in service to the public's need for artistic nurturance. It is this concept that spawned the National Endowment for the Arts (NEA). In contrast to Roosevelt's Works Progress Administration, however, it is important to note that the NEA's support to artists contemporary with its evolvement has been minimal; and if left to the legislative influence of conservative politicians, it may soon be none at all.

The sixties brought another era of creative productivity. With unprecedented ferment, black artists built on the creative traditions of their people to nurture newly responsive audiences. Postwar prosperity had created a larger African American middle class better able to afford the arts, while the civil rights movement had brought greater pride in black culture.

That generation gave birth to new expressions among whites also. In the shadow of massively destructive wars and the development of a technology capable of total destruction, faith in Western science and rational progress was countered by a growing disenchantment. Enriched by African American, Eastern, and Native American cultures, dissident white artists drew on their own roots to confront America with its contradictions. The "beats" and "hippies" of the period drew inspiration from African American protest, music, and lifestyles.

But the movement was short-lived. For blacks, the turning point was probably 1968, with the assassination of Dr. Martin Luther King Jr. For dissident whites, it was 1967, with the inevitable defeat of hundreds of thousands of people who dared to carry their antiwar protest to the Pentagon. The supreme power of technocracy set the course for today's generation—mechanization, destruction, apathy, and selfishness.

That the assassinations of King and Malcolm X—along with the repression of other African American leaders and their allies—should leave our black communities so shattered is perhaps a failure in the broader trust of our creative leadership. What was the relevance of our artistic expressions to the masses of poor people in our urban ghettos? Were the abstract powers of our music, our poetry, drama, and dance integrated into the lives of our people? Did it help them connect their spiritual roots to the struggle for integrity in an alien world? Unless they were actively involved in the creative process, probably not.

Neither art nor religion, as traditionally practiced, can afford total relief from this situation. As a summer evening's escape, the subtle complexities and contradictions of modern jazz fall on ears clogged with the realities of meaningless work, frustrating relationships, and impotence and hopelessness. The anger engendered by such alienation responds better to repetition and amplified noise. Jazz musicians remain poor, not only because funding is limited, but because the reality of our culture makes the immediacy of disco appear to be more relevant.

Many African American visual artists create paintings and sculpture that are only available to the affluent. Yet, when democratic conscience stirs the artists to produce inexpensive prints, most working-class consumers ignore their efforts. Better for them is a Woolworth's pastoral, denying the reality of feeling, of contradiction, of life.

There are those who would have us believe that the cultural choices of the masses are, at best, the result of limited education; at worst, a reflection of innate inferiority. It is obvious, however, that salsa did not evolve from academia, nor did the aesthetically beautiful religious objects of Africans or Native Americans depend on the scholarly rigor of advanced education. The creative expression of a people whose formal education seldom extended beyond puberty has been valued for centuries, while much of what is created today will be forgotten tomorrow.

As discouraging as this picture is, support for the arts is more essential now than ever before. Within the framework of technocracy, art stands as a vital force, preserving the values of psyche, the intuitive base from which all life-affirming action springs. We must organize our communities in the struggle for more, not less, NEA support and demand that our taxes be used not for bombs, missiles, and their inevitable by-product of death, but for creation, education, culture, and life-preserving human services.

The essential nature of the U.S. political and economic system has not changed, and people are no less in need of spiritually enriched artistic nurturance that can sustain them in times of stress and inspire them to seek self- and community-actualizing alternatives to status quo living.

The popular attraction to such movie spectaculars as *Star Wars* indicates a deeper public need than momentary escape into a fantasy world of the future. In spite of the otherworldliness of the scenes and characters of *Star Wars*, there is much that is identifiable with our world as we know it today and our everyday life as we live it. We can recognize immediately the similarity of basic issues that set the stage for struggle in both realms: life versus death, good versus evil, psyche versus techne, Princess Leia and Luke Skywalker versus Darth Vader, working class people versus the imperialistic ruling class.

Viewed in this framework, is it such a curious fact that Ronald Reagan, a celluloid "hero" of the past, survived politically to enjoy the adulation of

reelection? Do we need to ask how one whose fame and fortune was built largely portraying one of filmdom's fair-haired Indian slayers was qualified for such awesome responsibility in the real-life picture, with his trigger finger poised to fire nuclear bombs? Those of us who are familiar with the *Star Wars* epic will recall that Darth Vader had been a disciple of Obie Ben Kenobie, the patriarch committed to the Force. Just as the angel Lucifer attempted to usurp the power of God for evil purposes, so Darth Vader fell from grace to serve the Imperial Ruler, representing the dark side of the Force. In that capacity, he had awesome powers for use in service to evil, destruction, and death.

In our world, with his pretensions of concern for human rights, Reagan symbolically represented and was a false hero, shaped by the land of make-believe, revered by the worshipers of plastic legend. The presumption of his right to real power in the real world made him a useful pawn in the hands of those who persist in the unreality of their dominance over all humanity.

Except in terms of megatonic capability, Reagan's access to destructive nuclear power was no greater than that of any U.S. president since Harry Truman. But these are the 1990s, and although we have seen the defeat of one-term "Desert Storm" George Bush and the collapse of the Soviet Union heralding the end of the cold war, President Bill Clinton was greeted with the continuing media message daily proclaiming this to be an apocalyptic time; a time when the fabric of all that is life-affirming is being systematically ripped apart; a time when needed human services are forced to defer to the continued maintenance of the military-industrial complex; a time when vital artistic expression and creative growth are sacrificed in favor of military bands.

The artist draws from the life force wherever he or she finds it, to celebrate its victories and to expose and confront the forces of evil that work against it. Although many look upon "the artist" as an individual apart from the majority of humankind, it is the creative force in us all that leads to spiritual fulfillment. Whatever our roles in life, we have a responsibility for self-actualization, for loving, learning, and working effectively. By getting more in touch with our own artist within, we develop a new sense of wholeness. Art that is received passively is used as a defense *against* creativity, an ego adornment to disguise a multitude of evils.

In order to serve our spiritual needs, art must evoke an active and honest response. Those of us who paid attention to the historical details of World War II are familiar with the impressive art collections and adoration of nineteenth-century composers who involved the interest of so many Nazis during Hitler's reign of terror. A culture that had produced Goethe and Beethoven defended itself against the life force by its exploitation of the life force.

History can teach us a heavy lesson. We now live in a time when art as commodity is flourishing; but still today, art is too often a defense against concern, a defense against commitment.

Art has a sacred function as a vital expressive power that can inspire humanity to expose and confront the dehumanizing, life-destroying forces of our time and can set into motion creative, life-respecting alternatives. Street culture, driven by the necessity of psychic survival, often comes closer to meeting this function than do the approved modalities of bourgeois art.

There are those who believe that an art intended to transform emotions and consciousness must be based on a transformed life, a life in a setting uncontaminated by today's world. Many of us, however, feel that creative communication depends on the existential reality of living in the technocracy that oppresses us all. Perhaps both paths are valid.

We are one human family. Creative communication is our responsibility, not only to ourselves and to our oppressed communities, but to our oppressors as well. We must demand the economic means for our survival and for theirs. As artists and members of a global community, we cannot separate ourselves from the political process that will decide our ultimate fate. Our work is political, regardless of pretensions to purity. It supports the status quo; it questions it, condemns it, and, if our work transcends the present world, we must struggle to make this transcendence a possibility for all.

In our struggle for transcendence, we cannot separate our professional efforts from the totality of our day-to-day lives. Resolving contradiction is the essence of the creative process—in artistic production and in our commitments to social change. Our creative gifts obligate us to a larger responsibility in making history. We have an opportunity each day to make political decisions, to look honestly at the reality around us, and to make choices consistent with the affirmation of life.

NOTES

1. Ernst Fischer, *The Necessity of Art: A Marxist Approach*, trans. Anna Bostock (Baltimore, MD: Penguin, 1963), p. 14.
2. José A. Argüelles, *The Transformative Vision: Reflections on the Nature and History of Human Expression* (Berkeley, CA: Shambhala Publications, Inc., 1975), pp. 123–124.

7 / Art as a Vehicle for Empowerment

Nadema Agard
Winyan Luta Red Woman

In my work as an artist, I create metaphors for the cosmic relationships between the sacred feminine and the sacred masculine. Only in the understanding of how one defines the other can the empowerment of women also empower men. When these sacred feminine images—the doors where one emerges from the spirit world to this material existence—are respected, only then can there be harmony. These are the teachings of our tribal wisdom. The circle and the four directions, or the Medicine Wheel, is a symbol that inspires my works and installations to express the relationship of male and female in perfect harmony. In *Manhattan Days, Prairie Daze*, a large duo installation, the works of the male artist are installed in a circle around the central cross where my works are placed in the four directions. A solo installation of my works, *She Is the Four Directions—Transformational Crosses as Sacred Symbols of Life*, explains the male and female relationship as time and space. Time is male and the circle, while space is the directional cross and female. What is matte complements gloss; what is light complements dark, and what is hard contrasts soft. Vertical and phallic hierarchical forms are in balance with horizontal and nonhierarchical yoni forms. Such a balance is inspired by the traditional manner in which a man carves the bowl of the sacred pipe, which represents the female part of the universe, and the woman decorates the stem of the pipe, which represents the male counterpart. In *She Is the Four Directions*, a woman creates the work, and a man does the installation. This is the balance and the wisdom of the traditional elders.

As a contemporary or modern indigenous woman in the eyes of the Western world, my work appears nontraditional. However, taking a closer look, with a spiritual or heart vision, one will realize the spirit of the work derives much strength from the traditional arts and cosmologies of the native peoples of Mesoamerica, the Southwest, the Plains, the Southeast, the Northeast,

and the Great Lakes Woodlands. This eclectic vision is part of my intertribal ancestral reality that draws its roots from the Southeastern Woodlands and the Northern Plains and traces these to one tribal origin of all native peoples of the Western Hemisphere.

The difference between my work and that of a nonnative artist who might be inspired is the difference between art made for power and art made for reflection. Art made as "reality" by the Huichol[1] painters of Mexico, under the influence of peyote, is very different from art made as a translation of reality by the impressionist painters of nineteenth-century France. My work is a reality as well as a direct and real translation. It is a reflection of my involvement in teaching circles and ceremonies, but it is also a means of receiving power and, in turn, a means of healing. This work records the spiritual shorthand from my genetic memory and the understanding of the power of color and symbol. If I use images associated with medicine power, I must be responsible for the consequences of that use and know that all knowledge and the presentation of such knowledge has a price, both positive and negative. As a presenter on a panel entitled "Claiming Our Past: Appropriate Appropriation?" for the Women's Caucus for Art conference "Beyond Boundaries" in Seattle, Washington, I discussed the use of such imagery and the responsibilities of this usage. Speaking from the heart, I stated how artists who have a real connection with these images of sacred symbols or spiritual language will make art that has integrity. Artists who exploit these images will produce work that will be dishonest.

As a visual artist with an indigenous perspective, I see the symbols in my work as the language of the spirit and a capsule of the culture. "Art" described in indigenous terms, however, is not separated from tribal life. We make art and we are art. As a Native American woman, my art cannot be separated from my life, and so there is a constant dialogue between what is abstract and concrete, from the installation made in an art gallery to the creation of a new dance outfit for a powwow—one having no more or no less meaning and importance to my life. And because art is a vehicle for my spirituality, I make work as a visual prayer or votive offering, particularly to the life-giving powers of our mother, the earth, and our father who art in heaven, the sky.

Earth Mother and Her Children of the Four Directions (Figure 7.1) is a transformational box that represents a global perspective of space, where place is not so much a location but a state of mind. It shows the four sacred colors of humanity as four unique and separate newborn infants still connected to four different umbilical cords. Yet, they are connected and coming from the same source that shows how Earth Mother nurtures all her children with the same attention and respect.

These are the traditional teachings in visual form. Visual form is the

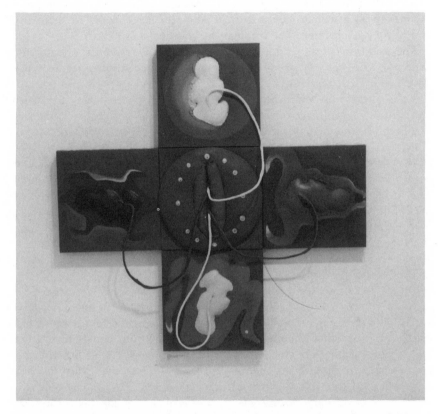

Figure 7.1. Nadema Winyan Luta/Red Woman, *Earth Mother and Her Children of the Four Directions*, 12″ × 12″ × 12″, acrylic/canvas mixed, 1991.

language of tribal people for most sacred teachings. I view this piece as sacred art in its presentation and subject because it portrays the sacred passageway from spirit to material life—the door to heaven (conception) and the door from heaven (birth). In creating this work, I am focusing all my powers as a woman-being to say, "We are sacred doors to this world, and no one comes here but through our mother—respect this!"

The traditional teachings recognize the balance between the female and male powers of nature. In my work, conception represents a female experience while birth represents a male experience, because it is also true that there is always the feminine in the masculine and the masculine in the feminine. It is said that our men singers initiate a song just as a man implants the seed and that our women carry the song as the women carry the child until birth. Two of my transformation boxes, *Blue Night Turtle Moon Birth Amulet of the West* (Figure 7.2) and *Yellow Day Lizard Sun Birth Amulet of the South* (Figure 7.3), represent the birth of a daughter child and a son child, respectively. They have the symbols of the feminine and the masculine, the yoni and the phallus, the horizontal or female axis of the four directions as east/west, and the vertical or male axis of the four directions as north/south. These pieces are directly influenced by the traditionally beaded birth amulets made in the image of turtles and lizards by women of the Northern Plains.[2]

Other works entitled *Corn Mother Box* and *Heaven's Door* (Figure 7.4) use a more personal iconography. The corn of central form surrounded by a yoni cradle represents a phallic symbol in the box, while four birds or male spirits are magnetically pulled toward a glittering yoni center in the door piece. The installation *Honor Thy Father and Thy MOTHER* has the male part created in three components, "Father Sky" (circle), "Morning Star" (eight-pointed star), and "Spirit Messenger" (bird). The female piece is a directional cross representing *The Sacred Feminine of the Four Directions*: Virgin Mary of Christendom (white/north), Tonantzin of the Aztec (red/east), Kichijoten[3] of Japan (yellow/south), and Isis[4] of Egypt (blue-black/west). The male and female dynamic exemplifies the most important relationship in nature, hence the numbers three (time) and four (space) total seven. *Honor Thy Father and Thy MOTHER* ultimately addresses our hearts as the seventh direction because we are the children of time, our father, and space, our mother.

As a Native American person with multivision, I am very comfortable in the language of syncretism that views one object or meaning simultaneously from many vistas or many definitions. To draw parallels in spiritual language, to assure the survival of the original language, is syncretism at its best. This syncretism speaks about the inclusive nature of indigenous people who are "and" people rather than "or" people. *The Virgin of Guadalupe*

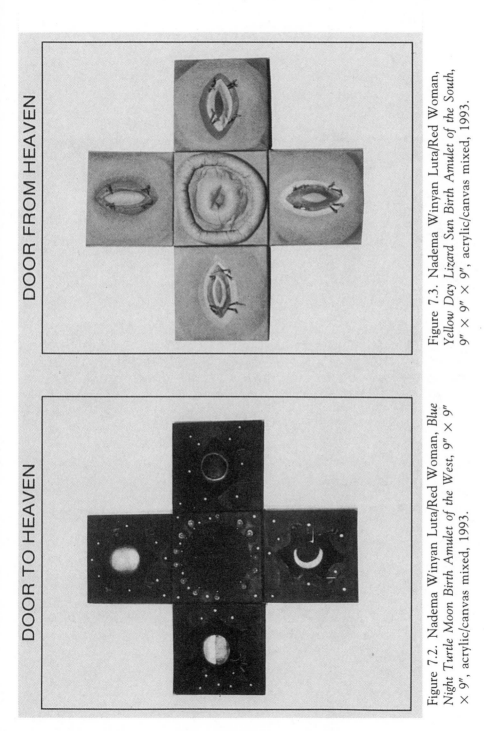

DOOR TO HEAVEN

DOOR FROM HEAVEN

Figure 7.2. Nadema Winyan Luta/Red Woman, *Blue Night Turtle Moon Birth Amulet of the West*, 9″ × 9″ × 9″, acrylic/canvas mixed, 1993.

Figure 7.3. Nadema Winyan Luta/Red Woman, *Yellow Day Lizard Sun Birth Amulet of the South*, 9″ × 9″ × 9″, acrylic/canvas mixed, 1993.

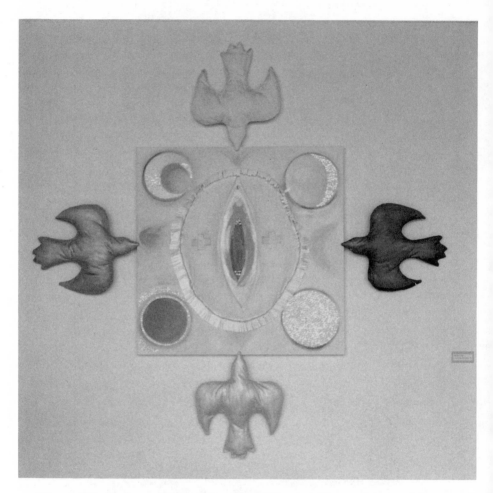

Figure 7.4. Nadema Winyan Luta/Red Woman, *Heaven's Door*, 36″ × 36″, acrylic/canvas mixed/shaped, 1993.

Is the Corn Mother (Figure 7.5) is a work in which I address my personal syncretism. For me, the image of the Virgin of Guadalupe,[5] who is also Tonantzin (Aztec mother of God), strongly serves two spiritual visions simultaneously. And although she perhaps may be seen by some as the Virgin exclusively, I understand her as both and recognize her power as magnified because of this cosmic status. My ability to perceive life from a multiple perspective allows for syncretism in all languages of my expression, like the visual puns of Eskimo artists that are carvings of two things simultaneously. My transformational boxes are visual syncretism because they can be more than one structure and they can be viewed from more than one direction. They can be hung vertically as a cross, horizontally in the same manner, or on a pedestal as a three-dimensional cube. Again, one can see the "and" nature of my native teachings.

The Virgin of Guadalupe Is the Corn Mother also demonstrates the power of tribal art as a vehicle for cultural and political resistance and a spiritual grounding for a world that has become unbalanced. This work shows how our persistence in continuing the tribal aesthetics of the Americas is born out of a natural resistance that employs all forms of survival: We will resist and adapt what is necessary to maintain our indigenous beliefs. Part of this grounding is the connection with the earth and its healing powers. I see this work as a matrix for a holistic experience and a connection with the creator and the creation, the earth and its healing powers.

I recognize the arts of traditional peoples as a visual vocabulary that serves the visual artist such as myself the way dictionaries and encyclopedias serve the Western literate society. I have also been aware that colors and symbols appear or are created in my works for specific purposes. In many cases, artists continue to perpetuate symbols through our work, although the meanings are sometimes unclear. We do it because we are culture bearers and must assure the survival of our art traditions. These images reaffirm the cosmic consciousness, and they are also glimpses into the other reality as spiritual doors.

As an indigenous artist, my work does not serve its own sake but is strongly connected to my community. It has a relationship with the community and often conveys a teaching. My works have adapted nontraditional materials and techniques to convey what is necessary for the cultural survival of our indigenous peoples, just as the Aztec people have adapted Catholicism to insure the survival of the Aztec beliefs and the Lakota[6] have adapted the star quilts of the missionaries to continue their own religious ceremonies. In this manner, my works are vehicles for our spiritual and political survival, which honor a tribal vision of the Great Mystery[7] as ever connected, cyclical, and reciprocal. This vision sees east not as a place but as a direction and all life and death as a transformation and part of each other.

Finally, *Grandmother Moon and Her Corn Moon Daughters* (Figure 7.6)

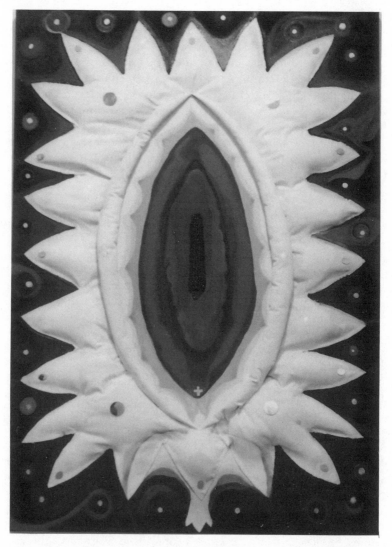

Figure 7.5. Nadema Winyan Luta/Red Woman, *The Virgin of Guadalupe Is the Corn Mother*, 42″ × 60″, acrylic/canvas mixed, 1992.

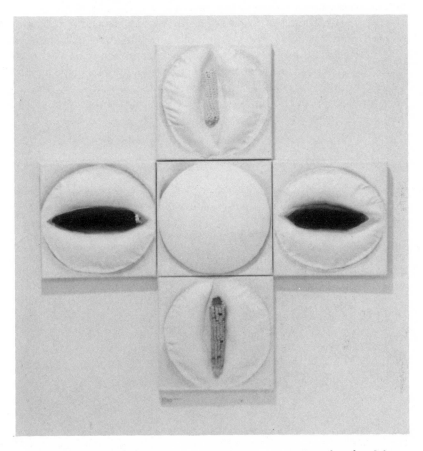

Figure 7.6. Nadema Winyan Luta/Red Woman, *Grandmother Moon and Her Corn Moon Daughters*, 12″ × 12″ × 12″, acrylic/canvas mixed, 1992.

honors the postmenopausal status of womanhood and the wisdom of experience. It is also a recognition of my participation with *Anishinaabeg*[8] women in the moon ceremonies of the Great Lakes Woodlands and a realization of the vision of our grandmother's who looks down to the earth and sees no borders between nations. It is an assurance that Grandmother Moon is the strength and support for all her daughters because her phases guide us through our monthly cycles of renewal and fertility until we reach her status. Her light is a reflection of the sun, our grandfather, and so the cycle continues as women and men are the source of each other.

NOTES

1. The Huichol is a native people of Nayarit, Mexico.
2. Birth amulets protect and preserve umbilical cords and insure long life for a newborn child.
3. Kichijoten is the Buddhist goddess of abundance.
4. Isis is the queen mother of Egypt, whose name means "giver of life."
5. The Virgin of Guadalupe is the patron virgin of Mexico.
6. The hakota are Sioux.
7. Also called the Great Spirit or Creator.
8. "*Anishinaabeg*" means "the people" in the language of the Ojibwa, who are also known as Chippewa.

8/ Art in Brazil: Several Minorities

Ana Mae Barbosa

Despite the fact that there are a great number of women artists in Brazil, "man" is still *the* universal canonical value. Women are deemed of equal value only if they accept men as the norm. Equality in Brazil doesn't take into account the difference. The discourse of equality and the discourse of difference, however, have to be articulated together in order to make it possible for women to be the subject of their own discourse.

The conquest of equality began in Brazil with the modernists after 1922. The modernists held anticolonialist ideas that led to the consideration of equality of gender, race, and cultural codes. Those ideas permitted the recognition of two women as the most important artists of Brazilian modernism: Tarsila do Amaral and Anita Malfatti. Before modernism, some women artists had been important in their own time, yet they were completely erased from the history of art. But modernist ideas alone may not have been enough to maintain the visibility of Amaral and Malfatti, for I believe that they, too, would have been erased were it not for two female art critics who wrote important books about them.[1] In Brazil, the celebrated equality is dismissed by the lack of memory for female production. An example of this involves two active protagonists at the beginning of abstraction in Brazil in the 1950s and 1960s, Samson Flexor and Yolanda Mohaly. A book about Flexor was published, and his work is carried on by his disciples. Mohaly, however, although she is considered a better artist than he by the twenty critics and artists I informally interviewed, is being forgotten.

Amaral, very influenced by Europe, and Malfatti, greatly influenced by the United States, were in contact with societies more open to the participation of women. This exposure no doubt contributed to their level of confidence, but it was not enough to guarantee their revolutionary aesthetics. Malfatti, in fact, was strongly criticized and almost destroyed by the powerful male writer Monteiro Lobato, who in 1917 wrote an article attacking

her called "Paranoia or Mystification?" I believe that he and his contemporaries, although concentrating their criticism on her modernist style, were really scandalized by a young woman's freedom to represent naked male bodies with feminine gesturality, a representation of an ambiguous sexuality. Sexuality, not style, was the reason for male aggressive and destructive criticism against Malfatti's art. It is curious that these two women, who operated the change of the aesthetics paradigms in Brazilian art of the twenties, at the end of their lives painted what society expects from women: boring landscapes and religious themes. The insidious norms of society prevailed upon their artistic behavior.

In Brazil, the challenge to traditional definitions of fine art helped women to achieve visibility for their art in the contemporary world. For example, printmaking was traditionally considered second-rate art, therefore a medium left chiefly to women even though the great masters were male. When the artistic concepts changed and the status of printmaking improved, many women were already known as accomplished printmakers and, consequently, their status as artists was consolidated. In contrast, the challenge to the primacy of painting and to the supremacy of art as commodity opened the field to alternative media such as installations—not so valuable in the market—that had traditionally been successful for female artists in Brazil. Basically, if money is not involved, women are allowed to animate the scenery; but if money is involved, the equality is destabilized. Maria Martins, for example, a friend of Marcel Duchamp, was a high-quality sculptor of the 1950s; despite her award-winning work, however, today she is known only by specialists. Her work has still not found a critic.

Most of the women artists in Brazil who achieve equality of visibility refuse to see themselves as women artists, therefore they refuse to acknowledge gender difference. In 1989, for instance, Josely Carvalho, a Brazilian artist who lives in New York, and Sabra Moore organized an exhibition called "Women Artists: Brazilians and North Americans in Dialogue," but it was very difficult to enlist the participation of Brazilian women artists who had by then attained the same visibility as their fellow male artists. The arguments, included, "I don't want any connection with exhibitions only of women. I am as important as a man, I don't need to be seen as separated" and "To expose myself, I don't need to appeal to gender; that is a way artists without quality succeed." It was clear that they thought they would lose status if they were seen as women artists.

Art critics reinforce this kind of metaprejudice. They refuse to confront gender categorization, afraid of being considered second-rate critics. When the Museum of Modern Art of New York invited me to speak during an exhibition of Latin American art, I was very proud because it is one of the most important museums in the world. But because I chose the format of a

roundtable on women's art, I received several put-downs. One of them, by a female art critic and art historian was particularly memorable: "No important art critic would accept to speak in a roundtable on this subject."

Another instance of prejudice occurred when Carvalho, Moore, and I tried to take the exhibition "Connections" to Brazil, despite a difficulty with sponsorship. In Brazil, private companies avoid sponsoring anything in the visual arts that is connected with difference: women's art, black art, Indian art, and so forth. Although Carvalho and Moore succeeded and presented the exhibition at the Museum of Contemporary Art, the press gave very little attention to it.

A woman artist who accepts being identified as a woman is suspected of mediocrity. Works of outstanding American artists, such as Ida Applebroog, Faith Ringgold, Nancy Spero, and May Stevens, and works of Latin Americans in New York, such as Liliana Porter and Catalina Parra, were exhibited in Brazil, but nobody noticed because they were exhibited as female artists. Very recently, however, Spero and Porter did successfully exhibit in Brazil, but they did so in a general exhibition absent of gender classification. Without explicit reference to their gender, they could be seen and appreciated.

On the surface, women artists, because they are numerous and have visibility (when they don't present themselves under gender categorization), seem to have equality with men artists. However, if they cross the paths of social differences such as gender, race, or class, this equality vanishes. For example, I researched the ten most important art galleries (where money counts) in São Paulo, some operating for almost twenty years, and found that they have never exhibited a black women artist, though but a few of them had exhibited black male artists. It is amazing that in a mestizo country assumed to be a racial paradise since Gilberto Freire wrote *Masters and Slaves!*, gender and race problems are hidden behind stronger prejudices based on social class.

Until a few years ago, women in Brazil, the educated women from the middle or high-middle class, had little problem being assimilated into middle-power jobs because there were not enough males with university degrees to fulfill the positions available. Even today, despite the large increase of universities in the last twenty-five years, only 1 percent of Brazil's population attends college, and only 60 percent of this 1 percent gets a degree.

Thanks to Auguste Comte's ideas of positivism that have influenced Brazil since the nineteenth century, women have been educated. The percentage of women students is large, chiefly in the humanities; and in art, 82 percent of the students are women. But among the overall student body, the percentage of men who succeed is larger than the percentage of women. This is probably one of the reasons that most Brazilian teachers are male.

In recent years, the effects of recession and unemployment began to affect the ease with which educated women can secure good professional positions. In professional competition, women always lose out to men, regardless if the latter are white or black, heterosexual or homosexual. A widely circulated magazine, *Veja*, demonstrated this through interviews with homosexuals in June 1993. All those interviewed agreed that women are more discriminated against than are homosexuals. An incident in São Paulo's administration in 1992 also evidenced this point. A female director of a state museum in São Paulo, a position occupied by several women in the past, was fired by the administration's secretary of culture under the premise that the secretary didn't feel women should direct museums because of their complicated nature. As a result, only men directed the museums that fell under the authority of the secretary of culture of São Paul from 1992 to 1995.

I don't want to convey a pessimistic impression of my country, because I am an optimist by nature. And there are several developments that give me some hope about the evolution of female consciousness in Brazil. One is that fact that eighteen artists and a critic who were previously afraid of feminism accepted roles as participants and collaborators in the exhibition "The Art of the Ultra Modern Contemporary Brazil" presented in the National Museum of Women in the Arts in Washington, D.C. To give you an idea of the extent of this improvement, only three of the eighteen artists who participated had accepted inclusion in women's art shows prior to this one, and all of those shows were in the United States. But even in this exhibition, prejudice in terms of identification of gender surrounded it. The only two women artists in the exhibition who were actively reflecting and commenting on the feminine discourse were critically viewed by women critics in unpublished sources as having no qualitative right to be there; and the two under attack were precisely the two who had been engaged with the feminine condition for a long time. They were judged inferior to the other participants, not on the basis of an objective analysis of quality, but on the basis that they contemplate the feminine, and for Brazilians, this translates as "they have nothing important or relevant to say."

Applied to the women artists in Brazil, Virginia Woolf's comment about women writers in history is very appropriate; she said that the women who wished to be taken for men in what they wrote were certainly common enough, but if history had given a place to those women who wished to be taken for women, the change would hardly be for the better. Paraphrasing Simone de Beauvoir and Eva Hesse, I would say that in order to forget you are a woman, it is first of all necessary to be firmly assured that you are and always will be a woman.

The rejection of gender differentiation in Brazil is a consequence of the rejection of thinking politically about and in art. Any political reflection is

labeled as pamphleteerism. The "wash hands" art is the aspiration of Brazilian artists. The only value is the European and white North American codes. In addition, what I call "supracolonialism" is a dominating force. Brazilian artists say, "Europe and the United States expect from us a folklore art; we have to react by giving them an art inserted into their codes." Any representation that reveals the environment where we live, our culture, is condemned under the allegation that we are submitting ourselves to the concept the First World has about our art. That is what I term supracolonialism. In order to say "no" to the colonizer, we say "no" to ourselves.

Some months ago, I had the opportunity to participate on a jury with Brazilian and North American critics and artists. A work of a young Brazilian artist, Adriana Varejão, a kind of deconstruction of a baroque angel resulting in the incorporation of bits of its form in a textured and abstract painting, was rejected with anger by one Brazilian and with suspicion by a North American, the "other," because it was revealing something that belongs to our culture. The word "roots" is a bad word in conversations on art. Again, respecting cultural policy and colonialism, we look for equality without taking into consideration the differences.

Institutions, art critics, and artists in general have no concern for cultural pluralism, multiculturalism, interculturalism, and so on. I have been trying to put into practice a multicultural policy in the Museum of Contemporary Art of the University of São Paulo. When I was the director there, we held about forty exhibitions a year that could be classified under the label of the "European code" and/or the "white North American code." But at least one exhibition a year brought to the museum the cultural code of "others." We had two projects going on from 1987 to 1993: "Aesthetics of the Masses" and "Art and Minority." The former was the more difficult to gain acceptance by the erudites of the university. Within this project, we organized an exhibition of carnavalescos, the artists who design the allegories for the schools of samba. We chose to display the work of five of them, two with university degrees and three barely literate. Among the five were two black carnavalescos and one female carnavalesca. The show was a great public success, changing our audience, that represented a step toward inclusion of low socioeconomic class people.

Another exhibition, carried out in collaboration with an anthropologist, resulted from research among construction workers on the outskirts of São Paulo. We identified some workers who approached their daily work with aesthetic concern. Three installations came out of that; one by two men who collaborated together without knowing each other before. They met to discuss the exhibition, they visited the biennial of São Paulo together, appreciating the works exhibited there, and they decided to make a tin house. Both earn their living doing exactly what they did for the installation:

They made objects out of used cans and floors from bits of ceramics. The floor composed of ceramic bits has become a solution for poor homes in Brazil. Scraps of broken ceramic tiles all of the same color are joined by cement of the same color to create the look of a homogenous, tiled floor.

Another installation was made by a group of women led by Ismenia Aparecida dos Santos. They decided to set a table with plates and food made of ceramics atop a tablecloth woven in traditional techniques. We showed them Judy Chicago's *Dinner Party,* but they concluded that their table was different: It was not ritual, but lucid.

And yet another installation of figures made of mufflers—a very common item adorning the signs for garages in Brazil—was the contribution of seven men and one woman. Painted panels of bar fronts completed the exhibition.

The challenge is to have this kind of anthropological, aesthetics-driven exhibition in the same museums that exhibit Picasso, Matisse, Braque, and the Brazilian avant-garde.

Multiculturalism in the United States means visibility for all cultural codes, but separation of these codes. There is in New York, for example, a museum for black artists, another for Hispanic artists, another for political artists, and so on. Affirmative action is still necessary in American society. In Brazilian society, however, our effort to confront cultural codes in the same space creates meaningful board lines that challenge the established canons of value. Several roundtables discussed the exhibition that I just described, which we named "Peripheral Art: Combogos, Cans, and Scraps."[2] And a course taught by Andreas Brandolini, a designer from Berlin who exhibited at Documenta 87, included an analysis of the installations in his class, and the creators of the tin house were invited to discuss with the students their work and their ideas about design, function, and form, despite the fact that they were illiterate men. At least we denounced the inexistence of bridges between the erudite and the popular, the high and the low.

In the silent space in between, in the interstices of the codes, we tried to produce knowledge, reflection, concepts, and finally, the revitalization of the aesthetic dialogue among different social classes. Even for the opening of the new building of the Museum of Contemporary Art (MAC) in October 1992, we tried to celebrate traditional media of art, ritual or popular art, together with the hegemonic code. There, the erudite art was presented in an exhibition of one hundred sculptures from the collection, with the exception of a sculpture by Louis Bourgeois borrowed from MOMA (MAC has very few North American artists in its collection of 5,300 works of art). Frida Baranek, Jac Leirner, and Cildo Meireles, who exhibited in the Latin American art show at MOMA, were represented in this exhibition at MAC too. Other exhibitors included: Boccioni, Henry Moore, Marino Marini, Max Bill, Cesar Domela, Pietro Consagra, Jean Arp, Calder, Barbara Hepworth,

Rafael Conagar, Cesar Baldaccini, Eduardo Paolozzi, Jeseus Rafael Soto, and Sebastian. But a group of popular (from the people) artists were also invited to design with sand a carpet that ran from the street, through the garden, to the entrance of the museum. Seventy-five people—men, women, and children—worked for ten hours to make the carpet. Everyone walked around them the whole day while they worked, commenting on their own experiences in their hometowns doing the same, for its proper aim, the procession of Corpus Christi.

The identification of something known leading to the doors of the museum made the entrance into the unknown easier. That night, we had 5,000 spectators, most of them lower-class workers of the university who would not have entered the museum if the carpet had not acted as a facilitator. Poor people in Latin America are afraid to enter museums, as Netstor Garcia Cancline and Paulo Freire have talked about.[3] For the poor are ashamed to be confronted with their own ignorance. But if they find the courage to enter, their fear is thereafter conquered, as they are seduced by the forms of at least one work. Even without formal understanding, these people can admire the erudite artist, even an artist who is the other. This is the result of the research we are doing.

Barbara Kruger was invited to the inauguration of the new building and generously accepted. Her work on billboards around the town and in front of the museum provoked the population, even the university's scholars. The social issue raised by Kruger on her billboards was "Mulheres não devem ficar em silêncio" (Women do not have to be silent). This issue therefore entered the museum, metaphorically, walking on the sand carpet, through the hands of the people.

The great multicultural challenge in Brazil is social-class prejudice, the result of the distance between the elite and the people.

NOTES

1. The two critics I am referring to are Aracy Amaral and Marta Rosseti, who, respectively, wrote about Tarsila do Amaral and Anita Malfatti.
2. The curators of the exhibition were Glaucia Amaral and May Suplicy.
3. See, for example, Freire's *Pedagogy of the Oppressed* (New York: Herder & Herder, 1970; rev. ed., New York: Penguin, 1996).

9 / The Continent of Ashe

Regina Vater

I was born and grew up in Rio de Janeiro. Although I spent my first thirteen years in a French Catholic school, it was unavoidable that I would be deeply touched and influenced by our African heritage. The African spirit is everywhere in Brazil. The wit and the flavor of our negritude is present in everything from the food we eat to the words we use. In one way or another, we are all blacks in Brazil. Certainly, we owe a lot to mother Africa, and I think that very many of us recognize this, if not overtly, at least underneath our skins. The vibration of ancient wisdoms of Africa still reverberate in many things in Brazil: in our sensorial spirituality, in our magical connection to life, in the endurance and patience under the most adverse conditions, in our stubborn hope for "better days," in the spontaneous connection to joy, in the strong sense of sweetness and generosity of love, in the freedom and inventiveness of the body, in the admirable musical Brazilian ear, and in the flexibility and adaptability in the face of the new.

To speak in detail about all these qualities that we inherit from the African people, it would be necessary to write a book. So I'll just pick some of them, to provide a very slight overview. I would like to start by discussing an African contribution that impacted not only Brazil. What I am about to say is a fact often denied or forgotten by both whites and African Americans in North and South America. I think that the input of African culture in this continent is an incredible achievement. I would like to qualify this concept as "the colonization of the white body by the ancient African science of the body." This science of the body is also an art with metaphysical origins, as all sciences used to be before the advent of mechanistic thinking. It is an art that is becoming the ruling model for Western artists, such as Joseph Beuys, who long for a more holistic approach to creativity and understanding of the cosmos.

For the African culture, the body acts as a stage for our emotions, or connection to the life energy, but it also serves as the primordial lab of our creativity and the primordial tool for our spirituality. Anybody who grew

up in Brazil knows almost naturally that in the African rituals the body is the antenna to the otherness and to the sacred. Through the African tradition (which survived in Brazil through the strategy of syncretism), we learned to be open to the other. Through syncretism, the Africans blended their ancient gods with symbols taken from Catholicism, Judaism, and the Native American and Muslim traditions. With this, even people who have archaic antagonism against one another were and are naturally connected by their psychological and spiritual needs. When you are in pain, it is easier for you to recognize your equality with the other, in spite of gender, color, and social category. In this territory of spiritual transactions, a psychodrama of reconnection with the supreme otherness—that is, the gods and goddesses (the cosmic forces that rule life and death in the universe)—is staged. Then, within this context of respect for one another's pain, not only do differences disappear, but each participant receives a burst of self-esteem, as well, from the collective sharing of the joy of belonging—belonging to the same mystery of life and to the sacredness of the natural world.

This archaic connection to the natural order is one of the most poetic qualities of the African tradition. It was one of the main forces that attracted me to the artistic work I began in 1970 inspired by the African gods. That year, I did my first installation/event, titled "Magi(O)cean," on a beach in Rio de Janeiro. In that work, I used the syncretic representations of the rainbow snake, Oxumaré, the goddess of hope, which in the Catholic religion is called Nossa Senhora da Aparecida. Nossa Senhora da Aparecida is the black Madonna, the patron of Brazil. For me, it is an extremely poetic coincidence that through the African eyes we are consecrated and sponsored by hope.

In the United States, the encounter with otherness through the Africanization of the white body did not occur inside the sacred realm but, rather, through the entertainment industry. I do not know if people consciously realize all the implications of this observation, but through the process of listening and dancing to the popular and profane rhythms of American music that originated from the African matrix, the white bodies instinctively learned to enjoy themselves in a more flexible, vigorous, and spontaneous way. This imperceptive colonization of the body by cadence and beat helped Europeans break the old rigidity of their movements, and it planted a different mind-set in the second half of the twentieth century in the United States. Why is Elvis Presley so revered? Perhaps because he was the recognizable bridge to spontaneity and creativity of the body, a legacy that he received from the blacks of Memphis, Tennessee. I am almost sure that the internal feeling of swing and the enjoyment of a sensorial energy that was missing among whites made them more receptive to new ideas and even more open to understanding the otherness.

Any good psychologist knows that through the body we understand our emotions. And it is also through our knowledge of our own emotions through our own body that we learn how to be in tune, in touch, and to read other peoples' emotions through the perception of their own body language. I feel that the African culture carries this ancient wisdom—a wisdom that we can feel at play in the streets of Brazil and that can be described as being at ease and inventive with your own body, being the master of your body with creativity and enjoyment. And that wisdom—a science, I would say—is propagated and taught there, here, and elsewhere in a profane way through the beat and rhythm inherited from Africa. It is a rhythm that originated in sacred forms of reconnections to the life source energy.

In my opinion, what we receive through African rhythms nowadays are fragments of an unknown science, a science that creates a direct instinctive link between the rhythm of the heart and the rhythm of the universe. For me, one of the most peculiar characteristics and qualities of this rhythmic connection is that it takes a very sensuous configuration in contrast with other mantric manifestations originated by other primeval cultures. In my opinion, too, it is precisely that sensuous or sensorial quality so much repressed by Judeo-Christian approaches to the sacred that makes an incredible difference in the degree and intensity of energy and openness to invention of the body that people touched by African culture have.

I am referring here to all the people in the black Americas in spite of credo and color of skin, even those who do not acknowledge the importance and power of black traditions and culture. This influence is more or less concentrated (according to the local conditions of receptiveness) everywhere the African diaspora was distributed. Angel-Suarez Rosado, a Puerto Rican artist whose work is also inspired by African spirituality, defines the distribution of that African energy and influence as "the geography of the Ashe." Ashe is the power to make things happen, a morally neutral power, a power to give and to take away, to kill and to give life, according to the purpose and the nature of its bearer.[1] The Ashe is actually dealt with in a very pragmatic way by the African religious practices that are still very well preserved in Brazil and in other countries in the Caribbean. The transactions with this powerful energy are established by rituals that involve the presence and active participation of the believers' bodies.

The Yoruba word "*Candomble*," which designates one of the main forms of rituals performed in Brazil, signifies "dance for the gods." It is through dance followed by chanting that the followers of the African traditions venerate and establish direct contact with their gods—a contact that is far beyond a mere intellectual and abstract connection. In the dances that take place all night (from 6 P.M. to 6 A.M.), the bodies of the followers often dance through many, many hours and finally succumb under the heart rhythm and the

mantric quality of the Yoruba songs; they are possessed by the gods and goddesses who are the impersonators of the cosmic energies of the universe.

The bridge, the threshold between reality and the sacred realm, is then established. And the follower, through his or her own body, penetrates into the other dimension. When that happens, the person's body turns into a sacred vessel for a higher energy and must be concealed under proper vestments with his or her face partially covered by a curtain of beads. This concealment of the energy's face is recurrent in many religions around the world. No one can see the face of the sacred, the face of God.

It was this aspect of connection to the sacred, as well as the whole idea of magic plants, which we also received from Africa, that inspired me to create a series of works that I titled *Comigo Ninguém Pode*, or in English, "None can annihilate me." Before I talk about these works, I would like to say something about the broadly disseminated use of magical plants in Brazil, a practice that we actually inherited from both the African and the indigenous people. In Brazil, even in the most southern "European" states like São Paulo, Paraná, Santa Catarina, and Rio Grande do Sul, the belief in magical properties of certain plants is very present. This belief is evidenced not only in private gardens, but also in the street markets where the use of *ervas* herbs for protection against the evil eye and for cleansing the aura is widespread. And this belief is held by more than the followers of the African tradition; a large number of conservative Catholics hold it as well. In fact, in my own traditional Catholic family, we observed the practice of using *arruda* with water for cleansing of the aura.

The *Comigo Ninguém Pode* (*Dieffenbachia*) is a very sturdy tropical plant used in the Brazilian African tradition as a shield against the evil eye. This protective quality perhaps originated in the fact that this plant is extremely resistant to neglect and has an incredible capacity for renewing itself even after cuttings. Or perhaps its protective quality stems from its venomous properties. Regardless, this plant is broadly used in Brazil by people of all classes and credos, placed in their doorways for protection.

In 1978, I made an anthropological photographic survey of the presence of this plant in the doorways of diverse buildings, houses, and stores both in Rio de Janeiro and in São Paulo. That survey led me in 1984 to start a series of installations and graphic works that I still consider a work in progress. I was motivated to do this series after I read in Sir James George Frazer's *Golden Bough*, the passage about the dying and reviving gods. In this section of his book, Frazer writes about the connection of the dying and reviving gods to vegetation and certain trees. For instance, Osiris was connected to the papyrus, Yacinth to the flower that bears his name, and so forth. Even Christ, through the wooden cross, is connected to a tree, and it is no wonder that the Christian religion adopted the ancient German pagan use of a

sacred tree ornamented during the winter solstice in the form of the Christ-mas tree.

Because of the desire to praise all those qualities connected to endur-ance, hope, and patience in confrontation with the vicissitudes of life that I had linked before to our African heritage, combined with a process of sequential and poetic analogies that I triggered in my mind, I ended up connecting the Brazilian people's qualities to the qualities of endurance and survival of the *Comigo Ninguém Pode*. Consequently, I found in the plant a metaphorical correspondence to the Tree of Life. And that correspondence turned the Brazilian people themselves into the personificators of the dying and reviving gods. I think that this bridge between a human person/body and the sacred dimension could have been revealed to me only through the live presence of the African traditions in Brazil. The presence of the plant itself as a personificator of the Ashe is another knowledge inherited from the same tradition. And sacred trees play an important role in the African cults that believe that all the components of the natural world, such as water, fire, wind, thunder, are the deliverers and the containers of the Ashe.

As I mentioned previously, when the bodies of people engaged in rituals are possessed by those higher energies, according to the tradition, they need to be concealed under special vests and their faces hidden behind a mask or curtain of beads. It was this poetic image of the concealed divinity that appeared in some of my installations in the *Comigo Ninguém Pode* series. In those works, instead of a curtain of beads to conceal the face of the sacred, I used a curtain made of photocopies to conceal the presence of the plant itself emerging from a mound of raw dirt. The plant then personifies the presence of the divinity and, at the same time, becomes a symbol of the tree of life. The Tree of Life or the Word Tree (Axis Mundi), is a universal mythical symbol—a classical cosmic threshold between space and spacelessness, between multiplicity and unity, between mortality and immortality. In many cultures, it is where the connection between heaven and earth is estab-lished. The Buddha found enlightenment under a tree; certain initiation rites in Nepal occur in the tops of trees; the Machi shamans in the Mapuche region of Chile also climb trees to establish contact with the sacred space; and Australian aborigines in their fire ceremony also climb tree trunks.

I also see here a connection to our interdependence with the vegetable world. Without vegetation, animal life could not exist on our planet. This ecological connection has not only been recurrent in my own work since 1970, but it is also a central characteristic of the African tradition. In that tradition, the main ruler of spirituality is nature itself, and because of this, nature should not only be venerated, but preserved as well. In Bahia—the most African of our Brazilian states—road contractors in the interior of the

state sometimes encounter severe problems with employees who refuse to cut down trees because those trees are regarded by them as sacred elements of the African tradition. This says something about religions that have forgotten about the sacredness of nature's beings.

Finally, I want to say something about the images I use in the photocopied strips that constitute the enclosure partially concealing the vision of the *Comigo Ninguém Pode* in my series. What one sees in those photocopies are thousands of faces of various colors, both genders, and all ages that belong to people from diverse social strata. According to Jose Celso Martinez Correia, one of the most important Brazilian actors and play directors who used one of my *Comigo Ninguém Pode* installations for a performance of "Cultural Spring" in Brazil in September 1993, these faces are the faces of our "family"—not one person's family, but our nation's family. Brazilians are a people who are able to preserve, in one way or another, old wisdoms, while at the same time remaining open to the new. We are a nation of individuals from different origins, whose differences dissolved within a shared understanding of pain, the endurance of hard vicissitudes, and an admirable patience and respect for the other. I believe that these qualities entered our land not only via the Portuguese, but mainly via the slave ships that brought with them the old arts and sciences of Africa. Very fortunately, we have been able to preserve these customs in an almost pristine form to the present day.

The *Comigo Niguém Pode* is for me not just an allegory: It is a sacred space within which this intense energy seems to sprout from the asphalt in the streets of Brazil; an energy that originates not in the nature of the country, but in the spirit and in the bodies of the people who inhabit it. *Comigo Ninguém Pode* is also a holistic body generated by the many bodies of a nation, bodies that learned somehow or another the language of the spirit through a very sensorial way of dealing with the life energy, bodies that together form the continent of Ashe.

NOTE

1. In Robert Farris Thompson, *Flash of the Spirit* (New York: Random House, 1983).

10 / The Politics of Difference: The Fate of Art in an Age of Identity Crisis

jan jagodzinski

Six years after the International Society for Education Through Art (INSEA) last met in Hamburg, Germany, in 1987, due to the unfortunate political unrest in the Philippines that canceled plans for a 1990 meeting, the Twenty-eighth World Congress of INSEA finally met once again in Montreal, Canada, in August 1993. The theme of the weeklong conference was the title of one of Paul Gauguin's acclaimed artworks, *D'où venons-nous? Que sommes-nous? Où allons-nous?* (Where do we come from? What are we? Where are we going?) These three questions, I assume, were identified by the conference organizers in order to bring the membership's attention to a historical climate where issues of identity have become a global concern. After a lapse of six years, these questions further held the promise of centering a global sense of educational community sometime in the future as evoked by the rhetorical use of the empty signifier "we."

Displayed prominently in the lobby of the conference center was a faithful copy, both in scale and content, of Gauguin's achievement. References to Gauguin and this particular painting were made numerous times in the program catalog by various presenters—mostly all positive.[1] Leading the parade of praise for Gauguin was the then-current president of INSEA, Ana Mae Barbosa of the Museum of Contemporary Art of São Paulo in Brazil. In her address to the Congress, she described her presentation:

> Gauguin's early experience in Latin America can be seen as one of the reasons for his flexibility to see different lands, different people in their own way, not as colonizer or invader. As a white European, he interpreted those so-called "primitives with respect for their environment and their myths." Those myths are represented by him as expression of their beliefs and aspirations, not as exoticism. Certainly his contact with Latin America and his Peruvian heritage made him flexible and sensitive enough to look to the "other."[2]

78

Barbosa defended Gauguin's character even further during her address when mentioning the fact that he had left his wife and children and traveled abroad, an act for which he should *not* have been condemned; for today, argued Barbosa, he would not be judged so severely. Her reasoning was that divorce and separation have become so common as to be deemed socially acceptable. Barbosa's defense of Gauguin as an exemplary artist who was sensitive to the Other[3] was further buttressed by quotes from his own journal that served as testimony to his sincerity.

In 1990, I attended the Seventy-eighth Annual Conference of the College Art Association (CAA) held in New York. In a panel called "Denaturalizing the Nude," the literary critic Peter Brooks argued that Gauguin's nude studies in Tahiti served to put into question the entire European tradition of nude studies, representing the woman's body in such a way that the male gaze was mitigated and made problematic. Gauguin's nudes, such as *Te arii vahine* (The noble woman, 1896), *Manao tupapau* (The spirit of the dead watches, 1892), and *Nevermore*, were direct comments on Édouard Manet's *Olympia* and *Dejeuner sur l'herb*. Brooks argued that Gauguin was wrestling with the problem of painting the nude "naturally"—fully erotic, without the connotations of shame, scandal, and exposure—which was problematic at the time, for the artificiality of the neoclassical style displayed the nude as a prostitute: The spectator's glance matched the glance of the paying customer.[4] Manet's *Olympia* had not solved this problem. Eve's nakedness was to replace Venus's nudity. His paintings acted like a Derridean supplement to the entire tradition, hence putting that tradition into question and disrupting its assumptions of sexuality. Such a reading was in direct contrast to that of the art critic Abigail Solomon-Godeau, whose article "Going Native" had appeared in *Art in America* a full year earlier.[5] Was Brooks's interpretation, then, an example of one-up*man*ship? I suspect so.

Solomon-Godeau argued that Gauguin's modernist primitivism was a form of "mythic speech"; his life, a paradigm case for "primitivism as a white, Western and preponderantly male quest for an elusive object whose very condition of desirability reside[d] in some form of distance and difference, whether temporal or geographical."[6] (The "elusive object" referred to by Solomon-Godeau was an earthly paradise, a place of plenitude where compliant female bodies presented themselves everywhere.) Gauguin's heroic journey out of Europe, to find himself, was part of the mythic sense of being avant-garde, original, self-creative, and heroic. Furthermore, Solomon-Godeau claimed, this vision was abetted by racial and sexual fantasies. His sojourn as a "savage" into Britanny, as his "initial encounter with cultural Otherness" into a "more archaic, atavistic and organic society," was more accurately a mystification of Britanny as a folkloric paradise. Britanny was a center of an international artists' colony (the *Pont Aven* circle) and tourism;

its peculiar and visually distinct aspects, especially women's clothing, were a sign of its modernity. The textual representation of Breton as being primitive was part of a broader discourse created by colonialism where a natural primitivism had emerged through the encounter with tribal arts, *Japonisme*, and *cloisonnéisme*.

Like symbolism, the significance of Gauguin's religious and mystical iconography, as exemplified through the representation of numerous calvaries and self-crucifixions, marks a crisis of representation brought on by the crisis of capitalism during the fin de siècle. The flight out from urbanity presented Breton as the Other of Paris—feudal, rural, spiritual, and static. As Solomon-Godeau further argues, the absence of men presented a "purely feminized geography," an unchanging rural world, an atavism where the perceptions of women, adolescent girls, and children were said to be closer to nature and the spiritual. Gauguin's nudes from this period are said to participate in this quest for the primitive. "The savage woman" was to exemplify the natural link between Eros and Mother Nature—the constellation of imagery around "Eve/Mother/Nature/Primitive." His depiction of Maori culture and women continued this mythic primitivism. The figure of the *vahine*, represented either monstrously (as in cannibalism and tattooing) or idealized as a noble savage, became a "metonymy for the tropic paradise tout court."[7] "Going native" was a facade: Gauguin never learned the Polynesian language; the customs he wrote about were plagiarisms drawn from previous accounts; his very survival depended on the *vahines* he so idealized; and his life was but a continuous rape of images and "pillaging the savages of Oceania."[8]

Such a scathing indictment of Gauguin raises many questions as to the ethics and politics of any textual reading. Feminist members of the audience, notably Griselda Pollock,[9] objected to Brooks's reading on the grounds that it was *still* caught by a male's appropriation of the woman's body. Needless to say, other artists in the audience reacted with some trepidation. Just what sort of representation of the female nude body was to be permitted by men to avoid such accusatory wrath? From within the confines of a patriarchal view, Gauguin's representations of Tahitian women represent an advance; but from a feminist perspective, Gauguin does not go far enough. From the perspective of a colonialist, Gauguin represents a heroic search for selfhood; but from the perspective of a postcolonialist, he is an exploiter and an invader. Each interpretation of Gauguin implicates the viewer/reader under a different set of ethical and political imperatives. What was it in Gauguin's own blindness that could not make him see past the exotic Other? Turning this question to more familiar territory, one could similarly ask why it was that Jewish intellectuals could see through the contradictions and the barbarity of German National Socialism while high-minded German

intellectuals such as Martin Heidegger and the Belgian intellectual Paul de Man were complictious, aiding and abetting a racist regime.[10] The politics of identity and difference are at play here.

Since the 1990 CAA meeting, Brooks published his account, "Gauguin's Tahitian Body," within his collection of essays that examines the representation of the woman's body in modernism.[11] Reassessing this essay in 1993, I found that Brooks had not entirely changed his mind. He maps out the metaphorical discourses that had shaped Gauguin's desire: the *Exposition Universelle* of 1899, which presented an exhibition of the French colonies; the fantasies associated with exotic travel; the search for the body of a beautiful woman and for the carefree life; and the quest for the noble savage. Gauguin's "authentic" journal voice begins to sound very unauthentic as he mimes colonial travel discourse sounding like a "Club Med travel brochure."[12] In short, Brooks rehearses many of the insights that Solomon-Godeau had identified earlier, yet he concedes very little to her, claiming that her discussion holds a "general truth" but requires a "more nuanced discussion" since she "distorts the original discursive framework of the European encounter with Tahiti."[13] Gauguin, according to Brooks, was engaged with the problem of Enlightenment philosophy and ethnology, actively seeking to invent a version of Tahiti earlier than the one he found in the 1890s in order to provide a commentary on the civilization that had produced Eve. Furthermore, Gauguin had denounced colonialist appropriation after his initial participation in it. In Brooks's account, Gauguin once again emerges as a hero: "Solomon-Godeau's argument does not do justice to the disruptive, interrogative force of Tahitian sexuality in Western discourse, and to the figuration of that force in Gauguin's Tahitian painting."[14] The rest of his chapter is a defense of this thesis.

We are back once again to an earlier discussion. From a *historiographic* and modernist point of view, within the confines of a male phallocentric discourse, Gauguin's "naked nudes" provide an advance on the representation of the female nude. Although Gauguin predates the rise of the avant-garde, he is interpreted as its precursor. The notion of the avant-garde within the context of critical postmodernism has been thoroughly critiqued[15] (in the context of this discussion, most notably the need for the avant-garde to define itself by "shocking" its audience from the solace of its comfortable forms of identity by always presenting a radicalized Other). This whole practice, Thomas Docherty notes, must be in "the time of the [O]ther." The avant-garde project is characterized by the forces of elitism, historicism, and individualism.

The avant-garde is elitist because the artist is the hero who has seen the future in advance of everyone else, and whose task is to risk her or his

own greater powers on behalf of the tardy common masses. The avant-garde is historicist because its artists are necessarily out of step with the masses around them [they have to catch up if progress is to take place]; . . . finally, and most explicitly, . . . the ideology of avant-garde has to be individualist, for its whole practice is based on the "expression *du Moi*."[16]

This "expression of Self" distinguishes the avant-garde self from its Others and thereby produces its Other. Such a ruse today has itself become a tradition: Fine artists separate themselves as "individuals" distinct from the "masses" and the mass culture that they consume.

This same ruse repeats itself in the discourse of colonialism. As Diana Fuss has persuasively argued, Franz Fanon proposed that the system of power-knowledge that upheld colonialism was premised on the white man's claim to the category of the Other.[17] The white man monopolized Otherness "to secure an illusion of unfettered access to subjectivity. . . . Fanon implies that the black man under colonial rule finds himself relegated to a position other than the Other."[18] The policies of colonialism create the boundaries as to which identities attain full cultural signification and which do not. Identification with the colonializer by the native becomes an impossible supposition. Either the native is not "white enough," or the native is "too white." In other words, natives either do not meet the criteria that is expected of them, or they come "too close" for white comfort. Their mimicry becomes an overexaggeration that threatens and exposes the impossibility of assimilation since their fictive sense of self-identification has already been bared. They are forced "to occupy, in a white racial phantasm, the static ontological space of the timeless 'primitive,' the black man is disenfranchised of his very subjectivity."[19]

Does Gauguin escape the ideology of Otherness so that he might be reinscribed as an exemplar of intercultural learning; as someone who enriched his sense of difference without falling into elitism, individualism, and historicism? This and the question of phallocentrism are the hinges around which the politics of interpretation are played out. Gauguin's "invented Tahiti" in his autobiographical account *Noa Noa* was a critique of Judeo-Christian mythology. But read with the hindsight of today's feminist and postcolonial perspectives, Gauguin had not managed to escape very far from the discourses that captivated him. As Linda Nochlin vividly illustrates, there was "no high art in the nineteenth century based upon women's erotic needs, wishes, or fantasies."[20] All such erotic art was meant for the male gaze, both homosexual and heterosexual. The very painting Brooks praises as Gauguin's greatest achievement in disrupting the lascivious gaze of male spectators, *Deux femmes tahitiennes* (1899),[21] is the *very same work* chosen by Nochlin to illustrate the opposite thesis: that the painting is merely another example illustrating the prime topic of erotic imagery in

nineteenth-century painting—"the comparison of the desirable body with ripe fruit."[22] For Brooks, the title translates as "Two Tahitian Women"; but Nochlin rewrites the title as "Tahitian Women with Mango Blossoms" (the signifier "bosom" is not far away). Each uses a different title to put forward the individual arguments. Lynda Nead's recent book *The Female Nude*, however, brilliantly deconstructs the nude/naked binary that informs this Western phallocentric practice.[23] No amount of apologetics for advances in a male artist's nude representation by Brooks can deny the force of her critique. Yet Brooks points to momentary passages in Gauguin's autobiography of a male trying to question his own constructed masculinity, wanting to explore a "polymorphous body"[24] but unable to do so, in the end falling back to asserting sexual differences. It should not be forgotten that "imagining" oneself as an artist, that is, the psychology of the "enacted biography," was enormously popular at this time. Biography and journalism enabled the artistic personae to merge: "Fact and fiction, history and biography, psychology and journalism, merged and overlapped in the mapping of an artistic 'type' and hence in the provision of raw material for new identities."[25] Gauguin consequently appears Janus-faced. Which face the interpreter happens to read has severe consequences as to how the modernist canon is to be judged. Perhaps more disturbing, Gauguin's two faces seem to co-exist comfortably; each face, it seems, can no more exist without the other than can the two sides of a coin. The face that shows itself in the reading is dependent on the discourse in which Gauguin finds himself, making a final verdict on him all but impossible. Hal Foster has tried to identify this ambivalence by applying a Freudian interpretation to Gauguin: "This conflict occurs because the primitivist seeks to be both *opened up to difference* (to be made ecstatic, literally taken out of the self sexually, socially, racially) *and* to be *fixed in opposition* to the other (to be established again, secured as a sovereign self)."[26]

I have introduced my essay with the controversies surrounding Gauguin as an example of the political play of identity and difference. Who, then, has captured the "right," "true," or "authentic" Gauguin—Barbosa, Solomon-Godeau, Brooks? This question is somewhat misleading, for it is the rhetorical effects of putting the figure of Paul Gauguin into play that form the important issues for artistic praxis and conference problematics. It is the different effects that the name Gauguin *as a signifier* is asked to produce that is at issue, for he is now an "invented" figure. Should Gauguin continue to be defined as an artist who did indeed bridge the two worlds between the colonizer and the colonized, or should the multiple discourses at play during his historical time be recognized as that which caught his artistic imagination within the metaphorics of colonial exoticism? If we choose the latter, should INSEA have chosen to put the figure of Gauguin into

play the way it did, or should provisions have been made to confront the grain readings that identified his authentic biographical voice as a form of "fiction-making"? Rather than working with a model of possible consensus, INSEA's committee members might have promoted the examination of the contradictions of alternate interpretations, highlighting the incommensurabilities of multiple differences. This chapter will continue to pursue such dilemmas of difference and identity, first by describing the current global condition where identity politics has become such a major issue, and then by developing the various uses of difference as I weigh the costs and benefits of these approaches in the context of cultural practice. I introduce examples of artistic practice to highlight these issues whenever appropriate.

THE NEW GLOBALISM

Three quotations from the cover of the recently established transnational journal *Diaspora*, highlight the play of identity in a postmodern world. The first quotation comes from Hamid Naficy, who writes about the poetics and practices of Iranians in exile:

> Fragmentation and deterritorialization force us to experience time differently. . . . We experience the present as a loss or, as Baudrillard would have it, as a phenomenon that has no origin or reality, a "hyperreality." . . . For the exiles who have immigrated from the Third World countries, life in the United States, especially in the quintessentially postmodern city of Los Angeles, is doubly unreal, and it is because of this double loss of origin and reality that nostalgia becomes a major cultural and representation practice amongst the exiles. . . . Nostalgia for one's homeland has a fundamentally interpsychic source expressed in the hope of an eternal desire for return, a return that is structurally unrealizable.[27]

The second quotation comes from anthropologist Roger Rouse, who practices a radically different postmodern ethnography when working with Mexican migrants into the United States. Rouse charts how their ethnicity is actively and socially produced from the opportunities and constraints that they face living in a border town, and he talks about the ways they appropriate, accommodate, or resist the forms of power and domination, opportunity and constraint, that they encounter:

> We live in a . . . world of crisscrossed economies, intersecting systems of meaning, and fragmented identities. Suddenly, the comforting modern imagery of nation states and national languages, of coherent communities and consistent subjectivities, of dominant centers and distant margins no longer seem adequate . . . we have all moved irrevocably into a new kind of social space.[28]

And the last quotation comes from Salman Rushdie, a paradigmatic writer of postcolonial literature:

> If I am to speak for Indian writers in England, I would say this: The migrations happened. "We are, We are here." And we are not willing to be excluded from any part of our heritage, which includes . . . the right of any member of this post-diaspora community to draw on its roots for its art, just as the world's community of displaced writers has always done.[29]

From these three quotes it can be readily seen that living in a postcolonial, postmodern world offers new challenges to questions of identity and difference. We live in a historical moment where there seems to be two opposing and contradictory trends occurring simultaneously: a homogenizing trend and a trend toward distinction. I shall develop each sequentially.

First, that is to say, on the one hand, more and more people of different backgrounds share an overlapping culture, influenced by the global homogenization of the electronic media, especially television and (Hollywood) film, and by North American popular music, which all over the world disintegrates folk cultures and redefines cultural identities.[30] We have, then, a situation that Benjamin Barber refers to as a "McWorld" of video, film, and television, which attempts to homogenize cultural experience through satellite technology.[31] The hegemony of both central Europe and the United States is reproduced globally since these territories control the communications media. Television and film media present lifestyles and news that would otherwise never be seen in many countries. Joshua Meyrowitz argues that this electronic media—especially television—has blurred the dividing line between public and private, severing the traditional link between physical and social place.[32] The homogenizing result has been a diffusion of group identities. Meyrowitz speaks of a *placeless* culture."[33] Groups whose place was formerly shaped by physical isolation are no longer segregated from larger social groupings, for example, American Indians on reservations, or aboriginal groups living in the Amazon forests, such as the Tukano Indians, who have become media stars through their protests against the Brazilian government's destruction of the rain forests and through the pop star Sting's visit there. Therefore, Meyrowitz argues, aspects of group identity that were dependent on physical place, and the experiences available to them, have been permanently altered by the electronic media. In these cases, cultural identity is shaped by the media as a *symbolic*, rather than a physical, place. People can now escape from their traditional place-defined groups. The "situational geography" of social life becomes altered.[34] Geographic identity, or identity of place, is continuously changing.[35] Thomas Fitzgerald mentions that the Samoan islanders immigrating to New Zealand no longer identify themselves as Samoans from a specific island in Samoa, but lump

themselves as "Pacific Islanders."[36] Such "morphing" of identities makes the identification of a corresponding artistic culture difficult.

This global homogenization of culture, however, is best understood economically. In a brilliant display of historically grounded political and economical insights, Masao Miyoshi develops his thesis that transnational corporations (TNCs) have continued this cultural colonialism.[37] This "is not an age of *post*colonialism," argues Miyoshi, "but of intensified colonialism, even though it is under an unfamiliar guise."[38] Miyoshi traces the loss of faith by the populous in nation-states; the failure of the state as a political authority to provide adequate public health, control currency, provide general education, and guide the national economy. It is not the nation as a whole that benefits from these services, rather only certain privileged classes receive the majority of state support. With the rise of multinational corporations (MNCs) in the late 1960s and the mid-1970s, and then with the advent of TNCs, the entire landscape of culture changed.[39] Manufactured products are advertised and distributed globally, being identified only with their brand names, not with the countries of origin. In order to talk to one another, the transnational class of professionals who live and travel globally are expected to avoid cultural eccentricities and speak English, "the lingua franca of the TNC era."

> National history and culture are not to intrude or not to be asserted oppositionally or even dialectically. They are merely variants of one "universal"—as in a giant theme park or shopping mall. Culture will be kept to museums, and the museums, exhibitions, and theatrical performances will be swiftly appropriated by tourism and other forms of commercialism. No matter how subversive at the beginning, variants will be appropriated aggressively by branches of consumerism, such as entertainment and tourism, as were rap music, graffiti art, or even classical music and high arts. Cable TV and MTV dominate the world absolutely. Entertainment and tourism are huge transnational industries by themselves.[40]

Like Barber, Miyoshi has no use for economic, environmental, and cultural devastation that TNCs wreak in their host countries. "While they homogenize regions, they remain aliens and outsiders in each place, faithful only to the exclusive clubs of which they are members."[41] In this context, most disturbingly, multiculturalism becomes an important strategy for TNC managers, who can now pay lip service and display sensitivity to the myriad of migrant workers who are on their payroll.[42] However, "neither nativism nor pluralism are in their thoughts, only *survival*."[43] David Rieff essentially agrees with Barber and Miyoshi, demonstrating the close link between multiculturalism and MNCs.[44] He shows how the market economy has embraced multiculturalism for its own ends. (As I argue later, art education makes the very same gesture.) Reading the feature articles in *Commentary*,

Barron, and *Fortune*, Rieff points out how MNCs are eager to let in women, blacks, gays, and any other marginalized group as paying customers. Multiculturalism has given capitalism its second wind.

In contrast to this homogenizing trend; that is to say, on the other hand, there is a strong tendency for many groups today to insist that they are, at the very least, *symbolically* distinct. Most often this argument is premised on being linguistically and culturally distinct, and in some extreme cases, biologically distinct and pure. These groups form what Barber characterizes pejoratively as a jihad, a diversity of common cultures, all trying to maintain their own sense of unique identity. War, for the jihad, is not an instrument of policy but an emblem of identity, an expression of community as an end in itself, like the colors of L.A. gangs. Jihads may be characterized as cultures, not countries; parts, not wholes; sects, not religions; rebellious factions and dissenting minorities at war not just with globalism, but with the *traditional* nation-states in which they find themselves. They form a mirrored reflection of the decline of the viability of nationalism as a politically unifying force. The list of them seems endless: the Kurds, Basques, Puerto Ricans, Ossetians, East Timoreans, Québecois, the Catholics of Northern Ireland, Abkhasians, Japanese Kuril Islanders, the Zulus of Inkathat, Catalonians, Tamils, and the Palestinians. These are people without countries inhabiting nations that they do not perceive as their own. In 1993, David Binder and Barbara Crossette counted forty-eight ethnic wars occurring in the world.[45] Stories carrying the jihadic side of identification can be found daily in any newspaper. On my flight to the INSEA conference on 11 August 1993, for example, the *Toronto Globe & Mail* ran a cover story on the plight of Russians living in Estonia who were denied citizenship on the grounds that they have no Estonian ethnicity. This situation is the same throughout all the Baltic states. White South African women were protesting against the first black Miss South Africa on the grounds that she was not pretty enough. Ernst Zundel, a neo-Nazi Torontonian, had been given permission to broadcast Holocaust revisionism via his radio program named rhetorically "The Voice of Freedom." There was even a story on how cowboy poets were trying to protect the purity of their craft from the invasion by "city slickers." This sampling is indicative of the numerous "nodal points"[46] that solidify jihadic consciousness around "floating signifiers" that temporarily form and secure the kernel of meaning of jihadic identities.

Given this situation, I take the characterization formed by the ampersand between the local and the global—"local&global"—to be indicative of the postmodern world. Both the multiple and contradictory centrifugal (that is, the decentering forces of the jihad) and the centripetal (that is, the centering forces of the McWorld) are held in dialectical tension by what has been characterized as a "dissipative structure," where the process of both

homogenization and fragmentation are at work simultaneously. Whether it is the McWorld of homogenized communication or the jihad world of iden-tity difference, neither process, argues Barber, leads to democratic ends but, rather, to new forms of neoracism. The worst part of this is to recognize that the use of difference by a minority or a marginalized group to assure its identity leads to, for example, fascism and Serbian ethnic cleansing, Islamic fundamentalism, and Muslim and Hindu antagonism in India. In this con-text, nationalism and strong cultural identities can be interpreted as holdovers from Enlightenment rationality, the formation of modern nation-states and its resultant colonialism and imperialism. Yet, it may be equally argued that as globalization intensifies, such neoethnicism becomes appealing because it offers simple solutions in such a complex situation, a point argued by Miyoshi. Perhaps, he argues, "the inadequacy of the nation-state is now fully real-ized, and the provincial strongmen [in Czechoslovakia, Yugoslavia, India, Myanmar] are all trying to grab a piece of the real estate for keeps before all is incorporated and appropriated by transnational corporations."[47]

THE EFFECTS OF DIFFERENCE: ESSENTIALIST TACTICS

I would like now to clarify and develop the *effects of difference* that have played such a vital role in the discourses on race, gender and ethnicity that characterize the dissipative structure of the ampersand—"local&global." It is in the interests of oppressed, marginal groups to appropriate difference for themselves for strategic socioeconomic and political purposes. Most often the purposeful use of "difference" by marginalized, feminist, and subaltern groups is to counter a now-outdated racist and sexist discourse premised on nature and biology that used "difference" for exclusion and separation. It was premised on the deviation and a deficiency from a norm. Difference was, and often still is, therefore, categorical and exclusionary—a difference of *kind*. In their weak form, biological and natural differences were applied primarily to gender differentiation: Women, especially white women, were given a separate but not equal sphere. Their difference replaced natural inferiority with a rhetoric of containment; that is, they were supposedly more nurturing, loving, caring, and mothering, so they should remain in the home and out of public life. The realm of public life was sold to them as not being worthy of women anyway due to its harshness.[48] The strongest reading of biological and natural differences is readily observable as physical differences in appearance, interpreted most often as moral deficiencies lead-ing to genocide (e.g., the Holocaust, the Cambodian "Killing Fields" of the Khmer Rouge) and to the castration and sterilization of "mentally retarded" men and women.

To challenge this exclusionary use of "difference," marginalized groups

argued that difference was a matter of *degree*, not kind. The normative use of difference now becomes one of description. "Separate but equal" and "different but equal" become the familiar *liberal model* for gender and racial equality. Cultural pluralism and the celebration of cultural diversity has been the familiar rhetoric of a Canadian cultural mosaic and a multicultural education that attempts to maintain this impossible plurality. The focus on liberal pluralistic notions of culture replaced *race* with *ethnicity*, making race a social category and thereby leveling the centralizing effects of race itself. According to Werner Sollors, the term "ethnicity" is relatively new.[49] Coined by W. Lloyd Warner in 1941, it became fashionable in the 1960s and in vogue by the 1970s. However, this state of affairs has proven to be particularly problematic.

By replacing race with ethnicity, the *essentialism* of race, which provided a centralizing principle for socioeconomic organization and cohesion, inadvertently denied the history of racism. In the United States, this meant that white responsibility for the present and past oppression and exploitation of both blacks and aboriginal peoples could be smoothed over or avoided. (In a related but different sense, "selective forgetting" applies equality to national ethnic identities. By not recognizing Quebec as a distinct society, for instance, the history of the inequality of French and English relationships in Canada can be downplayed and eventually forgotten.) In the United States, black people identified themselves as "Blacks" and then "African Americans," which reasserted race as the primary social-political-economic category of social organization. Race was constructed as an ideology and essentialized, as Henry Louis Gates Jr. argued.[50] The way this "Black difference" has since been "negotiated" has been recently elaborated through the subtle argumentation of Michael Awkward.[51] Further, it was, and still is, in the interest of well-known African American intellectuals to act as the representative voice of a black marginalized minority.[52] By offering a "counterdiscourse" and a "countermemory," deconstructing the historical memory that has been formed by the dominant white hegemony, black and aboriginal leaders formulate and center a stronger identity by affirming a "black" and "red" cultural aesthetic. Afrocentrism and Pan-Indianism present alternative educational historical narratives identifying a whole different set of cultural heroes. The history of slavery and aboriginal genocide is therefore kept current. The same use of radical difference may be said of all such cultural conflicts where a cultural essentialism is maintained, be it racial or ethnic or gendered, in order to keep the injustices *aktuell*, as part of the cultural memory of identification. The same reasoning applies to the separatist movement in Quebec. In order to preserve a definitive French Canadian culture, it becomes necessary to generate a distinctive Canadian history that tells the French Canadian side of the story: local sitcoms on television

must be produced that are reflective of the trials and tribulations of French Canadian lifestyles; the French language has to be preserved (e.g., a provincial law [Bill 101] makes it illegal to advertise in English); and traditional folk culture and festivals are circulated as points of identifiable cultural reference.

This use of essentialist difference and the claims to a "distinct society" are, of course, antithetical to the U.S. melting-pot ideology. As Joan Copjec remarks in an often-quoted passage:

> America's sense of its own "radical innocence" has its most profound origins in [the] belief that there is a basic humanity unaltered by the diversity of the citizens who share in it. Democracy is the universal quantifier by which America—the "melting pot," "the nation of immigrants"—constitutes itself as a nation. If all our citizens can be said to be Americans, this is not because we share any positive characteristics, but rather because we have all been given the right to shed these characteristics, to present ourselves as disembodied before the law. I divest myself of positive identity, therefore I am a citizen.[53]

Sollors offers an amusing anecdote regarding this melting-pot metaphor, which he claims is an ethnic extension of the religious drama of redemption and rebirth, portraying ethnicity in the imagery of melting in contrast to the stubborn hardness of boundaries:[54] In the Ford Motor Company's English School Melting-Pot Ceremony in 1916, foreign-born employees would undergo a ritualistic rebirth especially designed by their employers. During the graduation exercise, they were led down into a symbolic melting pot, emerging fully dressed in American clothes and carrying the American flag. The melting-pot ideology has been typically a neoconservative project of "hegemonic universalism,"[55] where both the denial as well as the overcoming of racial difference (understood as ethnicity) are to assure the workings of laissez-faire capitalism. As Howard Winant argues, the implications of hegemonic universalism defend the political and cultural canons of Western culture. University programs that promote African American or racial-minority studies are opposed. The late Allan Bloom[56] and E. D. Hirsch Jr.[57] present paradigmatic arguments as to why the Eurocentric canon should stay in place. Both authors argue that the decentering tendencies of both secondary and higher education have been brought about as each ethnic and racial group insists on its own version of cultural knowledge that should be transmitted to students in the name of tolerance and understanding, in order to balance the present historical record of intercultural relations. These demands of investment into the cultural capitalism of schooling have, according to the authors, produced an illiterate school and university populous that has no common core of cultural beliefs. The result has been a

failure of the educational institution to provide the necessary leadership of centering knowledge and preserving the canon of core beliefs as represented in Western literature, art, philosophy, history. In contrast to these neo-conservative views are university programs that promote African American or racial-minority studies, deliberate attempts to further decentralize the hegemony of the Western canon.

GAINS AND LOSSES OF ESSENTIALIST TACTICS

This embracing and maintaining of a separate "equality of difference" through forms of gender, ethnic, and racial essentialism have resulted in both gains and losses in relation to the perceived hegemony, be they patriarchal, racial, or ethnic. Looking at the gains made by black identity politics of the 1960s and 1970s, Stuart Hall argued in 1988 that the "relations of representation have been challenged by first, an *access* to the rights to representation by black artists and black cultural workers themselves and second, through the *contestation* of the marginality, the stereotypical quality and the fetishized nature of images of blacks by the counter-position of a 'positive' black imagery."[58]

The benefits of "access" and "contestation" gained from this position are directly applied to education. There are now school curricula in virtually every democratic country in the world where it becomes possible for children of minorities to receive an education partly, if not totally, in their own language; and the official curriculum is supplemented with their own history and traditions if there is enough economic support and resources to do so. An example of the access and contestation of representation was vividly demonstrated by the Métis Society in the province of Alberta, Canada, in 1988, which insisted that their representation in the new social studies textbooks for junior high be devoid of any implication of the psychological problems they may have had in adjusting to Canadian society. They insisted that the Louis Riel "Rebellion" be changed to the Louis Riel "Resistance" in order to have their side of Canadian history told in a positive light, and without such a change, they would not allow the curriculum material to be released. This resulted in a form of historical revisionism that was contradictory in its effects: On the one hand, students became aware of the misrepresentation of Riel as a political enemy and instead, recognized his achievement as a leader striving for equality and justice; on the other hand, the difficulties of intercultural conflict were masked. The historical overcompensation of memory merely reversed the blame.

Radical feminists claiming access and contestation based on essential difference (here I am thinking of ecofeminists, goddess-worship theologies, Sheshona Firestone's "dialectics of sex,"[59] and Carol Gilligan's "different voice"

hypothesis[60]) has led to claims of *moral superiority* in the very spheres that were coded as being the patriarchal inferior Other: the so-called affective sphere of caring and nurturing to name one; nonrational affective forms of knowledge, such as gossip and witchcraft, to name another. The ruse of moral superiority has been often used by indigenous and aboriginal groups in their claims to having a more symbiotic relationship with the land and nature than do whites who exploit it for profit and material gain.

I would argue that the downside of claiming essential difference for radical feminist, ethnic, and racial groups far outweighs its benefits. Outlining some of these contradictions presents further dilemmas for cultural identity, intercultural learning, and artistic practice. The problem of essentializing gender, ethnicity, or race is that a culture (or a sex) is presented as a monolithic, self-contained, and sexually stabilized entity. Being a member requires displaying the homogenizing characteristics of the cultural formation. Only members of the in-group, usually cultural intellectuals, those often farthest removed from the inherited traditions, are entrusted with the rights of representation. Fitzgerald has argued that the educated elites among such minorities constitute the most vocal champions of cultural revivals; that is, a group has to be well-off before its members have enough political clout to say anything.[61] For example, often only black filmmakers and artists are allowed to make statements about black experience. By virtue of belonging to this racial group, they are always on target and "politically correct." This leads to what has been called artworks of "cheering fictions,"[62] or more pejoratively, the "Aren't Negroes Wonderful School."[63] The writer, musician, actor, or visual artist becomes a public relations officer—a hired liar. The artworks are automatically considered "critique-free."[64]

In the case of radical feminism, the ruse has virtually backfired, for in a context where wealthy, white males set the standard, race and gender paradigms that assert "separate" or "different" but "equal" status always have difficulty maintaining what they claim to be different *from* or even superior *to*. They are often reinscribed, that is, recoded as "inferior." The claims by radical feminists of their nurturing, caring, and loving capabilities reinforce the separate sphere made available to them in the nineteenth century; and liberal feminists' claims of being equal to men in all spheres conflate into an androgynous position where difference runs on a continuum of human possibilities. This androgynous paradigm, since it relies on a concept of person, makes both race and gender differences invisible. Women are then reinscribed to do triple duty as mothers, executives, and homemakers.

In the case of aboriginal peoples, their claim of a superior relationship to nature has been cleverly used to relieve white people's guilt from their responsibility for creating an ecological disaster, which elevates the aboriginal peoples to the status of "noble savages" who provide the West with a

solution to its ills, as depicted in any number of recent Hollywood movies: *Dancing with Wolves, Thunderheart, Mosquito Coast, Emerald Forest, The Medicine Man, The Last of His Tribe, Clear Cut, Black Robe,* and so on. In these films, New Age spiritualism, combined with aboriginal mysticism, is offered as an allegory for the West's redemption so that a new Garden of Eden might emerge.

The purposeful essentialization by the Other also leads to polarization and alienation by those who do not perceive themselves as being in places of dominance or oppression; who are sympathetic to marginal causes but who find no space within the oppressed groups to accommodate their hybridity. This point is particularly important if intercultural learning is to take place, if any sort of bridge making is at all possible between genders, ethnicities, and races. The exclusion of men from feminist circles is one such consequence; the exclusion of whites from participation in the black emancipatory movements in the United States, Britain, South Africa, or the Caribbean is another. By consolidating an alternative, a vibrant, active, and proud black culture centered on race has left white identity in a social vacuum, stereotypically and singularly perceived as being oppressive. Such a state of affairs has been ripe for inciting racism by white supremacist groups who can say now, with outright conviction, that white culture is under siege— immigrants and illegal aliens are taking jobs away from whites; in the meantime, the state supports their right to promote ethnic self-identity. "For the far right, it is now whites who are victims of racial inequality."[65] The state has become the new target of hate, for it has betrayed its "people." Many young people, as the 1992 race riots in Toronto, Ontario, indicate, are easily persuaded by this traditional fascist argument. Bob Suzuki, teaching multicultural education to a group of high school students in Philadelphia, wrote about how little his white ethnic students knew about their family backgrounds compared to his African American students who had long narratives to tell.[66] Many white students felt that they had no "culture." For black youth, "ethnicity" seemed to be something that applied to them, something they could transform or adopt as they pleased. There was a feeling of energy, exuberance, and creativity growing out of this sense of self and exploration of potential. In this sense, "ethnicity" belonged to black kids in a way it did not belong to white kids.

Diana Jeater, a white British academician, talks about the problems of her white identity in the British context.[67] Jeater studied African politics at college; she wrote her doctorate on the construction of moral discourse in white-settler-occupied Zimbabwe; and she now teaches a course on black history. She lives in Brixton, and her mate is black, as well as the woman she rooms with; she can cook *sadza* or curry at the drop of a hat, but she hasn't a clue how to make Yorkshire pudding or cook roast beef. She

occasionally reads the *Voice* and listens to Choice FM (a black British radio station). Despite her protests, such a lifestyle has earned her the status of being called an "honorary black." Her actions are often interpreted as arrogant and typically white, an attempt to silence and deny the experience of black people who have suffered from the patronage of white people "wanting to be Black." In her analysis of the situation of whites in the field of black studies in England, she concluded that there were only three subject positions available to whites who were sympathetic to the black cause:

> We could embrace a cultural conception of "whiteness" as bestowing a limited and conservative "Englishness"; we could be guilty liberals; or we could accept that our marginalization from mainstream "whiteness" made us in some sense "honorary blacks."[68]

The identity politics of the late 1970s and the 1980s achieved many useful things, but it drove a wedge between people whose identities were presumed to be in opposition: male/female, Jewish/Palestine; black/white. I believe that this same argument applies to the exclusion of men by the radical side of the feminist movement, turning many women (and men) away from its cause. Men's studies have begun to show the array of masculine identities that exist, not all of which can be branded as oppressive and patriarchal.

POSTMODERN RACISM

The claiming of essential difference is fraught with a further danger, perhaps the most pernicious one as yet. In the strong sense, it leads to apartheid where separate and different spheres are used for purposes of containment and exclusion. Some examples of this include the issue of bussing in the United States, that is, the parents' right to send their children to the school of their choice, or parental withdrawal of their children from school if the curriculum does not reflect the culture they want taught. In 1987, the Yorkshire town of Dewsbury became the focus of national attention when white parents withdrew their children from a local school with predominantly Asian pupils, on the grounds that "English" culture was no longer taught in the curriculum. In Vienna, private schools are rapidly opening up to teach Austrian culture as East Europeans flood in from the decentering effects felt from Russia, Yugoslavia, and Czechoslovakia. Many parents feel that too much time is being spent in school catering to the children of refugees and immigrants, thereby depriving their own children of their language and heritage.

In the weak sense, different but equal status has produced what Etienne Balibar[69] has called "neo-racism" or "differentialist racism" in the postcolonial, postmodern period where "decolonialization" is taking place.[70] Others have identified this as "symbolic racism," or "new racism," and even the ironical

"civilized racism." There are many shades to this development; all of them use the democratic parading of cultural pluralism as a means to preserve dominant hegemony and national identity while at the same time appearing tolerant, inquisitive, helpful, and respectful of the Other.[71]

In contrast to the old racial biologism that was presented in a direct, raw, and brutally physical fashion, neoracism requires the "reflective" theorizations of an anthropological culturalism for justification of difference and otherness. In a postmodern era, writes Balibar, "There is in fact no racism without theory (or theories)."[72] This "meta-racism," as developed by academics, constructs a scientific theory that immediately explains and justifies the racism of the masses, linking their "visible" collective violence to a set of "hidden causes," thereby fulfilling an intense desire for an interpretative explanation as to *what* individuals are experiencing in this postmodern decentralization and who they *are* in the social world. This new differentiated racism, is, for Balibar, a "racism without race"; that is to say, racial tensions exist only as the incompatible differences between cultures, lifestyles, sexual preferences, traditions, and so forth. The necessity of maintaining these differences now parades as a "democratic" solution. Such a theoretical position "naturalizes" cultural differences in order to contain individuals or groups in an a priori cultural genealogy. They become essential, fixed entities separated by a margin of "cultural distance." In this way, cultural differences are maintained by erecting borders. The older notion of superiority of race is replaced by a multicultural theory that gives various groups status on the grounds that there is an essential culture to which they belong, one that can be observed and learned from at a distance as long as the barrier, the boundary, or distance is maintained. The Other can be admired and exoticized for its difference, but at the same time this very difference and particularity is maintained in order to maintain inequality. The category of "immigration" now replaces the old racist word for the biologically determined race. No sense of cultural change or hybridity for the Other is allowed or permitted. From a similar perspective, Stephen Greenblatt has argued that when the Other gets too close and begins to assimilate, then difference has to be reasserted in order to maintain distance.[73] It was precisely at that point in history, for example, when Jews became the National Socialist Party's Other, or when the Spanish conquered the Aztecs for reasons that included their human ritualistic sacrifice that too closely resembled the symbolic sharing of Christ's body during the Christian mass.

Multicultural educational curricula (especially as they are developed in art education and social studies), the popular media, and anthropology partake in this neoracism by claiming to be more progressive and universalistic in their attempt to understand the Other by getting at an emic or particularist view. A culture's informants or "interlocutors" and their artifacts (music,

art, dance, myths, and so on) provide the "authentic data" on which to premise the documentary or news report. In doing so, by implication, such action presents the Other as less progressive and more "primitive" because such inquisitive action on the part of the dominant culture is promoting, bestowing, and conferring a sense of cultural individualism on the Other.[74] "The cultures supposed implicitly superior are those which appreciate and promote 'individual' enterprise, social and political individualism, as against those which inhibit these things."[75] Homi Bhabha reconfirms this enterprise in yet another way:

> In fact the sign of the "cultured" [culture in the sense of *Kultur*] or the "civilized" attitude [here the word "*Bildung*" makes a distinction between academic and popular knowledge, and between technical and folkloric knowledge] is the ability to appreciate cultures in a kind of *musée imaginaire*; as though one should be able to collect and appreciate them. Western connoisseurship is the capacity to understand and locate cultures in a universal time-frame that acknowledges their various historical and social contexts only eventually to transcend them and render them transparent.[76]

Metaracism claims that it is natural for groups of difference to live together in a multicultural society provided the borders are not crossed. Doing so would be committing the intellectual death of humanity, perhaps even endangering the very mechanisms that ensure biological survival. Cleverly, a discourse of tolerance becomes instituted to maintain the very inequalities that such a policy is said to eliminate. As Ghassan Hage argues,

> When those who are intolerant are asked to be tolerant, their power to be intolerant is not taken away from them, they are simply requested not to exercise it. In fact, the very existence of a policy advocating tolerance implies the continuing existence of the power to be intolerant: why would anyone bother asking someone who has no power to be intolerant to the tolerant?[77]

Cultural pluralism (anthropological culturalism) is thus turned in on itself, for academic metaracism argues that it is "natural" for human groups to preserve their traditions and their identity. Cultural hierarchy functions as a double logic: It is both denounced and reconstituted at the same time through the practical application of the doctrine. As Bhabha puts it, there is "a *creation* of cultural diversity and a *containment* of cultural difference."[78] Culture now functions like nature. Should this necessary and natural distance be abolished, then interethnic conflicts and violence would surely arise. Racism is therefore explained, and a solution toward its prevention is also given. Such a liberalist theory thus appears *antiracist* at first sight, but it is actually yet another weaker form of apartheid—a more benevolent face of modernist (humanist) *barbarism*, which justifies white supremacist

activities (such as ethnic cleansing) on the grounds that such groups are simply preserving their own "white culture" by maintaining distance and reinstating a "tolerance threshold" so that racist conduct is *prevented*. Armed with this neoracist theory, the Ku Klux Klan can claim to be "truly" antiracist and humanist, discarding their hoods and boldly running for public office, as happened in the state of Louisiana when David Duke of the National Association for the Advancement of White People ran for senator and in Texas when Grand Dragon Charles Lee ran for governor. They both claim to represent the disenfranchised whites.

Neoracism forcefully shows how the humanistic project of the Enlightenment can be effectively used for fascistic ends. Zygmunt Bauman has usefully shown how the Holocaust represents the barbaric side of its rationalism,[79] developing Walter Benjamin's often-quoted statement: "There is no document of civilization which is not at the same time a document of barbarism."[80] The Holocaust, rather than being "an aberration, more than a deviation to an otherwise straight path of progress," was yet another face of modernist society.[81] The principles of its barbarism exhibited the horrors of its rationality. Structurally, the gas chambers were driven by the same presiding principles that were taken for granted as the positive aspects of modernity: the principles of rational efficiency. The structure of thought that facilitated the possibility of the Holocaust was inscribed in the philosophical structure of the Enlightenment itself. The drive for the Third Reich or for Serbian "cleansing" or for the French National Front of Le Pen or, in Austria's case, the Freiheitliche Partei Österreichs (FPO) party of Jörg Haider is the drive toward a rational society converted into a drive toward rationalism itself—a rationalism that can be used for fascist, as well as emancipatory, ends. As Bauman put it, commenting on Claude Lanzmann's film *Shoah*, it is difficult to discriminate the "rationality of evil" from the "evil of rationality."[82] In another context, Derrida makes a related point:

> The history of apartheid (its "discourse" and its "reality," the totality of its text) would have been impossible, unthinkable without the European concept and the European history of the state, without the European discourse on race—its scientific pseudo-concept and its religious roots, its modernity and its archaisms—without Judeo-Christian ideology and so forth."[83]

Another form of neoracism is perpetuated by ethnographical museums, museum education, and the inherited history of art that is taught and promoted in North American schools. This aspect of metaracism in ethnographic museums has been forcefully exposed through the writings of James Clifford.[84] The intent of his argument, and that of others who have followed his lead, has been to expose the interest of Western anthropological discourses and Western museum educators to essentialize and exoticize other

cultures as if they were frozen in time, displayed under glass as the West's Other. By documenting a "disappearing world" through the collection of artifacts, the ethnographical museum has managed to gain respectability, status, grants, and a sense of moral righteousness, adding to their collections on the grounds that the producers are disappearing: Only their artifacts remain to show the once-thriving culture. As R. Handler argues:

> Ethnicity in the museum, reproduces an ideology of culture which homogenizes and domesticates rather than enhances cultural diversity. . . . All such groups are [represented as] being more or less identical (doing the same thing) in such self-conscious claims for uniqueness based on so called authentic culture. . . . Due to this media homogenization and support, ethnics are becoming more alike even while many such groups continue to identify as "different" in certain expressive domains of their lives."[85]

The cultural theorist Lawrence Grossberg provides an interesting confirmatory anecdote:

> I attended a conference in Ottawa which focused on the new Canadian National Museum of Civilization: participants were given a tour of the facilities, hosted by the designer/curator and the architect. The papers were all predictably critical of the capitalist, imperialist, Eurocentric, ethnocentric, racist, sexist biases, not only of the particular displays, but of the design philosophy of the museum as well. They demanded that, in one way or another, the entire project be dismantled or turned over to "the people" on behalf of whom the various critics were all sure they could speak. Admittedly, the museum is perhaps most impressive as a suggestion of what would have happened if Marshall McLuhan and Walt Disney had ever gotten together: every technological gadget and marketing technique are deployed in its archetectonic spaces. And undoubtedly, the critics were right; it is easy enough for those who are trained to find evidence of the structured inequalities in our society—classism, nationalism, imperialism, racism, sexism, homophobia, Eurocentrism—coded into the practices of the museum. But then, wouldn't it be more surprising if the Canadian government had produced a museum that did not somehow incorporate inflections of these various relations?[86]

With the rhetoric of an essentialized but equal cultural identity come the issues surrounding "cultural property." To validate ethnic identity in the face of cultural erosion, the cultural artifacts of "art" have been used to prove the existence of a group in a concrete way, as well as to provide evidence for the group's sense of worthiness. Many Indian artifacts are now being returned from museums to tribes or groups that once possessed them.[87] Besides seeking material goods, ethnic groups are clearly seeking recognition, respect, and self-esteem. Their claims for material goods and resources (land claims) are often intimately related to the process of gaining recogni-

tion and respect, since Western capitalist culture equates the two. The up-surge of this ethnic "revival" is largely related to the perceived socioeconomic gains it allows individuals whose identities have been submerged or whose status has been denigrated in the past (e.g., the large cash settlements for aboriginal lands). In such cases, identity functions as a political assertion of pride in what the minority regards as its rightful heritage, in spite of any considerations of cultural authenticity. Geographic identity—a strong sense of land and place—remains the dominant metaphor for the definition of the aboriginal self in North America despite the dissipating power of dislocation by the media.

In major international ethnographical exhibits in a postcolonial context, argues Annie Coombes, where contact and exchange between dominant culture and aboriginals is supposed to exhibit an intercultural understanding, rarely if ever are the socioeconomic interests and conflicts exposed.[88] For example, the Tukano Indians of the Amazon protested against the 1985 "Hidden People of the Amazon" exhibition at the Museum of Mankind in London on the grounds that the exhibit failed to document the resistance that the Tukano Indians undertook against the Brazilian government against the devastation of the Amazon forest. Another instance of hidden conflict involved the Glenbow Art Gallery in Calgary, Alberta, where an exhibition, "The Spirit Sings: Artistic Traditions of Canada's First Peoples, "was planned to coincide with the Winter Olympics in January 1988. This controversial exhibit again illustrates a presentation of Indians absent of any self-determination by them.

> The Lubricon Lake Cree organized a demonstration and boycott of the Olympic Games in order to draw attention to their forty-year-old land claim. The exhibition itself gradually became the focus of the boycott since its very existence was only assured as the result of a substantial grant from the Shell Oil Canada Ltd.—who also happened to be drilling in precisely the area of the land claim. Bernard Ominayak, Chief of the Lubricon spoke: "The irony of using a display of North American Indian artifacts to attract people to the Winter Olympics being organized by interests who are still actively seeking to destroy Indian people seems obvious."[89]

Ominayak made it quite clear that there are complex interests at stake in the representation of culture in Western museums. This goes beyond the contextualizations that present the mythic and ritualistic significance of the objects, and beyond the reassessment of the validity of these practices for the canons of the Western art establishment, for it exposes the way these cultural displays are framed by a global politics. Such activism on the part of aboriginal peoples has forced the closing of some exhibitions and, in some cases, of feature films.

Like the discourse of the ethnographic museum, the visual art canon of

modernism, which we so vigorously promote in our classrooms, has been equally exposed for its incorporation of the "primitive" as its Other by Marianna Torgovnick. Just one quote from her book *Gone Primitive* is sufficient to present the kind of dilemmas art educators face when introducing works of modern art in their all too often formalist fashion:

> Continuing and expanding an older tradition of including blacks as signs of sensuality, paintings of the modern movement like Manet's *Olympia* and Picasso's *Les demoiselles d'Avignon* had used blacks and African masks in connection with debased sexuality, especially the depiction of prostitution and brothel life. Is it an accident that these two paintings—linking nonwhites, women, and sex for sale—have become the icons of modern art?[90]

Had Gauguin, then, indeed solved the problem of representing the woman's body that problematized the male gaze? Torgovnick thinks not. As she notes, the famous exhibition "Manet and the Post-Impressionists," organized by Roger Fry in 1910, featured one of Gauguin's paintings from his Tahitian phase; in contrast to the modernism of Matisse and Picasso, Gauguin's "'realistic' works were the only ones the public really liked."[91]

PASTICHE MULTICULTURALISM

Softer versions of neoracism appear in multicultural education, which has modeled itself on the "pastiche" and "quote" style of the conservative end of postmodernism. Here, many art educators come dangerously close to embracing this perspective by finding clever ways to reinstate and recirculate the signs of the Western artistic canon, such as having children reinterpret famous works of art from their own perspectives. Such a practice requires the activation of artistic historical works through performance. The task of having children identify famous works of art by matching the jigsaw puzzle pieces they have faithfully blown up and copied is a further illustration of this type of practice. I would argue that Annie Smith's *Getting into Art History* is an example of such an approach;[92] and the "new" and "improved" face of the Discipline Based Art Education (DBAE) program supported by the Getty Center for Education is *the* prime example of multicultural pastiche style. The profitability and benevolence of this curriculum approach matches perfectly with the appropriation of multiculturalism by MNCs and TNCs mentioned earlier.[93]

In this context, I would argue that the dominant culture practices a cultural pluralism by catering to an "ethnic pastiche" of symbolic borrowings from other cultures to display a sense of tolerance and benevolent cosmopolitanism as the centering notions of nationalism become more and more difficult to sustain. Like the Eurocentric canon of art history—especially architectural history, which becomes self-referentially used again and again

in conservative postmodern discourse to invigorate and sustain a "decline of the West" syndrome—a "multiculturalist pastiche" is most evident (and at its tamest) in its unabashed celebration of exotic food and clothing that presumably adds spice to culinary delight and flare to fashion. As an example, here's a descriptive advertisement of the Polos Cafe that appeared in a Canadian newspaper:

> The theme of the Polos Cafe is West meets East, or more to the point, West collides with East. The menu calls the cooking Orie-Ital cuisine— that's Oriental cooking with Italian flavor. There are many ways to eat here: the tapas approach (nibble on appetizers); or consider the pizza (no. 1 is tofu Italian); or enjoy a more traditional evening of salad (Caesar Oriental) and entree (chicken with honey ginger sauce). Polos also offers something called "the kebab symphony," which is merely a selection of "babs" ranging from the alluring beef with ginger apricot dip to the alarming calamari with spiced Hoisin sauce.[94]

What can one say? *Bon appétit!*

Black ethnicity, especially as marketed by basketball stars such as Michael Jordan and Magic Johnson, by black rap musicians, and by the marketing firms of Cross Colors and Mondetta labels, promote a superficial, or "surface," ethnicity wherein any specific connection between race and ethnicity is lost (e.g., it is perfectly possible to be black and French).[95] Ethnicity in its postmodern conservative form now becomes superficial, as marked by clothes, speech patterns, and music. Such ethnicity belongs to the homogenizing trend of TNCs, as discussed earlier. White kids who have no identifiable ethnicity to draw from can now purchase it as a commodity form. With no strong community roots, a consumable and surface youth identity becomes a way to center a sense of place. This is very different from the shared politics of ethnic difference outlined above.

The exoticism, fetishism, and selling of cultural identities ride on a parallel wave with the urban gentrification of late capitalism. Fine ethnic-food restaurants can be found in virtually every major city in the world.[96] As for the fashion industry, an anecdote is suitable here: On an overseas flight, I watched the Air Canada "news film" (I use these words cautiously, since it is one gigantic advertising scam), from which I discovered that the theme of fashion in the spring and summer of 1992 was "going primitive." I wrote down a number of phrases that capture the language of appropriated alterity for exoticization, fetishization, and consumption: "Let the native spirit run"; "jungle fever that is raising the temperature"; and "fashion takes a trip to paradise." Regarding the print patterns themselves: "tribal gazelles and ethnic shields," "the Congo line of African beauties." And saving the best for last, "Go primitive, it's the most civilized way to go!" Gauguin's distant trace is still there!

ANTIESSENTIALISM AND HYBRIDITY

To conclude this chapter, I would like to briefly outline the stance of antiessentialist, that is, poststructuralist, approaches to cultural identity. In the late 1980s, identity politics came to a point where there was a realization that the differences *within* ethnic groupings, genders, and races were often greater than the differences *between* other ethnicities, genders, and races.[97] Binaries began to be deconstructed; issues of class, color, gender, age, ableism, ethnicity, and location began to be more and more significant. Among feminist circles, this meant the realization that the representation of "woman" was a sign structured in and through differences. White middle-class academic women, who had first given shape to feminist discourse, had to concede to issues of class, color, and education as mediating factors of power, as women of color protested their hegemony. The hegemony of blacks as the dominant oppressed minority also came to be questioned by other marginalized groups of color in both the United States and Britain. In Canada, as is well known, a similar questioning took place, especially by aboriginal peoples when French Quebec wanted "distinct society" status during the Canadian Constitutional debates of 1992. These people named themselves "First Nations," actually inverting the hierarchy by claiming, "We were here first!"

The phenomenon of differences *within* being greater than the differences *between* has been interestingly analyzed by the anthropologist Michael Smith of the University of California, Davis.[98] Smith addresses one of the emerging questions inherent to an antiessentialist stance: Who now gives voice to authentic marginal sensibilities when issues of ethnicity, race, class, and culture are conflated and often encountered by conflicts over group identity? An example of this dilemma was illustrated by the recent controversy that took place between black filmmaker Spike Lee and poet Amiri Baraka (LeRoi Jones) over the right to interpret the meaning and legacy of Malcolm X. The film *Malcolm X* was shot amid the furor started by Baraka: "The black nationalist poet and playwright attacked Lee's credibility at a political rally in Harlem, proclaiming: 'We will not let Malcolm X's life be thrashed to make middle-class Negroes sleep easier.'" Baraka exhorted his audience to write to Lee, warning him "not to mess up Malcolm's life."[99]

Spike Lee's reply, while granting the right of anyone and everyone to interpret the story of Malcolm X in their own way, was equally abrasive, challenging Baraka's own claim to be the sole authentic spokesperson for Malcolm X's legacy. His response was published in *Newsweek*, wherein he used the discourse on class, as did Baraka, to settle the presumed racial conflict. "In fact, proclaimed Lee, when Malcolm was alive, Amiri Baraka was down in Greenwich Village running around with Allen Ginsberg and

living that 'Jungle Fever' beatnik-bohemian life style." In response to being called a bourgeois liberal, Lee retorted, calling Baraka a "limousine, radical," stating that "after the ... rally to protest the film, Baraka, the Black Marxist Revolutionary, jumped into a black limo and sped off down Lenox Avenue, past the lumpen proletariat in Harlem. And he calls me a 'middle class Negro!'"[100]

As Smith underlines, this rhetorical exchange conflated race, class, and culture.

> Not only do both would-be voice givers imply that the essence of black racial experience is rooted in underclass status, they also suggest that black intellectuals who can lay claim to slightly more proximity to the lumpen proletarian experience have a greater entitlement to speak for "black people" than those above them in the hierarchy of social classes. . . . Both of these would-be marginal voices fail to acknowledge the diversity of the experience of being black in America or the class and gender differences that are part of that experience. The controversy does reveal, nevertheless, some of the complexity of the seemingly straight-forward postmodern project of giving voice to marginal sensibilities and constructing a political space in which racial and ethnic "others" can name themselves."[101]

In another context, Sollors makes the point that "an Afro-American and the grandson of a Polish immigrant [living in the United States] will be able to take more for granted between themselves than the former could with a Nigerian or the latter with a Warsaw worker."[102]

Positionally, the awakening of an antiessentialist stance has meant treating ethnicity and gender as *signs*: Cultural and gender identities are *constructed* in difference from within a particular place, out of a particular history, out of a particular experience, and out of a particular culture. Such construction is not merely a textual matter confined to the imaginings of fantasy and the rhetoric of words. The cultural theorist Stuart Hall, in his 1988 publication on an antiessentialist black experience, made it quite clear that textual constructions produce *real*, that is, material, effects.

> My own view is that events, relations, structures do have conditions of existence and real effects, outside the sphere of the discursive; but . . . only within the discursive, and subject to its specific conditions, limits and modalities, do they have or can they be constructed within meaning.[103]

This process of emerging ethnicity has been called "ethnogenesis": the development and public presentation of a self-conscious ethnic group even, as it has been argued, when such a culture simply exists as a Baudrillardian simulacrum (a copy of a copy).[104] For example, the "counterfeit" or "unauthentic" culture of the Hurons of Quebec, who no longer know their

own language but who deliberately construct a stereotypical neo-Huron *counter*culture, is an attempt to achieve a phenotypical Indian identity. Theirs is a staged culture, ethnically militant in its determination to reclaim territorial rights:

> When I compared the characteristics of this neo-Huron culture with the culture depicted in the historic records, most of the modern traits, virtually everything, were "counterfeit": the folklore articles, the hair style, the moccasins, the "Indian" parade costumes, the canoes, the pottery, the language, the music. There is one thing, however, that all these constructed cultural characteristics have in common: they represent attempts to introduce a perceptible difference between Hurons and the surrounding Canadians in a way that suggests some Indian stereotype.[105]

Historically, the Hurons were decimated by disease through contact with the French and slaughtered by the League of the Iroquois (especially the Mohawks), their traditional enemy. Eventually, they were left with a tiny reservation area, the size of a small village. Given this historical memory, can their "fake" reconstructed culture be looked down upon considering the fact that they have no legal claims to other lands, only the argument that they feel cheated and that this land was stolen from them? Didn't Gauguin reconstruct his own Tahiti, as well, so that he might make ethical claims to living a different relationship with Tahitian autochthons?

Much too often Indian elders have forgotten their cultural heritage, but there can never be any simple "return" or "recovery" of their ancestral past that is not reexperienced through the category of the present; there is no simple reproduction of traditional forms that is not transformed by the technologies and identities of the present. The cultural erosion felt by the "second generation" is, as Roosens claims, a "true cultural mutation" that cannot return to a traditional culture that it never had in the first place.[106] This point especially hit home for me during a film and cultural festival celebrating native ethnicity in Edmonton, Alberta, called "Dream Makers." There, for the first time, I experienced the music of Indian rock and the hip-hop of the First Nations Society, as well as traditional native music blended with popular country music. Such forms seem to identify the decolonized "third space" of hybridity that cultural theorists such as Homi Bahbha[107] and Stuart Hall[108] called for at the end of the 1980s where "difference" was to be used strategically, yet was to incorporate other influences.[109] Hall put it this way:

> The diaspora experience as I intend it here is defined, not by essence or purity, but by the recognition of a necessary heterogeneity and diversity: by a conception of "identity" which lives with and through, not despite, difference: by *hybridity*. Diaspora identities are those which are constantly

producing and reproducing themselves anew, through transformation and difference.[110]

In a similar tone, Bhabha called for the construction of a third space:

> It is significant that the productive capacities of this Third Space have a colonial or post-colonial provenance. For a willingness to descend into that alien territory . . . may reveal that the theoretical recognition of the split-space of enunciation may open the way to conceptualizing an international culture, based not on the exoticism or multi-culturalism of the diversity of cultures, but on the inscription and articulation of culture's hybridity.[111]

This antiessentialist stance therefore deconstructs the binary of "authentic" and "unauthentic" cultural identities. This may be said of a new generation of Inuit youth living in Frobisher Bay who have never experienced the mush of a dogsled or learned the skill of throwing a harpoon. Skiddoos, rifles, and television satellite dishes have transformed their culture to such an extent that the rich tradition of myths influences only the older generation of soapstone carvers and lithographic printmakers. What is produced as a distinct Inuit art today is also a simulacrum of the past in the name of a cultural identity. This, I believe, is an example of cultural "translation," which Bhabha addresses: the activity of displacement within the linguistic sign.

> Developing that notion, translation is also a way of imitating, but in a mischievous displacing sense—imitating an original in such a way that the priority of the original is not reinforced but by the very fact that it can be simulated, copied, transferred, transformed, made into a simulacrum and so on: the "original" is never finished or complete in itself. The "originary" is always open to translation so that it can never be said to have a totalized prior moment of being or meaning—an essence.[112]

Bhabha seems to be advocating a form of textual poaching so brilliantly analyzed by Michel de Certeau,[113] a rewriting of the established canon of the Other, much as Salman Rushdie's ideas of an altered narrative structure make it quite clear that the techniques of his novel *Midnight's Children* reproduce traditional techniques of the Indian oral tradition: the techniques of circling back from the present into the past; building a tale within a tale; persistently delaying climaxes. Such features are reinscribed over the Western linear sense of progressive time. There is now a whole body of postcolonial literature that tries to create this hybrid third space.[114] Ella Shohat and Robert Stam provide a comprehensive review of an aesthetics of resistance by diasporic artists who reclaim archaic sources for their art—including the carnivalesque, the anthropophagic (cannibalism), disembodiment and syncretism (or hybridity)—in order to disrupt Eurocentric bias

and imperialist domination.[115] We should remind ourselves, however, that the established canon that is being "translated" is *not* simply a body of texts per se but, rather, a set of reading, listening, and viewing practices that resides in a nation's institutional structures of reproduction and dissemination: in its literary, music, and art educational curricula and in its communication networks. A specific form of "critical thinking," as embedded in the aesthetics of disinterestedness and distance, that grounds Eurocentric notions of connoisseurship and distances objectivity is difficult to challenge. "Translation" requires the mutability and diversity of other cultural forms to perform its displacement. Michael Geyer calls these "skills of transcoding."[116] Following the seminal work of Tesjaswini Niranjana, Geyer describes these acts as

> based on modes of inquiry that encompass, on one level, strategies of coping with the fear of otherness while honoring difference. Such strategies are familiar from a variety of therapeutic activities such as antirape or antiracist education. They can be made prominent features of the curriculum and form a scholarly and educational site for bringing together a great variety of disciplines in common projects, such as intercultural reading or explorations in symbolic exchange.[117]

In Canada, the concept of the mosaic has been an important cultural determinant that has gone beyond the nationalist stance of the melting pot of the United States. One would suppose that the space of hybridity could be claimed by Canadians as an exemplar for the global community. Unfortunately, the internal perception of the mosaic has not generated a hybrid literature to replace the nationalistic approach. Canada has tended to remain monolithic, to differentiate itself from Britain and the United States. It has retreated from the dynamics of difference into a neouniversalist stance.[118] Many Canadians live with a hyphen within their identity, but this often leads to cultural schizophrenia rather than to the decolonized space of hybridity. An autobiographical reflection by a Korean-Canadian that appeared in the "Facts & Arguments" column of the *Toronto Globe & Mail* in 1992 is a good example of this.[119]

Sixteen-year-old, Sun-Kyung Yi wrote about how the hyphen in "Korean-Canadian" often snapped in two, obliging her to act as either a Korean or a Canadian, depending on where she was and whom she was with. She was called Angela at school and Sun-Kyung at home. At school, she ate bologna sandwiches for lunch; but at home, it was kimchi and rice for dinner. She waved hello and good-bye to her teachers; at home, she bowed to her parents' friends visiting the house. The two separate, hyphenated worlds could not be maintained without questioning both sides.

"Many have tried to convince me that I am a Canadian, like all other immigrants into the country, but those same people ask me which country I came from with great curiosity, following it with questions about the type of food I ate and the language I spoke. It's difficult to feel a sense of belonging and acceptance when you are regarded as "one of them." "Those Koreans, they work hard. . . . You must be fantastic in math and science." (No). "Do your parents own a corner store?" (No.)[120]

Yi talks about working for a small Korean company in Toronto. Her parents were ecstatic that, at long last, their daughter had finally found her roots and an opportunity to speak her native tongue and absorb the culture. It turned out that Canadianized Koreans were not tolerated there though. She looked like a Korean, therefore she had to talk, act, and think like one too. Being accepted meant a total surrender to ancient codes of behavior rooted in Confucian thought. The Canadian part of her had to be left "outside." Unmarried, she was bombarded with every single available bachelor in the company and in the community. She was expected to accept her inferior position as a woman and behave accordingly. She could not practice her feminist views: Little Korea was for men, who filled all the senior positions. She was supposed to act like a lady and smile. She was scorned for her lack of ability to speak Korean better, scorned for her lack of cooking skills. Finally, she had to leave because she just wasn't "Korean enough." "But now I remain slightly distant from both cultures, accepted fully by neither." She concludes, "The hyphenated Canadian personifies the ideal of multiculturalism, but unless the host culture and the immigrant cultures can find ways to merge their distinct identities, sharing the best of both, this cultural schizophrenia will continue."[121]

From a similar biographical perspective, Ien Ang, a Dutch citizen born in postcolonial Indonesia into a middle-class Peranakan Chinese family who now works in Australia, explains how her inability to speak Chinese hegemonically constructs her as lacking—her inability becomes a sign of her loss of authenticity.[122] Like Yi, Ang, as a member of the Chinese diaspora, is either "too Chinese" or "not Chinese enough." In the West, she will never be able to erase traces of "Chineseness"; no matter how Westernized she becomes, she will never be considered white. But in China, the first thing she is accused of is a lack of Chineseness, especially since she doesn't even speak the language. The dilemma, as Ang puts it, is an impossible position caught between "where you're from" (the real or imaginary homeland) and "where you're at" (the host country). Against Hamid Naficy's skepticism about the cultural politics of hybridity,[123] Ang argues that such an in-between position, can enable a "creative tension" that forms Bhabha's third space—the space of collision/collusion of two cultures. However, the specificity and contextualization of such a space is absolutely necessary, for

it seems such a space can easily be self-defeating because of the impossibility of diasporic subjects to be completely nationalized within the dominant culture.

For arts education, the lesson to be learned from all this is not whether a culture is "authentic" or "unauthentic"; rather, it is the way a culture representation of difference is used within specific situations for socioeconomic and political gains and in new formations of identity, which might find forms of hybridity, that escapes the worst of both words. This is very different from the homogenizing effects of a consumerist "ethnic pastiche" of conservative postmodernism. Representation is therefore and foremost a *formative*, not only an expressive, place in the constitution of social and political life.

This hybrid space of difference is being developed today through the process of ethnogenesis by a youthful generation of artists who use and poach "difference" working within a logic of "both/and"—the "local&global." This hybridity is most evident by the cut-and-mix style produced from the combinations and borrowings from other ethnicities; yet it is a hybrid style that does not loose a distinctiveness that is specifically, say, aboriginal, or African American. During the "Dream Makers" festival I mentioned above, I met a young native film director and producer who told me that there was a lively exchange of videotapes recorded among various West Coast Native American tribes so that they could learn more about one another and appreciate their differences. It seems that the generation often identified pejoratively as the "baby busters" (that is, the so-called thirteenth generation, children of the baby boomers born after 1961) is the one creating these new spaces. I am reminded of Hungary, where anyone older than thirty is suspect of being a member of the former Communist Party and therefore devoid of generating new political possibilities and potentialities for the country. This more creative and, I would say, progressive form of difference, however, coexists with all the other forms of difference I have outlined: essentialist, homogenizing, racist, and neoracist alike. It requires intercultural nurturing.

All this then draws me back to Gauguin, INSEA, and Ana Mae Barbosa's talk. If hybridity and the formation of a third space provide a theoretical justification for dealing with the incommensurabilities between cultures, it seems there is justification in identifying Gauguin as someone whose self-chosen *différance* turned against, and stood in contrast to, the inherited discourses of colonialism and nude painting in his day.

> The labor of creating and maintaining the conditions for choosing and fashioning one's identity requires more than a faithful rendering of what is. It takes the assertion of artifice, the *expression* of difference and its simultaneous translation in order to redeem it. It takes, as it were, culture in the original sense of cultivation.[124]

Barbosa places Gauguin in good company by demonstrating that Tarsila do Amaral also had been influenced by Gauguin, Fernand Léger, and other European modernists. She "exercised similar flexibility to the 'other' as a part of herself analyzing the Black heritage in Brazil despite being White and descendent of a family who owned African slaves."[125] Both Paul Gauguin and Amaral demonstrate a nonsovereign self, a decentering or fragmentation of identity that is a "recognition of the importance of the alienation of the self in the construction of forms of solidarity."[126] As Jane Flax gleans from her therapeutic practice, such individuals exhibit an increased "tolerance for differences, ambiguity and ambivalence."[127] Both artists changed their identity, constructing a new social image through a retelling of the past. However, their negotiations could never *entirely* escape the discourses that shaped them. If Gauguin was caught by phallocentrism, surely Amaral was caught by the discourses of feminization. Yet both proceeded to rework and rethink their identity through the Other, thereby maintaining a spirit of alterity.

This third space of hybridity is as much informed by sexual difference as it is by racial difference, and it is to Barbosa's credit to have developed Amaral's story in this context, for a "third attitude" of hybridity has also been posited by Julia Kristeva.[128] Kristeva argues that a third generation of feminists has come into its own, learning and rewriting its own experiences from the experiences of the previous two generations. It is now possible to deconstruct the man/woman dichotomy. In this regard, I believe the films of Marguerite Duras present yet another complement to Gauguin, for in them, a white female colonizer living in French colonial Indochina recounts her childhood memories and, in doing so, opens up a hybrid space.[129] If art education were given such a mandate to develop the hybrid space of intercultural learning, it would indeed become a powerful tool to educate against the vicissitudes of neofascism, neoracism, and a humanist tradition that continues to perpetuate, in Gayatri Spivak's turn of phrase, an "epistemic violence."[130]

In proper postmodern fashion, I will end this chapter by asking whether the implied mandate for art education as discussed throughout has already been successfully carried out through an examination of the discourses surrounding AIDS. How the AIDS victim has been constructed in the media, health campaigns, and literature, and how alternative representations might rewrite these dominant views have been discussed at length by Douglas Crimp,[131] Tessa Buffin and Sumil Gupta,[132] Cindy Patton,[133] and Paula Treichler and Lisa Cartwright.[134] There is also a book edited by James Miller that is a compendium of alternative artistic representations of the AIDS body.[135] In this collection David White discusses the art of Andy Fabo, a Canadian artist born in Calgary who is a member of the group Act Up. White describes

Fabo's own translations of Picasso's *Les demoiselles d'Avignon* and, interestingly enough, Fabo's dialogues with Gauguin.

> "In *A Catalogue of Accusations & Counter-Actions*, the central figure from Gauguin's *D'où venons-nous? Que sommes-nous? Où allons-nous?* recurs at intervals throughout the book, and at one point the St. Sebastian pose is mocked by the substitution of suction-cupped toy arrows for the original weapons of his martyrdom. Since Gauguin and Picasso were notorious "heterosexuals," Fabo's intentions cannot be interpreted exclusively as allusions to gay history.[136]

If, as Peter Brooks claims, Gauguin was unable to deal with the "polymorphous body," Fabo, who identifies himself as gay, could. An art education that makes identity politics possible is also an art education that few will embark on in our secondary schools or universities.

Will this gap ever be closed?

NOTES

1. The possible exception is Richard Yeoman's presentation (session no. 43), "Child Art and Modernism," in *Official Program of the International Society for the Education Through Art* (Montreal: INSEA, 1993): "Gauguin's quest for an art of spiritual purity initiated an appetite for the 'primitive' in early modern art. This new 'primitivism' encouraged child art alongside the arts of Africa, the South Sea Islands, and folk art, and it can be argued that early modernism took possession of child art, elevating it, making it a significant branch of the modernist movement" (p. 64). Others, such as Annie Smith (session no. 64), saw an opportunity to examine it as a historical text open to interpretation. Still others interpreted Gauguin's "spiritual" return to "Nature" as the direction needed today (e.g., P. B. Lall, session no. 10).
2. Ana Mae Barbosa, "From Gauguin to Latin America: Who Are We?" in *Official Program of the International Society for Education Through Art*, session no. 1, p. 55.
3. The category of "the Other" is capitalized here to indicate that a Lacanian paradigm is being summoned and to distinguish it from the concept of "the other" written with a lowercase *o*. The lowercased other denotes a specular relation to an imaginary rival, for example, mother or father. In this case, the other is a *primary* narcissistic relationship, an identification that the subject either recognizes or rejects as its own image. In contrast, the Other is a *secondary* identification whereby a linguistic relation to a symbolic interlocutor is called upon. The Other marks a locus of intersubjectivity and, therefore, an effect of secondary identification; that is, the subject must shift its point of address to another speaking subject.
4. This idea was first developed by John Berger in *Ways of Seeing* (Harmondsworth, England: Penguin, 1972).
5. Abigail Solomon-Godeau, "Going Native," *Art in America*, vol. 77, no. 7 (July 1989): 118–129.
6. Ibid., p. 120.
7. Ibid., p. 124.

8. Ibid., p. 128.

9. See Pollock's remarkable essay where she clarifies the relationship of the artist and "his" model: "Painting, Feminism, History," in Michèle Barrett and Anne Phillips, eds., *Destabilizing Theory: Contemporary Feminist Debates* (Cambridge: Polity Press, 1992), pp. 138–176.

10. See David Carroll, "The Temptation of Fascism and the Question of Literature: Justice, Sorrow, and Political Error (An Open Letter to Jacques Derrida)," *Culture Critique*, no. 9 (spring 1990): 39–81.

11. Peter Brooks, "Gauguin's Tahitian Bodies," chap. 6 in *Body Work: Objects of Desire in Modern Narrative* (London and Cambridge, MA: Harvard University Press, 1993), pp. 162–198.

12. Ibid., p. 164.

13. Ibid., p. 179.

14. Ibid., p. 180.

15. Thomas Docherty, "Postmodern: An Introduction," in Thomas Docherty, ed., *Postmodernism: A Reader* (New York: Columbia University Press, 1993), pp. 15–18.

16. Ibid., pp. 17–18.

17. Diana Fuss, "Interior Colonies: Franz Fanon and the Politics of Identification," *Diacritics*, vol. 24, nos. 2–3 (summer–fall 1994): 20–42.

18. Ibid., p. 21.

19. Ibid.

20. Linda Nochlin, *Women, Art, and Power and Other Essays* (New York: Harper & Row, 1988), p. 138.

21. Brooks, "Gauguin's Tahitian Bodies," pp. 193–194.

22. Nochlin, *Women, Art, and Power*, p. 139.

23. Nead's analysis is a brilliant deconstruction of the phallocentricism associated with the nude in Western art, deconstructing the binary of naked/nude as developed by Sir Kenneth Clark. She then examines how feminists have sought different representational interventions. Lynda Nead, *The Female Nude: Art, Obscenity, and Sexuality* (New York and London: Routledge, 1992).

24. Brooks, "Gauguin's Tahitian Bodies," p. 183.

25. Lisa Tickner, "Men's Work? Masculinity and Modernism," *Differences*, vol. 4, no. 3 (1992): 6.

26. Hal Foster, "'Primitive' Scenes," *Critical Inquiry*, vol. 20 (autumn 1993): 85.

27. Hamid Naficy, "The Poetics and Practice of Iranian Nostalgia in Exile," *Diaspora*, vol. 1, no. 3 (1991): 285–302.

28. Roger Rouse, "Mexican Migration and the Social Space of Postmodernism," *Diaspora*, vol. 1, no. 1 (1991): 8–23.

29. Salman Rushdie, *Diaspora*, vol. 1, no. 2 (1991); quoted by David Lopscomb on the issue's cover.

30. During my trip to Poland in the summer of 1993, satellite dishes were visible everywhere—not only in major cities, but also in small villages—making readily available television programs from the United States, Germany, Italy, France, and England. Apparently, this phenomenon is repeated in virtually every Eastern European country, except in the poorer countries such as Romania and Albania. The meaning of this to the changing Eastern European identity is only now emerging, as illustrated by the theme for the First European Film and Television Conference, which took place in London in 1994, appropriately entitled "Turbulent Europe: Conflict, Identity, and Culture." My observation

of this homogenizing phenomenon applies equally to popular music. Musical casettes are cheaply reproduced in Poland, and tapes of virtually every recent pop group can be purchased there. The same phenomenon is repeated in Ljubljana, the capital of Slovenia, and throughout every other East European capital. At the level of popular culture at least, multinational capitalism continues to homogenize the globe. In contrast, the fine arts do not have the same appeal as the popular arts of television and rock music. The 1993 Biennial Graphic Exhibition, which I attended in Ljubljana, represented an international array of artists and was spread massively over the space of three museums, but the attendance could be counted on one hand.

31. Benjamin R. Barber, "Jihad vs. McWorld," *Atlantic Monthly* (March 1992): 53–63.
32. Joshua Meyrowitz, *No Sense of Place: The Impact of Electronic Media on Social Behavior* (New York and Oxford: Oxford University Press, 1986).
33. Ibid., p. 125.
34. Ibid., p. 57.
35. The notion of belonging to a West-East European community is yet another aspect of the homogenizing effects that are taking place. I experienced how this works in the summer of 1993 when traveling through the Czech Republic with my son. As Canadians, we required a visa, which cost a whopping U.S. $45 just to travel through the country. But the traveling companions we met from Austria, Poland, and even Great Britain belonged to the European Community and required no such visa.
36. Thomas K. Fitzgerald, "Media, Ethnicity, and Identity," in Paddy Scannell, Philip Schlesinger, and Colin Sparks, eds., *Culture and Power: A Media, Culture, and Society Reader* (London, New Delhi, and Newbury Park, CA: Sage Publications, 1992), pp. 112–133.
37. Masao Miyoshi, "A Borderless World? From Colonialism to Transnationalism and the Decline of the Nation-State," *Critical Inquiry*, vol. 19 (summer 1993): 726–751.
38. Ibid., p. 750.
39. Miyoshi makes a distinction between MNCs and TNCs. MNCs still have loyalty to a nation, and their headquarters are centered there. In contrast, TNCs have no loyalties to any nation. They are decentered, constructing a new networking space that has its claws in many host countries. They form their own corporate selves.
40. Miyoshi, "A Borderless World?" p. 747.
41. Ibid., p. 749.
42. Mike Davis, in *City of Quartz: Excavating the Future of Los Angeles* (London and New York: Verso Press, 1990), writes about the Los Angeles Festival, which is funded by Pacific Rim capital: "Since Los Angeles is the only city in the world whose ethnic diversity approaches or exceeds New York's (eighty-six different languages were recently counted amongst its school children), multiculturalism seems an obvious emblem for its new globe-trotting pretensions. Yet (so far) this is still largely an import strategy, focused on an emerging network of transactions between elite cultural institutions, and designed to pluralize the tastes of Los Angeles's upscale arts consumers" (pp. 80–81).
43. Miyoshi, "A Borderless World?" p. 748; emphasis added.
44. David Rieff, "Multiculturalism's Silent Partner: It's the Newly Globalized Consumer Economy, Stupid," *Harpers*, vol. 287, no. 1719 (August 1993): 62–78.

45. David Binder and Barbara Crossette, "As Ethnic Wars Multiply," *New York Times*, 7 February 1993, pp. A1, A12.

46. See Ernesto Laclau and Chantal Mouffe, *Hegemony and Socialist Strategy: Towards a Radical Democratic Politics* (London: Verso Press, 1985). Following the psychoanalytic work of Jacques Lacan, they argue that the structures of meaning are constituted through "nodal points" (*point de caption*) in which the signifiers and signifieds are temporarily sewn together. These overdetermined points operate to fix the multitude of "floating signifiers" that circulate in the ideological field. This process seems to provide a suitable description of the postmodern jihadic consciousness as adopted from Barber.

47. Miyoshi, "A Borderless World?" p. 744. This dystopia of TNC takeovers has become the "stuff" of cyberpunk science fiction film and literature: William Gibson, Bruce Sterling, John Shirley, and Rudy Rucker are writers loosely grouped within the genre of "cyberpunk." Films such as *Bladerunner, Free Jack, Demolition Man, Logan's Run, The Running Man, The Terminator, Brazil, Millennium*, and *Fortress* are just some examples of this cinematic genre. See Andrew Ross, *Strange Weather: Culture, Science, and Technology in the Age of Limits* (London and New York: Verso Press, 1991), who characterizes this entire development as a male fantasy of the space western.

48. Paula Rothenberg, "The Construction, Deconstruction, and Reconstruction of Difference," *Hypatia*, vol. 5, no. 1 (spring 1990): 42–55.

49. Werner Sollors, *Beyond Ethnicity: Strategies of Diversity* (Bloomington: Indiana University Press, 1986), p. 25.

50. Henry Louis Gates Jr., *Figures in Black: Words, Signs, and the "Racial" Self* (New York and Oxford: Oxford University Press, 1987).

51. Michael Awkward, *Negotiating Difference: Race, Gender, and the Politics of Positionality* (Chicago and London: University of Chicago Press, 1995).

52. In this regard, I take Jesse Jackson's Rainbow Coalition to be an exception. The second Jackson presidential campaign moved the ground from race to class and attempted to institute a "radical democratic project," that is, to articulate a class agenda in racially conscious terms. On this development, see Howard Winant, "Postmodern Racial Politics in the United States: Difference and Inequality," *Socialist Review*, vol. 20, no. 1 (January–March 1990): 121–147.

53. Joan Copjec, "The *Unvermögender* Other: Hysteria and Democracy in America," *New Formations*, no. 14 (summer 1991): 30.

54. Sollors, *Beyond Ethnicity*, pp. 89–90.

55. Winant, "Postmodern Racial Politics in the United States," p. 130.

56. Allan Bloom, *The Closing of the American Mind* (New York: Simon & Schuster, 1987).

57. E. D. Hirsch Jr., *Cultural Literacy: What Every American Needs to Know* (Boston: Houghton Mifflin, 1987).

58. Stuart Hall, "New Ethnicities," in *Black Film, British Cinema: ICA Document 7* (London: Institute of Contemporary Art [ICA], 1988), p. 28.

59. Sheshona Firestone, *The Dialectic of Sex* (London: Women's Press, 1979).

60. Carol Gilligan, *In a Different Voice: Psychological Theory and Women's Development* (London and Cambridge, MA: Harvard University Press, 1982).

61. Fitzgerald, "Media, Ethnicity, and Identity."

62. Hanif Kureishi, "Dirty Washing," *Time Out* (November 1985): 14–20; quoted in Hall, "New Ethnicities," p. 30.

63. Fitzgerald, "Media, Ethnicity, and Identity," p. 119.

64. The issues surrounding "politically correctness" apply equally to emancipatory methods of education that claim to help Others achieve a critical, self-reflective understanding in order to overcome their "false consciousness" and thereby obtain a "true" ideological understanding of their position. In this sense, emancipatory education, as preached and applied to identity formations, especially by Henry Giroux ("Living Dangerously: Identity Politics and the New Cultural Racism: Towards a Critical Pedagogy of Representation," *Cultural Studies*, vol. 7, no. 1 [spring 1993]: 1–27) and Peter McLaren ("Multiculturalism and the Postmodern Critique: Towards a Pedagogy of Resistance and Transformation," *Cultural Studies*, vol. 7, no. 1 [spring 1993]: 118–146), is the obverse face of this ethnic correctness. Both authors have moved into the postmodern, postcolonial debates, attempting to salvage their embarrassment from such criticism by quoting everyone in sight/cite/site in order to have the "last word" in this developing discourse. Gurulike status replaces their prior elitism, assuring that their dominance is maintained through the presses.

65. Winant, "Postmodern Racial Politics in the United States," p. 127.

66. Bob Suzuki, "Unity with Diversity: Easier Said Than Done," *Liberal Education*, vol. 77, no. 1 (1991): 30–35; quoted in Giroux, "Living Dangerously," p. 23.

67. Diana Jeater, "Roast Beef and Reggae Music: The Passing of Whiteness," *New Formations*, no. 16 (spring 1992): 107–121.

68. Ibid., p. 118.

69. Etienne Balibar, "Is There a 'Neo-Racism'?" in Etienne Balibar and Immanuel Wallerstein, *Race, Nation, Class: Ambiguous Identities*, trans. Chris Turner (London and New York: Verso Press, 1991), pp. 17–28.

70. Ibid., p. 21. Balibar interprets "decolonialization" as "the reversal of population movements between the old colonies and the old metropolises, and the division of humanity within a single political space."

71. A brilliant application of Balibar's theory with Lacanian psychoanalysis to explain the racism of Serbian, Croatian, and Muslim interrelations can be found in Renata Salecl, "Phantasmen des Krieges: Patriarchat und Mutterland— Heimat und Rassismus," *Lettre International*, vol. 21 (1993): 8–11. Salecl teaches at the University of Ljubljana, Slovenia, in the Department of Law and Justice. Her book *The Spoils of Freedom: Psychoanalysis and Feminism After the Fall of Socialism* (London and New York: Routledge, 1994) provides many more insights into the way fantasy structures are mobilized for self-identificatory ends.

72. Balibar, "Is There a 'Neo-Racism'?" p. 18.

73. In Martin Doerry, "Baß Erstaunt im Zauberreich," *Der Spiegel*, vol. 22 (30 May 1994): 192–196.

74. Since the appearance of Edward Said's seminal work *Orientalism* (London: Penguin, 1978), wherein the critical importance of textural representation in the work of appropriation demonstrated the colonizer/colonized relationship, the whole issue has raised the question of the way ethnographical educational research appropriates the Other. This question was first raised by the now well-known conference at the School of American Research, Sante Fe, New Mexico, the proceedings of which were published as James Clifford and George E. Marcus, eds., *Writing Culture: The Poetics and Politics of Ethnography* (Berkeley: University of California Press, 1986); see especially Anne Opie, "Qualitative Research, Appropriation of the 'Other,' and Empowerment," *Feminist Review*,

vol. 40 (spring 1992): 52–69, for an informed review of the issues in the context of feminist research. Art educators globally reproduce such appropriations of the Other, particularly within the context of "helping" teachers to empower native and aboriginal cultures with whom they work. Following Gayatri Chkravorty Spivak ("The Politics of Translation," in Barrett and Phillips, eds., *Destabilizing Theory*, p. 194), I would argue that this has become postmodern, postcolonial art education's way of recovering art's lost "aura" (cf. Walter Benjamin). This "aura of alterity" provides another way of restoring "spirituality" to art, which is said to have been lost in an electronic age. The project of emancipatory education (e.g., Henry Giroux's and Paulo Freire's series Critical Studies in Education, published by Bergin & Garvey Press), which always had a tone of being politically correct within the discourse of a neo-Marxist, liberationalist theology, can now be put to service in such ethnographical appropriation.

75. Balibar, "Is There a 'Neo-Racism'?" p. 25.
76. Homi Bhabha, "The Third Space: Interview with Homi Bhabha by Jonathan Rutherford," in Jonathan Rutherford, ed., *Identity: Community, Culture, Difference* (London: Lawrence & Wishart, 1990), p. 208.
77. Ghassan Hage, "Locating Multiculturalism's Other: A Critique of Practical Tolerance," *New Formations*, no. 24 (winter 1994): 21.
78. Bhabha, "The Third Space," p. 208.
79. Zygmunt Bauman, *Modernity and the Holocaust* (Ithaca, NY: Cornell University Press, 1989).
80. Walter Benjamin, *Illuminations*, ed. Hannah Arendt, trans. Harry Zohn (New York: Harcourt, Brace & World, 1973), p. 258.
81. Bauman, *Modernity and the Holocaust*, p. 7.
82. Ibid., p. 202.
83. In Couze Venn, "Subjectivity, Ideology, and Difference: Recovering Otherness," *New Formations*, no. 16 (spring 1992): 44–45.
84. James Clifford, *The Predicament of Culture: Twentieth-Century Ethnography, Literature, and Art* (London and Cambridge, MA: Harvard University Press, 1988), chap. 9, "Histories of the Tribal and the Modern," and chap. 10, "On Collecting Art and Culture."
85. R. Handler, "Ethnicity in the Museum: A Culture and Communication Discourse," in S. Keefe, ed., *Negotiating Ethnicity*, NAPA Bulletin, no. 8 (Arlington, VA: National Association for the Practice of Anthropology, 1989), p. 19.
86. Lawrence Grossberg, *We Gotta Get Out of This Place* (New York and London: Routledge, 1992), pp. 89–90.
87. Fitzgerald ("Media, Ethnicity, and Identity," p. 122) mentions the preserved head of a Maori warrior that was returned to New Zealand. In Canada and in the United States, newspapers have printed stories about young native men on "vision quests" to museums to reclaim sacred artifacts that once belonged to various tribes.
88. Annie E. Coombes, "Inventing the 'Postcolonial' Hybridity and Constituency in Contemporary Curating," *New Formations*, no. 16 (spring 1992): 39–52. Coombes examined five such exhibitions: Museum of Mankind's "Lost Magic Kingdoms" and "Six Paper Moons for Nahuat l" (London, 1986); Museum voor Volkenkunde's "Kunst uit een Andere Wereld" Rotterdam, 1988); Beaubourg's "Les Magiciens de la Terre" (Paris, 1989; and the Museum for Contemporary Art's "Africa Explores" (New York, 1991).

89. Ibid., p. 47.
90. Marianna Torgovnick, *Gone Primitive: Savage Intellects, Modern Lives* (Chicago: University of Chicago Press, 1990), p. 99.
91. Ibid., p. 85.
92. Annie Smith, *Getting into Art History* (Mesquite, Lake Jackson, TX: Barn Press, 1994).
93. See Michael E. Parks, "Art Education in a Post-Modern Age," *Art Education*, vol. 42, no. 2 (March 1989): 10–13, for a conservative defense as to why the Getty-sponsored DBAE curriculum fits so well into "postmodernism" as he defines it. Parks supports what I would call a "corporate pastiche multiculturalism."
94. *Edmonton Journal*, 4 September 1993, p. G1.
95. Michael Eric Dyson, "Be Like Mike? Michael Jordan and the Pedagogy of Desire," *Cultural Studies*, vol. 7, no. 1 (spring 1993): 64–72.
96. The rise of these "ethnic" restaurants has been coterminous with the rise of gentrification. See Sharon Zukin, *Landscapes of Power: From Detroit to Disney World* (Berkeley, Los Angeles, and Oxford: University of California Press, 1991).
97. On this matter, see Michèle Barrett, "The Concept of Difference," *Feminist Review*, vol. 26 (July 1987): 29–41: and Linda Gordon, "On 'Difference,'" *Gender*, vol. 7, no. 2 (spring 1992): 91–111.
98. Micahel Peters Smith, "Postmodernism, Urban Ethnography, and the New Social Space of Ethnic Identity," *Theory and Society*, vol. 21 (1992): 493–531.
99. Ibid., p. 515.
100. Ibid.
101. Ibid., pp. 515–516.
102. Sollors, *Beyond Ethnicity*, p. 14.
103. Hall, "New Ethnicities," p. 27.
104. Eugene E. Roosens, *Creating Ethnicity: The Process of Ethnogenesis* (Newbury Park, CA: Sage Publications, 1989).
105. Ibid., p. 47.
106. Ibid., p. 137.
107. See Bhabha, "The Third Space"; "Commitment to Theory," *New Formations*, no. 5 (summer 1988); and "Interrogating Identity," in *Identity: The Real Me, Post-Modernism, and the Question of Identity: ICA Document 6* (London: ICA, 1987), pp. 5–12.
108. See Hall, "New Ethnicities"; also his "Minimal Selves" in *Identity: The Real Me, Post-Modernism and the Question of Identity*, pp. 44–46, and "Cultural Identity and Diaspora," in Rutherford, ed., *Identity*, pp. 222–237.
109. A similar space has been philosophized by William Desmond, *Desire, Dialectic, and Otherness: An Essay on Origins* (London and New Haven, CT: Yale University Press, 1987). He coins the term "metaxalogical" view, a space that goes beyond dialectics of a Hegelian *Aufhebung*, grounding a positive plurality where "each of whose members is rich in its distinctive identity, and whose mediation is not only self-mediation but also *inter*mediation" (pp. 7–8). See also Ella Shohat and Robert Stam, *Unthinking Eurocentrism: Multiculturalism and the Media* (London and New York: Routledge, 1994).
110. Hall, "Cultural Identity and Diaspora," p. 235.
111. Bahbha, "Commitment to Theory," p. 32.
112. Bahbha, "The Third Space," p. 210.
113. Michel de Certeau, *The Practices of Everyday Life*, trans. Steven Rendall (Berkeley: University of California Press, 1984).

114. See Bill Ashcroft, Gareth Griffiths, and Helen Tiffin, *The Empire Writes Back* (London and New York: Routledge, 1989).
115. Shohat and Stam, *Unthinking Eurocentrism.*
116. Michael Geyer, "Multiculturalism and the Politics of General Education," *Critical Inquiry*, vol. 19 (spring 1993): 499–531.
117. Ibid., p. 531.
118. This perception is changing, however. Michael Ondaatje, born in Colombo, Sri Lanka, and now living in Canada, has achieved an international reputation with his recent book, *The English Patient* (Vintage Books, 1992), which was awarded the prestigious Booker Prize that same year.
119. Sun-Kyung Yi, "An Immigrant's Split Personality," *Toronto Globe & Mail*, 2 April 1992, "Facts & Arguments," p. U1.
120. Ibid.
121. Ibid.
122. Ien Ang, "On Not Speaking Chinese: Postmodern Ethnicity and the Politics of Diaspora," *New Formations*, no. 24 (winter 1994): 1–18.
123. Hamid Naficy, *The Making of Exile Cultures* (Minneapolis: University of Minnesota Press, 1993).
124. Geyer, "Multiculturalism and the Politics of General Education," p. 531.
125. Barbosa, "From Gauguin to Latin America," p. 55.
126. Bahbha, "The Third Space," p. 213.
127. Jane Flax, "Multiples: On the Contemporary Politics of Subjectivity," *Human Studies*, vol. 16 (1993): 39.
128. Julia Kristeva, "Women's Time (1979)," in Toril Moi, ed., *The Kristeva Reader* (New York: Columbia University Press, 1986), pp. 187–213.
129. See Hamid Naficy and H. Teshome Gabriel, eds., "Discourse of the Other: Postcoloniality, Positionality, and Subjectivity," Special Issue, *Quarterly Review of Film and Video*, vol. 13, nos. 1–3 (1993), especially Christine Anne Holmlund, "Displacing Limits of Difference: Gender, Race, and Colonialism in Edward Said and Homi Bhabha's Theoretical Models and Marguerite Duras's Experimental Films," pp. 1–22.
130. Gayatri Spivak, "Gayatri Spivak on the Politics of the Subaltern: Interviewed by Howard Winant," *Socialist Review*, vol. 20, no. 3 (July–September 1990): 81–97.
131. Douglas Crimp, ed., *AIDS: Cultural Analysis/Cultural Activism* (Cambridge, MA: MIT Press, 1988), and "Portraits of People with AIDS," in Lawrence Grossberg, Cary Nelson, and Paula Treichler, eds., *Cultural Studies* (New York and London: Routledge, 1992), pp. 117–133.
132. Tessa Boffin and Sunil Gupta, eds., *Ecstatic Bodies: Resisting the AIDS Mythology* (London: Rivers Oram Press, 1990).
133. Cindy Patton, *Inventing AIDS* (New York: Routledge, 1991).
134. Paula Treichler and Lisa Cartwright, eds., "Imagining Technologies, Inscribing Science," Special Issue, *Camera Obscura*, vol. 28 (January 1992).
135. James Miller, ed., *Fluid Exchanges: Artists and Critics in the AIDS Crisis* (Toronto, London, and Buffalo, NY: University of Toronto Press, 1992).
136. Ibid., pp. 71–72.

11 / Chiasmus—Art in Politics/ Politics in Art: Chicano/a and African American Image, Text, and Activism of the 1960s and 1970s

Freida High

The 1960s and early 1970s marked a critical epoch in the history and cultural production of African Americans and Chicano/as of the United States. It was a time of indelible struggles for identity, representation, and power that shook the structures of an exclusionary democracy. Within that epochal storm, art and politics shifted in chiasmus as an optimistic youth overlaid their forces atop those of older generations and, through divergent strategies and groups, collectively, mobilized with action and production to materialize a new order of thought. Moving through spaces of contestation, artists among that youth (and some among the older generations) collaborated with others to negotiate and process identities, representation, and their own sociality through agency that transgressed borders and boundaries of difference in the translation of themselves in struggle for change. In many ways, despite the longevity of their existence in the United States, African Americans and Chicano/as occupied spaces of borderlines, boundaries, and interstices, where they moved (and continue to move) in flux away from social colonization, yet always in transition and translation, which Homi Bhabha identifies as "the *element of resistance* in the process of transformation."[1] It is in the process of cultural difference, or multiple specificities of African Americans and Chicano/as, that struggle of the tumultuous sixties made an unprecedented impact. An examination of the activism and the art of that activism through the notion of chiasmus will allow us to go beyond conflated references to that art as mere ideological reflection to recognize its agency as rupture and enunciation that significantly spearheaded the tumultuous period that changed the social structure and art of the United States then.

118

Though much attention has been given (separately) to the political struggles of African Americans and Chicano/as of that era, minimum attention has been given to the idea of their art as struggle, and none to my knowledge has considered the commonalities of art as struggle in the political activism of the two ethnic groups. This chapter proposes to do just that by exploring the ways in which art and struggle for those living/transgressing borders were one in the same in reverberations of chiasmus.

African Americans and Chicano/as were at the forefront of the monumental surge of political struggle that erupted throughout the United States in the 1960s. Therein they stridently constructed activism influenced by divergent enunciations, yet coalesing in desires for recognition and liberation from their perceived subjugated colonial status, the interstices, of their own country. Throughout the political storm, they produced ineradicable aesthetic forms that signified sites and signs of struggle implicating the internalization of the past in the present and a processual present that transcended its materiality for posterity.

I argue that the art resulting from that storm constituted struggle in struggle: As such, it was not part of a separate artistic movement that paralleled a political movement, as is often stated;[2] rather, it was a critical aspect of a complex multipolitical/cultural renaissance wherein art and politics were a one-in-the-same structure that shifted internally in chiasmus. The primary character of the art of that period was an inextricable regenerative aspect of struggle formed by words and images of visual potency that shifted with other strategies materially and socially. Such similarities, in artistic forms and purposes, occurred among African American and Chicano/a artists as a consequence of commonalitites in their histories and struggles in a democracy wherein they were marginalized, disenfranchised, and economically subjected; the emergence of cultural commonalities was a consequence of parallel and interactive enunciations to negotiate the self from the interstices of migrancy, from the peculiar sites of displacement caused by enslavement and colonization. That peculiarity, overlaid by agency, desires, and activism for the enunciation of self-determination, is what connected those two major "minority" groups as they negotiated cultural representation and social representation in spaces that they perceived as theirs.

For Chicano/as, borders crossed them through the Treaty of Guadalupe Hidalgo (1848), wherein the United States annexed land in Mexico after continuous conflict and war. Territory lost by Mexico became the U.S. states of California, Arizona, Nevada, Utah, New Mexico, and Texas, and areas of Colorado, Oklahoma, and Wyoming.[3] African Americans had crossed borders, through forced migration, some two centuries earlier to develop land of subjugated others (Native Americans) for dominant others (Europeans). Given their histories, African Americans and Chicano/as were linked

psychologically in political quests to dismantle borders that excluded them from what they perceived to be a country that was rightfully theirs. They were also linked in positionality by the conflict of their own cultures (language, religious beliefs, orality, etc.) with that of the dominant powers; hence, they, similarly, had to negotiate culture in hostile surroundings.

Similarities in the form and purpose of Chicano/a and African American art nested and resonated in the visions and ideals of iconography and iconology that collaborated in circulating transgenerational cultural values replete with the flux of self-identity, self-affirmation, and self-determination as defined and redefined by African American and Chicano/a producers. The alternations of art as politics and politics as art mediated those values and variably facilitated representation through struggle. I support my argument throughout this discussion by considering the following questions: What were the particular visual sites and signs that emerged during that turbulent decade of demand? How did they process into the storm through which they were articulated? What were their ephemeral and permanent correspondences, and how did they collectively and effectively engage dialogic imponderables resistant in struggle while asserting the ideals of a youth on the move for an inevitable social change? Such questions will take us onto discursive terrain beyond the limits of art history into the realm of cultural studies.

Though Americans of all ethnicities participated in massive social movements to normalize the ideals of a democratic United States during that agitated period of national unrest, African Americans, Chicano/as, Native Americans, and Asian Americans accelerated ongoing struggles to confront the socioeconomic inequities that they had encountered for generations. The vanguard role assumed by African Americans and Chicano/as is not surprising, given that they were the largest "minority" groups in the United States and had inherited the battle for equal rights from their ancestors (Africans and Mexicans). Moreover, they had continued to fight for a better America through civil rights struggles that were overlaid by new strategies asserted by the youth calling for "Black Power" and "Brown Power." For both groups, that period was one of heightened political activism that was dialectical to their specific histories and issues of racial and cultural difference in the United States. It was one wherein their vision and language (image and text) reaffirmed consciousness and identity as signifiers of struggle in struggle. Given the inextricable relationship between the visual form and other activism of each group, the phenomenon of chiasmus exploded onto the visual field suturing art in politics and politics in art. Visual form became central to political change, and political change became central to the cultural projection of visual form.[4]

As a literary term, "chiasmus" refers to the action of two parallel phrases

meeting and crossing, thus producing a shift in the meanings of those phrases; that is, the sense of the first phrase is reversed in the second.[5] In the first phrase of the parallelism "art in politics/politics in art," art assumes agency in politics; in the second one, politics assumes agency in art. Hence, chiasmus signifies the process of changeability in fluid, connecting interchanges.

The appropriation of the word "chiasmus" to the images and action discussed here is emblematic of the reversals in the multipolitical/cultural struggle of African Americans and Chicano/as of the sixties and seventies, since artists of both ethnic groups rejected pure painterly form in favor of illusion and language (image and text) to didactically engage their audiences,[6] and their audiences reciprocally engaged those images and texts. If there is any truth in Craig Owens's summary description of movements in postmodernism as an "eruption of language into the field of the visual arts" and in W. J. T. Mitchell's identification of postmodernism as an "explosive breakdown of that barrier between vision and language that had been rigorously maintained by modernism,"[7] then surely the art of Chicano/as and African Americans of that renaissance period, which epitomized those descriptions, was the fountainhead of postmodernism.

Rather than arguing the pivotal role played by the art of African American and Chicano/a artists in directing the postmodern turn, however, I am more interested in exploring the ways in which graphics, murals, painting, and other forms, through image and/or language, alternated in chiasmus with social action to reconstruct cultural projection coherent to the politics of self-determination. I will show that the particular chiasmus, or the alternating crossover, from art in politics to politics in art was preeminent in the turbulent struggles of the 1960s and 1970s among African Americans and Chicano/as. Second, I will demonstrate that self-representation was foremost in that phenomenon, since self-definition and self-determination were the guiding principles of Chicano/a and African American political struggles that were grounded in the enunciation of a negotiating nationalism. Third, I will show that vision and language, image and text, operated interactively with self-perception to construct self-representation; hence, as artistic form/visual culture, they were critical aspects of political struggle. Finally, I propose that the given chiasmus was inextricable to Chicano/a and African American cultural practices that rejected boundaries between "popular art" and "fine art," artists and politicians, religion and dance, and art and life. The erasure of such boundaries within African American and Chicano/a communities, particularly during the given epoch, problematizes the separation of art from politics. By exploring the various propositions, I will reveal specific material manifestations that characterize the multipolitical/cultural renaissance as a struggle of affirmation and resistance, as a sweeping peak in a slow climb from Plato's mythologized cave, to Martin Luther

King's mountaintop and Cesar Chavez's soaring *huelga* (strike) eagle that resonated with optimism through the currents of a raging storm.

CHIASMUS: WORDS-IMAGES IN ACTIVISM/ACTIVISM IN WORDS-IMAGES

Through images, words, and activism during the 1960s and 1970s, a Chicano/a and African American post–World War II generation, filled with optimism and emancipatory agency, advanced a radical political movement that incessantly confronted racial exploitation, war, and global inequities.[8] Words and images (art) erupted in struggle (politics) and struggle erupted in words and images to project the ideals of a youth intent on disrupting hierarchical systems in the streets and institutions of the United States to negotiate self-representation and power.

Amid those flows, Chicano/a and African American artists produced an art of theatricality that resonated with meanings of self-determination. Influenced by its spatial and temporal materiality, that art constituted agency that intervened in the struggles of it producers[9] as it negotiated Chicano/a and African American consciousness, experience, identity, representation. Visual and other cultural forms, through images and words, performed what Tomas Ybarra-Frausto identifies as a credo to "educate and edify" in a "freedom call" to "conscience and consciousness."[10] They projected meanings in mass demonstrations, on windows and walls of local businesses, and in community centers, churches, homes, and other architectural structures, in their enunciation of visual codes of change.

The "freedom call" projected by the arts was an aspect of that alternating call to mass action that was variably evident in the strategies and activities of organization. A brief discussion of that action is critical to understand the attitudes and concerns of that younger (and older) generation as civil rights struggles intensified toward militancy during the sixties. While older generations engaged political struggles through caucuses, strikes, and other activity to challenge discriminations in schools, automobile plants, transit unions, and agribusiness,[11] the youth, impatient with their elders' tactics of legalism, emerged with new processual identities ("Afro-American" and "black" rather than Negro, and "Chicano/a" and "brown" or "bronze" rather than "Mexican American") to distinguish themselves from their perceived conservative elders. They simultaneously developed new organizations with divergent objectives and activities to affect social change. But regardless of the "newness" proclaimed, youth groups operated on the foundations of centuries of experience and an "amalgam of individuals and organizations" with common pride, identities, commitments, and desires[12] that made them closer to those elders than they would believe, though in greater opposition (less assimilative) to institutions of power.

In their activism, that younger generation emerged nationwide to chart new directions. The National Association for the Advancement of Colored People (NAACP), the Congress of Racial Equality (CORE), and the Southern Christian Leadership Conference (SCLC) were among the organizations that had provided many African American youth and others with their first political experiences. For Mexican American youths and others, particularly in the Southwest, the American League of United Latin American Citizens (LULAC), the Mexican American Political Association (MAPA), the Political Association of Spanish-Speaking Organizations (PASSO), the G.I. Forum, and the Community Service Organization (CSO) were among the organizations that had initiated them into political activism.

Nevertheless, that younger generation's discontent with what they perceived to be a multiplicity of failures in ongoing civil rights activism was firm, and they wanted to mobilize to avoid failures and problems of the past: for example, Mexican American failed efforts to retrieve land lost in the Treaty of Guadalupe Hidalgo; Mexican American cotton, pecan, and mining strikes of previous decades that led to killings, jailings, and deportations; abuse of contemporaneous migrant workers; educational systems insensitive to the Spanish language; arrests and photographing of Mexican American striking farmworkers; and Texas Ranger brutality, among other atrocities in the Southwest.[13]

Many were particularly frustrated by passive-resistant direct action wherein thousands of demonstrators who marched against "separate but equal" facilities in the Southeast were exposed to brutal acts of violence, both within and outside of the "law": unleashed dogs on protesters by police officers; demonstrators forced down in the streets by blasting water hoses aimed by firefighters; the beating of "Freedom Riders" who rode desegregated buses and the burning of those buses; physical abuse of participants in sit-ins; and so forth. They were also disturbed by, among other atrocities, the firing of people from jobs and the foreclosing on mortages for registering to vote, the pelting of demonstrators with bottles and rocks, and the outright murdering of leaders and young field-workers.[14] And though the youth had adopted Dr. Martin Luther King Jr.'s position that struggle in the street had greater impact than in the courts and the ballot box,[15] given the disenfranchisement of people of color and their exclusion from the courtrooms during the 1950s and early 1960s, they had become impatient with the "nondefensive" strategic methods for justice that appealed to the national conscience with little effect. Essentially, the youth rebelled against the slow processes of change within Mexican American and African American efforts to gain economic and political parity and against the hostility that surrounded them in exclusive, social regimes of power.[16]

By structuring their own organizations, Chicano/a and African American youth saw that they could set their own priorities, utilizing self-defined

strategies. The Mexican-American Youth Organization (MAYO), the Lowndes County Freedom Organization (LCFO), La Boina (or the Brown Berets— "serve and protect"), Las Mujeres Muralistas (Chicana muralists), the Student Nonviolent Coordinating Committee (SNCC), black student unions, the Black Panther Party for Self-Defense, Where We At (black women's organization), Afri-COBRA (the African Commune of Bad Relevant Artists), the African and African-American Cultural Organization (AACO), and hundreds of other organizations in communities, colleges, the workforce, and other institutions throughout the country represented a generation surfacing the tides of democracy to redirect struggles for social equality.

Such organizations developed plans and actions coherent to the needs of urban and agrarian communities. Collectively, they challenged poor living conditions of Chicano/as and African Americans; that is, poor housing, inadequate education, exploitive working conditions, exploitive pay, voting rights, land rights, outright physical abuse and intimidations by Euro-American racists, and border patrol abuse, among other issues.[17] Chicano/a youth, moreover, engaged in activism that challenged the abuse of the farmworker, confronted Texas Ranger brutality of Chicano/as and others, and moved to control their communities by campaigning for Chicano/a representatives who ran for public office and by supporting the movement to reclaim Mexican land in the United States that had been annexed in the Southwest.[18] Many were particularly stimulated by the land rights activism of Alianza Federal de Mercedes, founded by Reies Lopez Tijerina in New Mexico,[19] and by the voice/vision of politician-poet Rodolfo "Corky" Gonzales, a prominent figure in Chicano/a nationalism who emerged in the mid-1960s and who founded the Crusade for Justice in Denver, Colorado, in 1966, which organized the First National Chicano/a Youth Conference in May 1969. Gonzales's poetic text *Yo Soy Joaquin* (I am Joaquin) became a seminal work of Chicano/a nationalism.

African American youths became particularly involved in challenging segregation in the Southeast and racism in the Midwest and elsewhere. They introduced "sit-ins" in the South (the first one initiated by four students of Negro Agricultural and Technical College in Greensboro, North Carolina, 1 February 1960),[20] which moved demonstrations into the interior of racialized, exclusionary, "white only" facilities, such as restaurants, libraries, universities, and hotels.[21] Those youth were members of the SCLC.[22] Many participated in "Freedom Rides," for example, initiated by CORE in 1961, which checked and countered segregation of interstate bus travel in Alabama and Mississippi.[23] Other activities included voter-registration drives and pickets. Malcolm X and Stokely Carmichael became seminal figures/icons for black self-determination, Black Power. Beyond confrontational projects, members of both groups organized other nurturing programs such as breakfast programs (Black Panthers) and artistic-educational programs that fed dignity and power

to the mind. Those involved in the latter were Afri-COBRA members, who produced prints for "the black community" in Chicago, and members of La Raza Graphic Center in San Antonio and the Royal Chicano Air Force in Sacramento,[24] who produced prints for El Movimiento (the Chicano/a movement) and various aspects of the Black Power movement. Given the wide range of transgenerational activities that emerged from different subject-positions—whether assimilationist, nationalist, or other—African Americans and Chicano/as engaged collective yet divergent forms of activism to direct greater control over their lives and conditions. Visual form infused that activism, penetrating consciousness and giving plastic permanence to the affirming subject-positions of solidarity.

Literary critic Larry Neal, in referring to the artistic currents among African Americans, characterized them as "the Black Arts Movement . . . the aesthetic and spiritual sister of the Black Power Movement," observing that as the latter sought to liberate black people from racial oppression, the former attempted to free them from "Euro-Western sensibility."[25] Lerone Bennett concurred with Neal, separating art from political struggle to identify a "double revolution": "a revolution in the streets and a revolution in symbols, images and ideas—a revolution in the word, of the word."[26] Bennett expounded that "the two revolutions unfolded at the same time and were complementary facets of the same reality: the historical explosion of a people in the sudden labor of self-discovery, self-determination and self-legitimization."[27]

Although I agree with Neal and Bennett that the turbulent unrest of the sixties constituted "revolution," I reiterate my disagreement that there were two revolutions (one in art and another in politics) and alternatively repeat there was *one* complex revolutionary dynamic wherein art and politics were inextricably united (an argument that goes against the camps of nationalism). This view is critical because, beyond its recognition of the importance of the art-politics struggle of that epoch, it calls attention to art's inextricable agency as struggle. Without the persistent enunciation of the visual art struggle that continually excited consciousness beyond physical endurance of lived conditions, the multipolitical/cultural struggle would not have existed, for political struggle without vision *and* visuality becomes impotent. Given the cultural projection of struggle through symbols, images, and ideas on posters, murals, paintings, dress in the streets and elsewhere, it is apparent that art was not separate from, but inextricably infused in, revolution. Rebellion infused art, which reversed in chiasmus. Such reverberation prompted an observant Hoyt Fuller to comment that the "Negro revolt is as palpable in letters as it is in the streets."[28] Indeed, the letters and streets were a one-in-the-same revolution that was constituted in revolutionary words, images, and struggle in the streets, churches, community centers, homes, and elsewhere.

SIGNS, SITES, AND INSIGHTS OF STRUGGLE

Within the theatricality of revolutionary activism of both ethnic groups, visual signs and images loomed large amid political events to encode messages of group identity, solidarity, and collective action with self-affirmation and rebellion.[29] Artists were critical to the invention of signs, sites, and insights of struggle. Their words and images did not emerge from passive reflection, but from active participation in struggle to analogically imprint permanence through vision and visuality. In addition to producing visual forms and performances, among other works, artists gave permanence to ideas by contributing to the writing of manifestos and to the circulation of words-images (knowledge) in diverse contexts. They were centrally integral to politics. For example, Luis Valdez (performance artist and director of El Teatro Campesino, which he founded in 1965) wrote "The Plan of Delano" (California) in September of 1965,[30] during the collaborative strike of the National Farm Workers Association and the Filipino grape pickers in California. The plan launched a call for unity against oppression of the farmworker as it "proclaimed the beginning of a social movement."[31]

Though the political struggle of farmworkers of the Southwest had been ongoing and had been formally organized in 1962 by Cesar Chavez and Delores Huerta, the mid-1960s marked a new character with the involvement of students who were highly inspired by the power and commitment of Cesar Chavez, the union director. Valdez also projected signs through El Teatro Campesino, wherein he and his company of performance artists embodied revolution in *actos* (plays) that corresponded to the demands of plans that he and others wrote. He, like other youth (especially students) and elders (especially farmers), culturally projected the political ambience of *"Huelga!"* ("Strike!") and *"La Causa"* ("The Cause") in various contexts through posters, performances, dress, paintings, and so on. Cultural forms, as Jose Angel Gutierrez observed, were critical to capturing and presenting the spirit, emotion, and vision of "collective consciousness" in Chicano/a "ideology."[32]

Words (language) and images (pictures) intervened in the oppressive conditions of the lives of African Americans and Chicano/as with a summons for social activism. The words, "Freedom Now," "Viva La Raza," "Brown Power," "Bronze Power," and "Black Power" were among texts that consistently appeared on posters, murals, and other visual forms, corresponding to verbal articulations that resounded in meetings and demonstrations. Signs shifted in medium, flowing from bodily action, to word, to image, as exemplified in the movement of the clenched fist motif towering above the head of a living body, to the words "Black Power" on a placard, and to the painted black fist motif on the same placard or assimilated into a mural. Such shifting conveyed the same message, and such repetition gave mental, permanent

presence to particular signs and images. Other signs also acquired eminent status: the *huelga* eagle, the Egyptian pyramid and ankh (cross), and the images of La Virgen de Guadalupe (Madonna), Malcolm X, Che Guevera, Mao Zedong, the campesino (Chicano farmer), and other ordinary people. Their meanings signified solidarity by suturing the heroic and the ordinary, the real and the spiritual, the local and the global, the past and the present, man and woman, Mexican and Chicano/a, African American and African, and all Third World peoples—a hybridity in identity of transnational character that enunciated a psychological and physical battling of colonialism. Particular empathy was held for Vietnam, colonized African countries, Mexico, and other nations that fought to be free of Western imperialism.

African Americans and Chicano/as consistently criticized not only the Vietnam War, but also the irony of disproportionately high numbers of African American and Chicano soldiers drafted and killed in service of their oppressive government. This point is illustrated in Roland L. Freeman's photograph of black students demonstrating in Washington, D.C., in 1969 by carrying a casket filled with the names of black soldiers who were casualties in Vietnam (Figure 11.1). It is also evident in a photograph of Chicano demonstrators whose poster shows disproportionate statistics of Chicanos serving and dying in a war that they reject (Figure 11.2). Manuel Gomez comments on this view as he speaks about the Vietnamese: "They are not my enemy but brothers involved in the same struggle for justice against a common enemy. We are all branches of the same tree, flowers of the same garden, waves of the same sea."[33] These signs and poetic voices signified hybrid, migratory struggle shifting in chiasmus in resistance to a justice system fraught with contradictions.

Words and images on posters juxtaposed messages of group desire and cultural identity as they displayed collective ideas, icons, and symbolic color schemes. A poster/banner held by a demonstrator at the Chicano/a and Delano grape boycott demonstration, for example, displayed both the word ("Viva La Raza") and the image (the *huelga* eagle) to signify group solidarity in support of fair labor conditions and wages for the farmworker. Icons were also displayed without words, and words without icons, as apparent in the consistent display of the religious image of La Virgen de Guadalupe, an omnipotent symbol among Chicano/as. Figure 11.3 pictures such a banner of the Virgin, commanding a prominent position among other symbols to enunciate multiple significations: Chicano/a presence, identity, cultural/religious beliefs, and resistance to the Vietnam War. In this context, the icon visually articulates struggle as it occupies a site of struggle. Shifra Goldman and Tomas Ybarra-Frausto point out that the Virgin of Guadalupe and the *huelga* eagle flag in red, black, and white were prominent in virtually every Chicano/a demonstration and procession.[34]

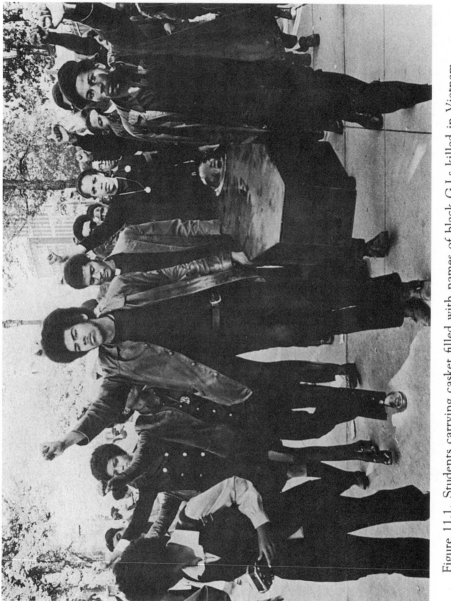

Figure 11.1. Students carrying casket filled with names of black G.I.s killed in Vietnam, Washington, D.C. Photograph by Roland L. Freeman, 11″ × 14″, silver print, 1969. Reprinted with permission of the artist.

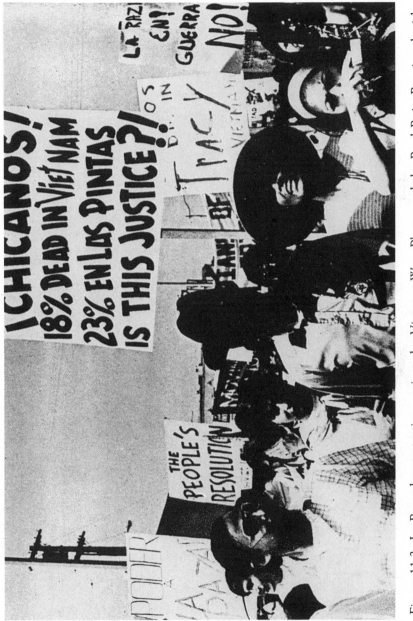

Figure 11.2. La Raza demonstration against the Vietnam War. Photograph by Raul Ruiz. Reprinted with permission of the artist.

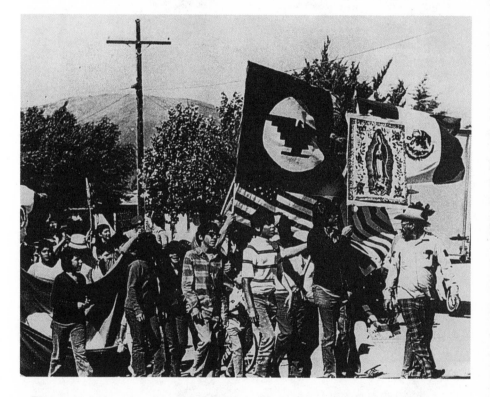

Figure 11.3. A prominent display of La Virgen de Guadalupe and the *huelga* eagle flag.

As sign, La Virgen de Guadalupe merits particular consideration given its preeminence. The Virgin, a religious icon, patron saint of the Catholic Church, is the single most potent religious, political, and cultural image of the Chicano/a and Mexicano/a today, according to Gloria Anzaldua.[35] An icon of mixed heritage—Native American and Spanish (a mestiza identity), a heterotopia who is both conquered and conqueror—the image moves in flux across the divisions of religious belief, class, race, language, nationality, and sexuality to embrace Chicano/as as a spiritual symbol of suffering and despair with hope, faith, and power.[36] As patron saint and defender, the Virgin is regarded as all powerful. Belief in her power is illustrated in the appearance of her image in many contexts beyond the church, in homes, on automobiles, during political demonstrations, on the backs of prisoners, in paintings, and so forth. (This sign/figure is addressed in greater detail in my discussion of the work of Yolanda M. López later in this chapter.)

As in Chicano/a struggle, words and images produced by African American and other minority artists lunged from the surfaces of banners, posters, murals, and other media to culturally project visions of self-determination among an African American youth. Signs were not arbitrary, but selected with purpose. The icon of a black panther, for example, which symbolized black power, was selected by the SNCC (the civil rights youth group initially associated with Dr. Martin Luther King Jr.) because of its strength and perceived defensive character; the panther "is reputed to be an animal that never makes an unprovoked attack but will defend itself vehemently when attacked."[37] As a symbol of the LCFO political party of Alabama (a branch of the SNCC), it reiterated black power at the voting booth, a site of power where people of color in the United States have long been disenfranchised. The SNCC had confronted efforts of the Ku Klux Klan, plantation owners (for whom many African Americans worked), and institutional racism by urging intimidated African Americans to register and vote, and the panther was displayed prominently to mentally invoke power and the SNCC's political participation.[38] The panther's symbolism corresponded to the subject-position espoused by Stokely Carmichael and other burgeoning black nationalists who collaborated for equality, mutual respect, solidarity, and racial pride with emphasis on "black consciousness" and black power;[39] it signified that nationalists were prepared to defend themselves or strike back if struck.

The panther icon spread nationwide in correspondence to the expansion of the youthful Black Panther Party. It was consistently displayed on buttons and other formats by Panthers and non-Panthers to demonstrate solidarity with Black Panther ideology, which challenged police brutality and other forms of oppression as it instituted social programs in black communities; particularly popular was the breakfast program for children. Flags bearing

the image of the panther, displayed at demonstrations such as the Free Huey Newton rally in 1968,[40] signified solidarity as they evoked the aura of black power confronting institutional racism and the extension of self-help community action into the public sphere of the justice system at the borders of conflict.

In addition to presentation on banners, posters, prints, paintings, and murals, these preeminent signs appeared in publications such as the United Farmworkers Union's biweekly, bilingual newspaper El Malcriado: La Voz del Campesino/The Voice of the Farmworker, particularly in the form of cartoons featured in these publications. Andrew Zermeno, for example, cartoonist for El Malcriado, invented figures that he consistently depicted to raise consciousness about hegemony through satire: Don Sotaco, the underdog; Don Coyote, the labor contractor; and Patroncito, the boss—folksy characters as cultural enunciations of struggle.[41]

The juxtaposition of cartoons in popular media with other forms of art debunked the separation of various categories of art, in addition to conveying sociopolitical messages. Posters and cartoons appeared, for example, with images of engraved calaveras by Mexican printmaker Jose Guadalupe Posada (1852–1913), which simultaneously conveyed satirical political statements, invoked Mexican traditions of communication, and recalled celebratory rituals of Dia de Muertos (day of the dead).[42] Works of Los Tres Grandes (David Siequeros, Orozco, and Diego Rivera) and Frida Khalo, heroized by Chicano/a communities, were culturally projected with contemporaneous events of struggle and historical narratives. Similar cultural projections among African Americans appeared in group newsletters and popular magazines such as Ebony, Jet, and Black World, especially this last wherein black poets and visual artists consistently presented their work and thought. The given juxtaposition of words and images of such different types of cultural production in the same format reveals the holistic regard for art among these peoples.

MEMORY, REPRESENTATION, AND IDENTITY: MURALISM

Through vision and language, Chicano/as and African Americans negotiated an entire social milieu perceived through memory, experience, and a network of learned signifiers to refigure identity and representation.[43] Although Chicano/as and African American enunciations cited difference, similarities were apparent in the materiality and sociality of their existence, production, self-representation, and self-determination, which were underscored by the dialectics of affirmation and resistance that pervaded their activism. Similarities implicated the objective of each group to gain control over their bodies/minds amid hostile regimes of knowledge and practice in racialized capitalist systems that subjugated people of color.

Representation was critical to struggle, and struggle critical to representation, during the sixties and seventies. "Representation," as Griselda Pollock in Foucaultian terms points out, is not merely a word for "picturing, depicting imaging, drawing, or painting," but conceptually suggests social relations "enacted and performed through appeals to vision, management of spaces and bodies for a gaze."[44] Its currency is in its exchanges, mutual references, constant productivity, and relay of signs that construct power through social relations.[45]

African American and Chicano/a representation of the 1960s and 1970s signified heterotopic self-perceptions and the enactment of solidarity in the negotiation of power relations.[46] Representation in the visual form generally constructed new heterotopic identities that looked back to a perceived ancient, preslavery African American and pre-Columbian Chicano/a heritage of dignity, yet simultaneously looked to the contemporaneous nurturing and oppressive social conditions of the producer—identities of hybridity, of flux. It was primarily directed toward the gaze of an audience with shared values, though it challenged the gaze of those who commodified black and brown representation as the stereotyped "other" in the subjugation-fetishism of capitalism.[47]

Representation is inextricable to memory and vision, for it is through memory and vision that one sees, perceives, experiences, and interprets the world and objects in the world. Memory as medium facilitates the subject's "seeing" and processing of the self in the world. Mitchell's discussion of memory underscores its preeminence in one's negotiation of existence and identity. As he explains, "Memory, in short, is an imagetext, a double-coded system of mental storage and retrieval that may be used to remember any sequence of items, from stories to set speeches to lists of quadrupeds."[48] In elaborating, he observes that the classical memory technique is the reconstruction of "temporal orders by mapping them onto spatial configurations," especially "architectural structures, with various 'loci' and 'topoi' or 'memory places' inhabited by striking images and sometimes even words."[49] His elucidation of memory underscores its psychological and historical value to the mediation of representation, given that it is also "a way of mapping an oral performance, an oration from memory, onto a visual structure."[50] Orality is critical to the history of African American and Chicano/a culture, and orality overlaid by the visual gives permanence to "reality" and to the representation of reality.

Muralism was a monumental medium for representation. As an artistic movement, muralism mediated cultural memories and constructed "memory places"[51] wherein it enacted representation through processing fluid-identity and history of self-affirmation and resistance. Identified as the most important, widespread, cohesive, and publicized aspect of the Chicano art movement

during the seventies,[52] and critically significant to the black art movement of the late sixties and seventies, murals enacted political struggle as they transformed dull, exterior walls of architectural structures in Chicano/a and African American communities into these memory places. They culturally projected the fire of dignity and self-determination in representation that mediated past and present crossing multiple borders of struggle. "Walls with tongues," Victor Sorell calls murals, and though they cannot engage the audience as the artist can in the flesh, they "can be didactic, discursive, and performative all at once."[53] While their subject matter offers insight into history and contemporary issues, murals themselves are offered sites to negotiate memory, identity, representation, and, through them, struggle.

Muralism of the sixties was spearheaded in 1967 by the production of *The Wall of Respect* (Figure 11.4), painted by the Visual Art Workshop of the Organization of Black American Culture (OBAC). OBAC consisted of scholars, artists, musicians, dramatists, and performance artists; all were political activists. The idea spread throughout the country, primarily in urban areas. Though initiated during that epoch by African Americans and produced by people of all ethnicities, no group surpassed the output of Chicano/as, and no area was more inundated with the impact of the movement than California. Timothy Drescher informs us that of the murals located throughout the state in Los Angeles, Berkeley, and Oakland, among other cities, those in San Francisco constituted "the highest per capita mural output in the world":[54] some 445 in a population of 700,000. Los Angeles has approximately 2,000 murals in a population estimating three million, the largest overall number of murals in California. And the largest population of people of Mexican descent in the country, and outside of Mexico City, live in Los Angeles.[55]

Though emerging in the late 1960s and growing out of the mobilization and struggles of the Chicano and Black Power movements, the mural movement continued into the 1990s because of a number of factors, including the political consciousness of community, available funding, collaborative interests of artists, and social atmosphere. Their production and longevity signify their value to their communities.

The murals of the turbulent epoch had precedent in the Mexican Mural Renaissance between 1920 and 1925, which had tremendous influence on the development of muralism in the United States during the time of Franklin Roosevelt's New Deal projects (i.e., the Works Projects Administration) in the depression era.[56] Mexican socialist theories that were manifested in monumental, socially conscious, public murals by David A. Siqueiros (1896–1974)[57] and Diego Rivera (1886–1957)—the latter who defined art as a "weapon"[58]—were particularly influential. These works were especially important to Chicano/a artists, but also to African American artists such as

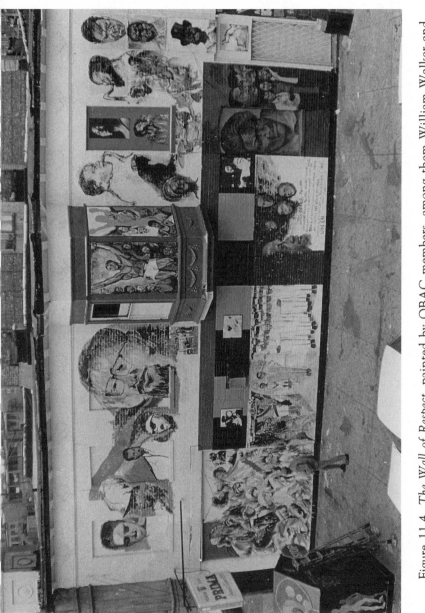

Figure 11.4. *The Wall of Respect*, painted by OBAC members, among them William Walker and Jeff Donaldson, Chicago, 1967. Photographed by Roy Lewis in 1973 as *The Original Wall*. Reprinted with permission of the photographer.

Charles White (1918–1979), who, in addition to being exposed to Mexican murals in the United States, had an opportunity to view them when he first traveled to Mexico in 1946. White, whose work was published in *Ebony* and discussed within the theme of dignity, had tremendous influence on the African American sixties generation (as did Elizabeth Catlett, Romare Bearden, John Biggers, Jacob Lawrence, and others who were exposed primarily through black media). Furthermore, for African American artists, the murals of Hale Woodruff (1900–1980) of the Atlanta University complex were very important, as were the murals of Harlem Renaissance artist Aaron Douglas (1899–1979). Mexican, Chicano/a, and African American artists derived pleasure from producing an aesthetic form imbued with dialogic iconography. Through such work, they enacted call-response-call enunciations constitutive of mutual subject-positions, aesthetic values, and desires to redefine themselves and their borders.

A critical aspect of those enunciations was hybridity in representation. Chicano/as looked back to traditions in Mexico, reclaiming pyramids, sculpture, murals, and mythology of the ancient "constellations of nations": their ancestral Toltecs and Aztecs in the reinvention of the self. In what appears to have been a civilizing nostalgia, Chicano/a muralists, like other Chicano/as, produced politicized cultural statements by reinscribing memories of others' memories in a constructed mytho-history that was real in their perceptions. It was also real in terms of heritage, conquest, and their site of liminality that longed for visibility, particularly one enunciated in the greatness of "what was" to resist the subjugation of the "what is" and to migrate into the emancipatory site of "what will be."

Aztlan was a cornerstone in Chicano/a representation during the turbulent epoch, and it continues to be so today. Aztlan is Mescaltitlan, the legendary place of Aztec or Mexican origin.[59] It is "a geopolitical signpost for a glorious empire . . . a territorial point of rebirth."[60] In finding Atzlan in the memories of memories, Chicano/as found memory places—temples and natural geographical formations—that marked representation of identities: Aztec civilizations of their identities before their mestizo transformation. They discovered memory places of their origin, the great ancient city of Tenochtitlán, "the place of the nopal Cactus,"[61] and its center, the Templo Mayor, with its visual culture/records of history, politics, and religion; they found the more ancient topos of Teotihuacán, the city or "place where one may become a god."[62] They discovered, through those memory places, the thought of their ancient heritage, ideas about "man's place in the cosmos and in human society,"[63] wherein they located the origin of their own humanity. Therein they also discovered brown men and women, gods and goddesses (e.g., Coatlicue) of power, who were venerated. Preeminent is the sun king Huitzilopochtli, whose motif invokes ancestral roots in the

sun god who had ruled the Aztecs from 1397 to 1417; Huitzilophchtli's protective forces guaranteed the continuity of Aztec life.[64] He was the god of "war, the sun, the daytime and fertility."[65] The symbol of the sun was therefore adopted to signify identity. And the symbol of the eagle was adopted to signify resistance, for in Aztec mythology, the eagle devours the snake as a sign of triumph in struggle and marks a new home for the wandering Aztec. Cesar Chavez, for example, used the eagle for the United Farmworkers Union (UFW) as a "symbol of Chicano triumph over injustice."[66]

In their discoveries, Chicano/as redefined themselves in name and in representation. Chicano/a signified *patria* (native land)/Mexican heritage and *familia* (family) that spanned borders, and collective power to self-define and self-direct. Carlos Munoz Jr. explained that such changes among Chicano/a youth represented their criticism of racial and class oppression in the United States, as well as "a return to the humanistic cultural values of a Mexican working class" in their rejection of assimilation and in their search "for a new identity and for political power."[67] Ybarra-Frausto, in discussing the thought of Chicano/as during that era, observed that it was one of "introspection, analysis, and action."[68] Influences were evident in monumental scale, in the warm palette of Mexican aesthetics, in social realist themes that spoke to the people, and in Mesoamerican themes in Mexican art. Octavio Paz observed that the Mexican muralist movement was the first American answer to the long monologue of European art.[69] On this score, one might consider the contemporary movement among Chicano/a and African American artists as an answer to their particular objectives to refashion the self and locate a home for the self, as well as a possible answer to the distant abstract art of the United States in the sixties.

The historic *Wall of Respect* (see Figure 11.4) produced in Chicago (1967) and another at El Teatro Campesino (farmworkers' theater) in Del Rey, California (1968) painted by Antonio Bernal (Figure 11.5) are two seminal memory places of the 1960s renaissance that signify the Black Power and Brown Power movements; that is, movements of militant civil rights struggles that sought "proper representation and sharing of control" for African Americans and Chicano/as in the political process of modernity.[70] The effectiveness of the murals in summoning communities to meet in the public sphere before the memory place, in fact, is evident in the spread of muralism throughout the country and its role as a site for collective enunciation and collaboration in various activities ranging from its production to its consumption through meetings, festivals, mournings, and so on.

Murals engendered encouragement through iconography that represented transgenerational struggle, rebelliousness, and dignity in words and images. This iconography depicted heroic and self-deteetermined figures and symbols of the past and present. For Chicano/as, indigenismo was critical to the

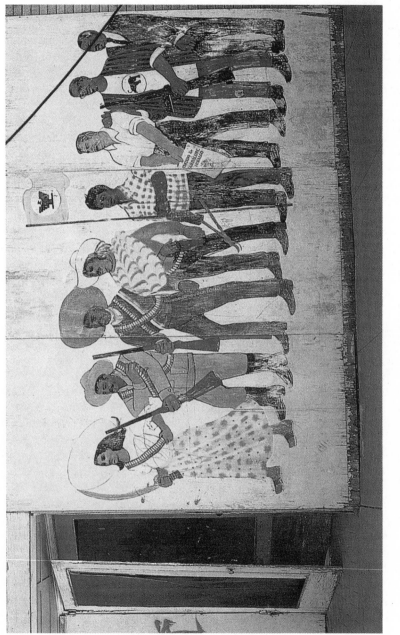

Figure 11.5. The Wall of Respect by Antonio Bernal at El Teatro Campesino headquarters in Del Rey, California, 1968. Reprinted with permission.

construction of representation in murals and other forms. Amalia Mesa-Bains calls attention to the preeminence of *indigenismo* to Chicano/a aesthetics through which representation was invented, delineating its qualities as follows: (1) *Palabras*—the affirmation of cultural reality through resistance that requires the practice of self-naming and recognition of origin and historical figures; (2) *Obras*—the recognition of cultural practice such as healing and ancestral honor; and (3) *Memoria/Futura*—recognition of border culture, the particular place where one stands with all of its challenges.[71] These points recall Bhabha's notions of transition and translation. Given murals' significance to sight, as sites of insight that negotiate memory, identity, and representation, their importance and proliferation throughout the country, especially in the Southwest, becomes understandable. Their value by far surpassed the notion of art form for aesthetic contemplation, though surely this notion is inextricable from the process as a whole. As a locus for negotiation, the materiality of murals stimulated contemplation, dialogue, and activism.

Murals raised consciousness by taking minds through specific histories and reiterating aesthetic orientations that collaborated in transmitting messages of mobilization for political change, particularly in urban areas where they towered above the "masses" as sites of meetings, cultural events, and protests. Alan Barnett observed that murals exposed "the racism, sexism, and economic exploitation of our society and helped bring people together to overcome them."[72] Essentially, the reversals in the revival of murals stimulated by political activism,[73] and the political activism of murals that raised consciousness to reclaim identity and self-defense, constitute a phenomenon of chiasmus.

In discussing the dynamics of such exchanges within El Movimiento, Carlos E. Cortes outlined the following qualities of the movement that stimulated visual artists, performers, poets, strike leaders, and farmers: pride in Mexicanidad; dedication to enhancement of Chicano culture; desire to improve the socioeconomic position of Chicano people; and commitment to constructively changing "American society."[74] Through such stimulation, the exchanges, in turn, variably stimulated activism, functioning in a "triad of conservation, struggle, and invention."[75] According to Ybarra-Frausto, artists "organized, wrote the poems and songs of struggle, coined and printed the slogans, created the symbols, danced the ancient rituals, and painted ardent images that fortified and deepened understanding of the social issues being debated in Chicano communities."[76] They addressed a diversified audience: the wealthy businessperson, the civil rights worker, the farmer, the grandmother, the *pachucho*, the *loco*, *la mujeres*, gang members—all of whom experienced and participated in the collective activism of group solidarity to improve their social conditions.

Throughout the nation in African American communities, artists similarly intervened in society with murals, as well, culturally projecting images and texts that coalesced with the summons of preeminent black nationalists, such as that of LeRoi Jones (Amiri Baraka), which called for art "with a message of revolution," and that of Ron Karenga, which called for that message to speak to "Mose the miner, Sammy the shoeshine boy, T. C. the truck driver, and K. P. the unwilling soldier";[77] in other words, the grass roots of the community. (I should note that Karenga did not include "Dorothy the hairdresser" or "Mattie the waitress," which is consistent with the gender problem of nationalism.) Artists were predominantly already creating/producing aestheticized activism though visual forms of various types. Many of their works, like the voices of Jones and Karenga, issued a call that stimulated consciousness and action, invoking heterotopic identities through the juxtaposition of icons of past and present, signifying the process of people "becoming" new consciousness in flux through divergent, spatial-temporal orders; a transient identity-enunciation, though somewhat romanticized and sometimes problematically flowing in essence/s. Through new consciousness, nationalist subject-positions perceived shared identity indicative of feelings "tied to a certain world."[78] Nationalists articulated connections through linking sensoriums, as espoused by Leroi Jones, Amiri who announced, "We are our feeling. We are our feelings ourselves. Our selves are our feelings."[79] Through their feelings and collective desires, artists of various subject-positions spoke to their audience in iconography of revolution that simultaneously looked to a mytho-historic past laden with symbols of dignity in civilization and to a destructive present characterized as oppressive and potentially genocidal. Their audience reciprocated in discourse with shared values, though not without ideological and strategic disagreement.

Issues of struggle are evident in the discussions of Afri-COBRA artists, who, at their very first meeting (14 June 1967) as part of the Visual Art Workshop of OBAC, articulated shared values of art, particularly those regarding representation. They perceived art as cultural expression that was "useful as a weapon," for building self-esteem and for stimulating revolutionary action.[80] Collectively, they collaborated and produced the first *Wall of Respect* on the south side of Chicago at 43rd and Langley. It was a monumental theatrical performance of dignity that articulated representation through historical and contemporary subject matter, projecting unity between images of human, spatial, and temporal divergences. The artists collaboratively reached back into time to locate the image of W. E. B. Du Bois ("the black prophet") and juxtaposed it with that of Muhammad Ali ("the black champion,"[81] a national icon of power and resistance due to his boxing championship and refusal to fight in Vietnam). Other popular figures pictured included singer Nina Simone, saxophonist John Coltrane, Malcolm X (the

contemporaneous prophet of black nationalism), poet Gwendolyn Brooks, student leaders Stokely Carmichael and Rap Brown, and historian Lerone Bennett. The engaging iconography shouted unity in its historical signification and proclaimed oneness with "the black community." Bennett announced that the wall marked a significant breakthrough in "legitimizing black culture and black history" at a location "where it should be—in the midst of the people—as opposed to being in a museum or a special, out-of-the-way place."[82]

The wall's images resonated with text: "THE WALL OF RESPECT" appeared beneath the representation of Ali, and was centered on the surface of the building. African American popular magazine *Ebony* announced that the wall's artists "directed their genius to the community of their roots" and essentially told the community, "Our art is yours, you are us, and we are you."[83] The wall called out to the people through shared memories of persistence and struggle, and the people called out to one another to make more memories of struggle and self-determination. Jones wrote a text/poem that summoned an "S.O.S., calling black people, wherever you are," and the people responded to the call from around the nation; so did thousands of others who made a sojourn to the Chicago memory place of former slaves and kings. People received knowledge from the wall and were activated by it. Don Lee/Haki Madhadbuti, for example, viewed the creation, then wrote "The Wall," screaming out in the parks, schools, and all across the nation:

> . . . a black creation
> black art, of the people,
> for the people,
> art for people's sake
> black people
> the mighty black wall . . .
> our heroes, we pick them, for the wall
> the mighty black wall/
> about our business, blackness
> can you dig?.[84]

Jeff Donaldson, one of the OBAC artists, observed that the wall attracted many individuals and groups during and after they had painted it. Musicians from the Afro-Arts Theater in Chicago played as the artists painted, and dancers and singers performed; "the air was charged with the heady ambience of camaraderie, confidence, and courage," though the OBAC group subsequently became splintered by tensions when the wall attracted FBI agents and undercover Chicago police who disrupted the collective.[85] Donaldson cites infiltration by J. Edgar Hoover's National Counter-Intelligence Propaganda Campaign as the cause of the splintering that disrupted and destablized the group, given its mission to dismantle "subversive," "radical," and/or "un-American" activities.[86] The power of *The Wall of Respect* as

subversive speech to hierarchical regimes of power brokers, however, was potent, and it was effective in calling black communities to action through affirmation and through generating many other such memory places and artworks that may not have reached the wall's monumental stature, but were nevertheless important.

Representation in *The Wall of Respect* emerged from memories of historical figures of African ancestry in the United States who signified self-determination consistent with the persistence of contemporaneous pockets of revolution that burst through urban areas—Watts, Detroit, Chicago, among others—that responded violently to the Vietnam War, to civil rights struggles, and so forth. It also recognized divergent religious and secular groups and ideologies, encouraging them to unite in solidarity.

Dana Chandler's *Knowledge Is Power, Stay in School* (Figure 11.6) responded to *The Wall* in a dialogue of mutuality, as it expanded the discussion to include the value of Pan-African linkages in the power-knowledge paradigm. Chandler's mural synthesizes African masquerade with images of revolutionary leaders, symbols of nationalism in form and color, and a map of the United States. The text—, "Unite: Education"—is critical to the signification of social values in the ladder to power in America.

The mural is a monumental, symmetrically balanced composition structured in curvilinear and angular form that is harmoniously accentuated with organic polyrhythmic shapes. Its horizontal format is united by horizontal shapes and lines and a red, black, and green color scheme. Dominated by greens, the work is punctuated by its complementary red and by contrasting black maps, pyramids, and fists that are accented by zigzag-like lines suggesting fire or lightening. The central area is most commanding, partly because of its location, but also because of the tremendous amount of agitation in multiple configurations and the sharply contrasting white oval form. This iconography, a cracked egg forced open by the numerous human figures bursting upward from within, metaphorically enunciates childbirth. Chandler notes that it speaks of blacks bursting from the white racism of capitalism. Close inspection reveals African Americans of diverse roles—the soldier, firefighter police officer, tennis player, and mother, among others—overshadowed by a prominent, youthful, militant-looking figure whose extended forms evoke the crucifix. Is the central Christlike figure the sacrificial warrior sent to educate, unite, and liberate/emancipate the black community? Is it he who is helping them escape the confinement of racist-capitalist subjugation? Is it he who links African Americans with their African relatives, as might be suggested by the extended arms connecting encircled, flaming, blackened continents?

Flanking the Christlike figure on either side of the composition are masculine figures of monumental scale who suggest political identities: Malcolm X and another. The surrealistic figure on the left side of the composition

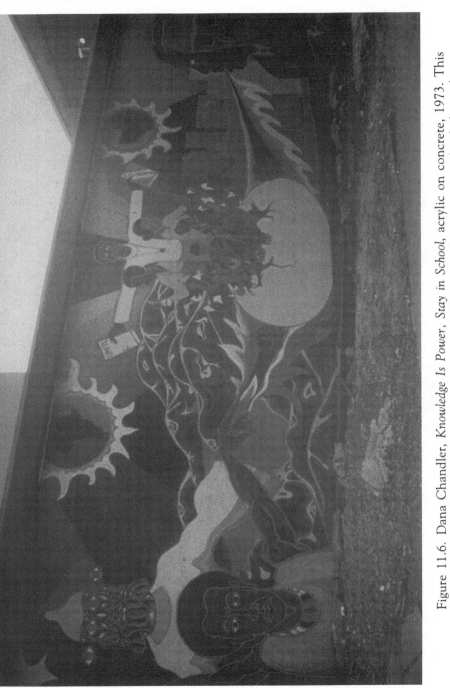

Figure 11.6. Dana Chandler, *Knowledge Is Power, Stay in School*, acrylic on concrete, 1973. This moral represents the artist's way of encouraging children of color to stay in school, for without knowledge, Chandler states, there can be no real power. Reprinted with permission of the artist.

who towers behind and above the figure in the foreground suggests an African spirit, particularly because of its proximity to the continent and tripartite facial character, thus linking real to mythological. The natural landscape, emphasizing land and water (nature), on the left and the cityscape on the right suggest the connection between the two spaces, political rhetoric of having one's own land and control of one's living spaces and destiny. Is control suggested by the extended arms and fingers (the Creation), which send black fists to crack the egg of conquest? The emergence of fist icons from the head and hand of the figures on either side perhaps emphasizes the mouth and hand as liberatory tools and the ethics of education (head) and work (hands). The background to the action consists of bold, diagonal areas of colors and rhythms that provide flat, angular designs allowing the eye to rest from the continuous rhythms of the mural's format.

Overall, this striking, monumental work has enduring aesthetic power that shouts revolution while commanding thought. The gaze searching the power and beauty of its form could easily become so enraptured that it could fail to notice the shabby environment in which one stands to experience it. Yet, in responding to the call, one is bound to interrogate the structures of the environment and their causes upon moving back through those spaces. As Chandler speaks to the community about the significance of unity and education, he educates and encourages unity through the process. As a memory place, the mural is also a consciousness-raising site that stimulates one to consider her or his own subject-position. Such a painting engages issues of struggle, identity, and representation and, in this way, is similar to the concerns of Chicano/a murals. I should note the great emphasis on males in this work, a typical characteristic of nationalist processes. There were some murals done by women during this epoch, but at the time, men dominated the movement among the African American and Chicano communities.

The earliest recorded Chicano/a mural was produced in Del Rey, California, on the exterior wall of El Teatro Campesino headquarters by Antonio Bernal, as mentioined earlier (see Figure 11.5). It was produced in two panels, one representing pre-Columbian "Bonampak-like" rulers (of ancient Maya) and the other representing revolutionary figures. The various figures are derived/mythologized from memories of indigenous pre-Columbian figures, memories of revolutionaries of Mexico, and of the Chicano/a and Black Power movements. Shifra Goldman points out that as the mural movement picked up momentum, significant events were occurring across the country such as massive student protests and the formation of MALAF, a group of four key muralists (Manuel Hernandez-Trujillo, Malaquias Montoya, Esteban Villa, and Rene Yanez).[87] Political activities in support of farmworkers and others, as discussed earlier, were ongoing. Hence, murals were interactive with

currents of activism in various forms as they incessantly enlivened the activism through representation.

Representation in the Del Rey *Wall of Respect* depicts eight historical subjects, all wearing dress that suggests their characteristic personality. From left to right, they are: "La Adelita," a nameless revolutionary soldier and the only female in the composition; Francisco "Pancho" Villa and Emiliano Zapata, who were revolutionaries against an oppressive Mexican dictatorship; Joaquin Murieta, a victim of theft and a murdered wife during the westward movement of Manifest Destiny, who transformed into a revolutionary after the given atrocity; Cesar Chavez, the monumental figure of the United Farmworkers Union and seminal icon of the Chicano movement, though he maintained that he was a unionist rather than a nationalist; Reies Lopez Tijerina, who challenged the dishonor resulting from the Treaty of Guadalupe Hidalgo of 1848 and led the land grant movement in New Mexico; an African American man wearing a shirt with the panther emblem; and Dr. Martin Luther King Jr., foremost figure of the civil rights direct action camp. Goldman identifies the man next to King as a Black Panther, and Sorell speculates that he may be Malcolm X or another prominent leader. But given that all the other subjects represented are dressed appropriately to their character—and that Malcolm X usually appeared in public dressed in a suit and, furthermore, that Panther members wore black outfits with black berets—the man could be neither. I suggest that he is probably a generic, young, black revolutionary empowered by the knowledge of Malcolm X and the defensive drive of self-determination of the Panthers. He may signify the youth leadership of the Black Power/civil rights groups, perhaps the SNCC, whose symbol was a panther—the same motif on the figure's shirt that peers between his open dashiki-type shirt.

The objects in the hands of the mural's subjects are symbols that convey the activism of those represented. All have guns except King, who extends a large hand, and Tijerina, who carries a newspaper to expose injustice. A flag bearing the *huelga* eagle flies above the head of Chavez, and all the figures are united on a common ground line, which suggests solidarity without hierarchy, and in their common directional movement. This mural calls out encouragement to farmers, students, and ordinary people of the community. As a constructed memory place, it educates onlookers about a heritage of struggle and encourages a future of self-determination. The mural is politicized by its subjects, and the subjects politicize the community, the audience—hence the similarity between the two walls in Chicago and Del Rey and Chandler's mural.

Structurally, this *Wall of Respect* is painted on three panels on the exterior wall of the building. The rendering is flat and linear, with outlines delineating forms and patterns of clothing. Bold reds strikingly stand out in

areas of the clothing and particularly in the *huelga* flag, which occupies a prominent place as it towers above the subjects' heads. The display of weapons, symbols, the flag, and a newspaper explicitly renders the figures revolutionary, reiterating the stance of Malcolm X who articulated, "Freedom by any means necessary" and the activism of older revolutionaries who fought for freedom by every means necessary. Even King's empty hand symbolizes power in its size. The monochromatic light color in the background lends unity to the figures while it simultaneously enhances their boldness by contrast, thus the subjects are as visible in the composition as they were in actuality.

Bernal's mural is unique in its multipolitical representation. The diversity of figures from Chicano/a, Mexican, and African American (passive-resistant and militant) history reveals the border crossing of Chicano/as in their struggle for liberation and, moreover, a collective envisioning of a diversified community of color linked in activism for self-determination. I am unaware of any such work done by African Americans in that period; African American murals then tended to link the United States with Africa.

In looking back to an African heritage, African Americans discovered Egyptian pyramids, palaces of Benin, Nigeria, and slave castles, this last perceived as the beginning of their debasement. Pyramidal memory places took them through memories' memories into the origins of civilizations of humanity. Palaces opened doorways to visual testaments of intelligence, wealth, and leadership: in royal Benin, bronzes depicting heads of kings and queens; in Asante (Ghana), royal kente cloth woven with philosophy; and in Egypt, hieroglyphs, plaques, and other regalia (that) signified control of the written and pictorial image-text—loci of transgenerational knowledge. Such findings reinforced familial nurturing as they negated socially dominating Euro-myths of inferiority deeply embedded in experiential memories. Chandler's work displays African imagery in its map motif, its deity/masquerader/ spirit figure, and its subtle pyramidal structure, thus projecting symbolical references to an affirmed African heritage and associational power. It is a formal and iconographical enunciation of political struggle: It materializes political struggle, and political struggle materializes it.

Mexico and Africa became memory places that empowered political struggles of Chicano/a and African American youths as they made sojourns to those sites; but those visits were not entirely new experiences since many had visited their "homelands" before in the form of their African and Mexican identities that had remained within the memories, culture, and politics of those ethnic groups since their very beginning, in spite of migrations—or in spite of the migration of borders. In any case, memory and memory places resoundingly activated affirmation and struggle, and the discourse of sojourn to memory places proliferated among the youth and older generations. They continue to do so today.

African American and Chicano/a artists engaged memories as they encountered existential realities of social conditions circumscribed by regimes of power that subjugated, fragmented, and distorted their lives and traditions. Hence, the dualistic tendencies of self-affirmation and resistance against forces of subjugation tended to prevail, garnering heterotopia and hybridity. Both factors contributed to the transgenerational activism of each group and to the proliferation of social unrest that emerged through memory, invention, and collaboration.

As Pollock reminds us, art consciously produces ideology, history, and psychology wherein "worldviews, definitions, and identities are constructed, reproduced, and even redefined."[88] The visual forms of Chicano/as and African Americans retrieved memories in juxtaposition with perceived ideals of heterotopic desires to construct representation that redefined themselves and their perceived world. The control of representation meant control of images and words, or image-texts, giving credence to self-perception and self-determination. Representation by Chicano/a and African American youth was constructed on the synthesis of memories of a historical and romanticized past of Mexico and/or Africa and memories of a more recent colonial past marked by Euro-disruption, overlaid and dominated by memories of collective and personal experiences. In short, representation emerged from the consciousness of a body that constructed and received perceptions of a world of memories, memory places, and experiences that the individual fused through "time-space compression" and culturally projected according to the judgment of that individual's subject-position. Murals, prints, and other art forms projected representation as a critical aspect of political struggle; and in seeing representation, the audience was activated/politicized, mentally and/or physically, through the media of vision and memory.

SIGNIFIED STRUGGLE IN CIRCULARITY: ICONOGRAPHY ON THE MOVE

Unlike murals on architectural structures, prints, paintings, sculpture, and other forms of visual art circulated with great fluidity in the 1960s and 1970s. As evidenced by the banner of the Virgin of Guadalupe (see Figure 11.3) at the Vietnam moratorium and by the panther flags swaying at the "Free Huey" protest referred to earlier, works on small, two-dimensional surfaces circulated in political contexts, imaging struggle in struggle. By looking more closely at iconography, the particular meanings of struggle that it culturally projected will become clearer. Moreover, its effect as enunciation of struggle can be better understood.

The prominent raised clenched first motif that was discussed earlier signified defiance and self-determination and gained power as a critical sign

through its repetition. The fist, like other motifs utilized by Afri-COBRA (and other organizations), was balanced as image with text in order to successfully meet the objectives of the group's dictum to deliver messages to the people. In Barbara Jones's print *Unite* (Figure 11.7) (Jones was then a member of Afri-COBRA), the stiff towering arms with clenched fists are repetitiously arranged vertically with a degree of linear perspective. The perspectival movement of the crowd meets near the midpoint, as do the letters above it, though in nonalignment. The polyrhythmic effect of bold red, gold, and blue letters repeatedly delineating the word "UNITE" in reverse linear perspective is dynamic. The alternating rhythms reiterate the agitation of the figures in the crowd, establishing a harmonious interplay between figurative and geometrical form. Solemn and expressive black and brown faces, vertically extended clenched fists, and words resonate in tandem in the Afri-COBRA's aesthetics of free symmetry, mimesis at midpoint, visibility, luminosity, and bright colors with sensibility and harmony, recalling the canons of Yoruba aesthetics. The placement of the words above the heads of the crowd in such bold colors and commanding rhythms calls attention to the functioning of the text as language to be read and repeatedly shouted. The human subjects are commanding, self-consciously "black" with their Afros and in their gestures of solidarity (as defined by the epoch). Heads and fists emerge from areas of blackness that unite the figures. Highly contrasting bold black and gold colors produce an agitated and dramatic effect, evoking the mood of an emotional crowd engaged in struggle. The overall unity of the piece, with its pyramidal dynamics, is both aesthetically convincing and legible in text and symbolical values, right down to the details of the ankh earrings displaying Egyptian heritage. It is important to observe that black is used as a color, rather than as shading. Black as color is an aesthetic quality that is characteristic of much African American and Chicano/a art, though not all. The various other works discussed in this text illustrate this point.

Jones's fusion of word and image in this silk screen is typical of the Afri-COBRA movement of the late sixties and early seventies to produce art for the people. According to Jones, the group took the position that art could be a "liberating force" and coalesce to "uplift black life toward a common unity and destination."[89] The print, like many other works of this period, totally defies Greenbergian formalism that expunges texts and all references to meanings beyond the form itself.[90] The Afri-COBRA corpus used texts, human figures, and symbolical objects with extra-aesthetic purpose to send a summons other compositions conveyed messages such as "Wake Up," "Manhood," "Black Family," and "Homage to a Giant." As a call, such works met the communities in circulation, particularly in the homes of ordinary people. It reached them through the efforts of the artists, who actually took

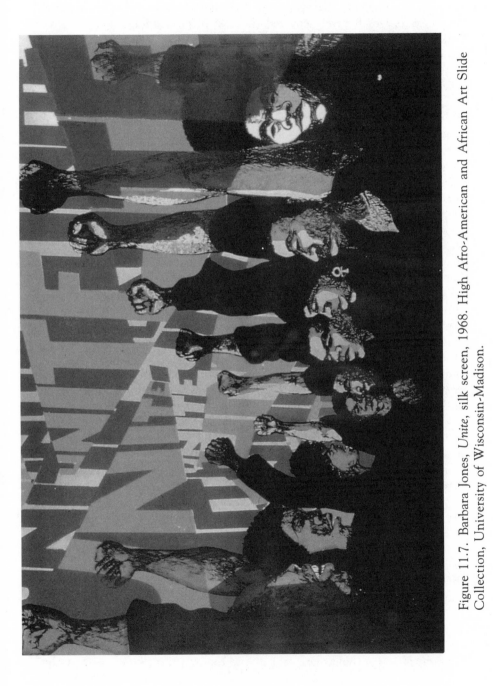

Figure 11.7. Barbara Jones, *Unite*, silk screen, 1968. High Afro-American and African Art Slide Collection, University of Wisconsin-Madison.

works to the doors of the people in the community and sold them for as little as $10, which barely covered the cost of production. Those original works, their function as struggle and their access to their audience, indicate the commitment and participation of the artists in struggle; education is the first step in struggle.

Whether used in a Jones print or in another Afri-COBRA print of stylized human bodies engaged in struggle, the fist motif invariably remained in the mental culture of public life during the critical epoch of demand. It spoke intertextually and intersubjectively, across age, gender, class, race, and nations. It is interesting to view this symbol of struggle for power in the sculpture of Elizabeth Catlett, who went to Mexico in 1946, and subsequently became a part of the fabric of Mexican life, though crossing borders to the United States through interpersonal communication and, occasionally, through physical presence. *Homage to My Young Black Sisters* (1968), a wooden sculpture, is particularly striking in its monumentality (Figure 11.8). The subject symbolizes women's participation in the global struggle against the subjugation of women of color, engaging the language of struggle in form, iconography, and iconology.[91]

Each work circulated in the scope of visuality, functioning as a call-response-call for activism and a rupture of oppression. The clenched fist, as a cultural icon, signified power and revolution as it shifted between art form and human form to challenge the incompleteness of democracy. Such icons by African Americans and Chicano/as represented aestheticized political agency. Their range of form from popular to fine arts imploded boundaries between art and politics while dismantling boundaries of categories in artistic production.

Paintings, like silk screens, posters, sculpture, cartoons, and other forms, depicted iconography of Chicano/a nationalist consciousness that alternated in chiasmus. Words and images of activism boldly enliven Salvador Roberto Torres's painting *Viva La Raza* (Power to the People) (Figure 11.9). The pictorial form of the composition displays expressive image-text iconography; its words literally speak to its audience. Its color scheme of red, black, green, and white is arranged in three wide, horizontal, parallel planes to offer stability to the activated *huelga* eagle in flight. A Chicano/a nationalist flag motif is invoked, though the work exhibits a highly painterly quality. Dominated by the red eagle image that is frontally spread against a white textural plane, it conveys messages in graffiti-like form similar to that found on the walls in the barrios. The bold red of the *huelga* image against the white symbolizes "the triumph over economic injustice by means of the farmworkers' union."[92] Its flat, painterly, modernist plane is particularly striking, and though the symmetry of the composition suggests calm stability, the variation of script (bold, dark text at the top and thin, lyrical text at the

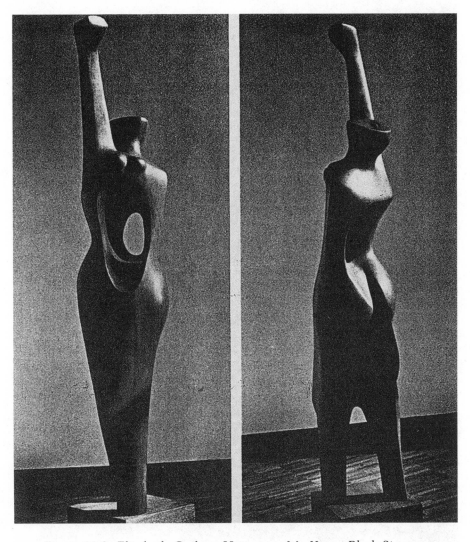

Figure 11.8. Elizabeth Catlett, *Homage to My Young Black Sisters*, cedar sculpture, 1968.

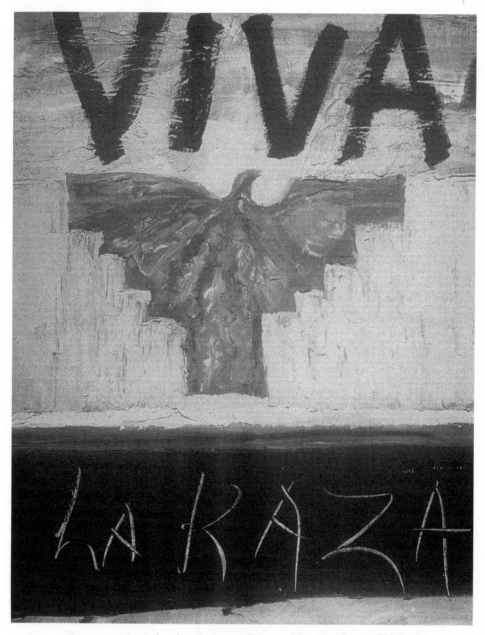

Figure 11.9. Salvador Roberto Torres, *Viva La Raza*, 53″ × 42″, oil on canvas, 1969. Collection of the artist.

bottom), in combination with the expressive brush strokes and dynamic color, incites rhythmical surface movement, effecting a resonant Chicano/a nationalist power and movement through symbolical representation.

The inscribed, digital words reciprocate with the analogical/pictoral image, both encoding a consciousness of Chicano/a struggle through slogan and pictorial symbolism. Image-text iconography links the painting to the popular poster, and both to the perceptions of Chicano/a identity and politics in support of El Movímiento. It should be pointed out that the symbol was popularized by the Chicano document "El Plan Espiritual de Aztlan" (The spiritual plan of Aztlan) presented at the First National Chicano/a Youth Conference in Denver in 1969, organized by "Corky" Gonzales. Manuel M. Martinez, an artist of struggle who worked with Chavez, Tijerina, and Gonzales, produced the design with Chavez in 1962 for the farmworkers when they decided the UFW needed a symbol.[93] Essentially, this work stands as a powerful modernist form, yet its extra-aesthetic political referentials defy modernist form-in-itself proscription. This work, like the others discussed, suggests the flux of thought emerging from shared perceptions, experiences, identities, histories, and desires, as it projects cultural values in symbolical forms of African American and Chicano/a communities that crossed the borders of media and spatial-temporal zones to unite in the negotiation of self-representation and power.

Though Torres's painting may be found in a gallery or museum, it refuses to hang quietly against a white wall in a Greenbergian, formalist mode with a life all its own. Alternatively, like many other works by Chicano/as and African Americans, it displays extra-aesthetic iconography that resonates with the iconology of Chicano/as voicing political desire. Its agency conjoins the prints, paintings, sculpture, banners, and other works around it that, just as easily as Torres's painting, move between the gallery walls and mass demonstrations; and regardless of the context, such works shift in chiasmus with meanings imbued with politics as they participate in struggle.

Although males dominated the production of these arts during the given epoch, and although they certainly received much more attention than did their female counterparts, women were producing works at this time as well. Judy Baca began *The Great Wall of Los Angeles* in 1967; Patsi Valdez worked in the performance group ASCO when they began in 1968 to produce satirical works; Faith Ringgold completed *Die* in 1967; Where We At, a group of black women artists, began in 1969; Las Mujeres Muralistas began to collaborate in San Francisco in 1974; and Betye Saar and many other African American and Chicana artists were outputting works. Yolanda M. López also emerged on the scene, producing a series of prints and drawings that challenged the conditions of her border experience, and reaffirmed identity stimulated by cultural and individual memory. One series of work that she

produced during the seventies that is particularly commanding thematizes La Virgen de Guadalupe and merits a special discussion given its aesthetic power and polyvalent character, which stimulates much thought about feminist struggle within political struggle, within national struggle—a multiplicity of borders to negotiate.

López constructs an inventive gaze of the monumental icon La Virgen de Guadalupe, re-representing the subject with an imaginative, feminist, critical eye. Unlike the conventional, calm, enduring, shrouded image of the Virgin that is preeminent in Chicano/a culture, López metaphorically utilizes the icon to culturally project women whom she knows, including herself. The subjects of her series of three compositions are "normal" women dressed in everyday attire and engaged in women's work; that is, the Virgin is transformed into portraits of López her mother, and her grandmother—three generations of Chicanas symbolized as icons of suffering and despair, hope, faith, and power: chiasmus, Chicana women in La Virgen and La Virgen in Chicana women.

Mesa-Bains points out that López's Guadalupes are feminine images that have the "potential to emancipate women" in their consciousness-raising action.[94] She describes them as "mobile, hardworking, assertive, working-class images of the abuela (grandmother) who is presented as a strong, solid nurturer, and her mother assumes the image of a family-supporting seam-stress, while Lopez, the daughter, emerges as contemporary artist and powerful runner."[95] The fusion of the sacred icon with secular Chicana women's experiences and roles as enduring, suffering, nurturing, hardworking mothers inscribes reality and critique. La Virgen as grandmother and mother are seated, the former holding the skin of a snake in one hand and a knife in the other as she stares out at the viewer. Has *abuela* skinned the snake to shatter the image of earth goddess in order to call attention to the goddess in herself? The mother sits diligently working on a mantle behind a sewing machine, though she is staring off into the distance. Roses are strewn along the ground. Does the mantle force the mother to labor, and why are roses scattered on the floor? Both women are encompassed by the *esplendor/mandorla* as expected of La Virgen. In this series, the grandmother sits on her mantle, the mother sews hers, and the daughter holds hers over her shoulder, allowing it to flap in the wind as she runs. Does the given movement of the mantle around the body of the figures suggest Chicana women's contemplation of their sociocultural positions and subsequent actions taken to free their bodies/minds/movement in the spirit of self-determination?

López's self-portrait in the series is entitled *Portrait of the Artist as the Virgin of Guadalupe* (1978) (Figure 11.10). It is the most popularized composition of the group and merits greater consideration here. The figure of the youthful Guadalupe emerges in dynamic action, unlike the enduring

icon. This image evokes a contrast between elder and youth, convention and change, which iconologically corresponded to the attitudes of El Movimiento. In this oil pastel on paper, the Virgin, through the figure of a young female subject (López), is transformed from the enduring, suffering, religious mother icon to an image of a youthful Chicana who, in her monumentality, emerges from the encapsulating, dark, oval sunburst *esplendor/ mandorla* in the background, running toward the spectator with long strides and an aura of victory. In her left hand, she holds one corner of a dark blue mantle that is draped over her shoulder, blowing in the wind, and in the other, she holds a serpent that also dangles in the wind; her lowered foot squashes a red, white, and blue cherub.

Though the image is open to interpretation, it appears that López's iconography constructs a multilayered social critique that simultaneously subverts/destroys Chicana women's subjugation and transforms a reclaimed Mexican heritage. Guadalupe, according to Anzaldua, assumes multiple identities among Chicano/as. She is at once the Indian Coatlalopeuh (Catholic diety Virgin), the Aztec Coatlicue (earth goddess, "Serpent Skirt"), and the Totonacs Tonantsi (goddess of crops, health, protective nurturing mother.)[96] The iconography invokes meanings that encompass diverse identities: La Virgen as enunciation (heterotopia, transnational, translation), as bordering world and otherworldliness, as mythology and political struggle, as Chicano and Chicana, as Spain, Mexico, and the United States. She is not a binary, but is process and negotiation. Emerging from the *esplendor/mandorla*, which is symbolic of the intersection of heaven and earth,[97] the Virgin descends to the earth, the realm of Aztec earth goddesses. Her pink, warm, earthly, feminine dress flys freely, blowing in harmony with the dismantled mantle and revealing her human flesh. Sun rays within the dark, oval-shaped *esplendor/ mandorla* radiate in contrasting, bright orange, wavy lines around her body, as if emitted by it. The dark mantle framing her body from behind is bordered in gold with gold starlike patterns that work in harmony with the subtle gold floral outlines in the pattern of her dress. Her departure from the two dark ovals behind her suggests a metaphor for birth. Has the spiritual Virgin become the Coatlicue, the earth goddess who dwells in the realm of earth goddesses?[98] Does her symbol, the snake, become a weapon? And, if so, is it to be used to conquer others or to protect herself, unlike Coyolxauhqui (Coatlicue's daughter) who was unarmed when killed by her brother, Huitzilopochtli, the sun and war god?[99] Or will she avenge Coyolxauhqui, whose head was decapitated and body dismembered by Huitzilopochtli who used *xiuhcoatl* (the turquoise snake) like a rope to do it?[100] Is she the transgressive woman of today, as Coyolxauhqui was of yesterday? Does she warn earthly women of the dangers of assuming roles of endurance, tolerance, pain; of making willing sacrifices, perhaps to the point

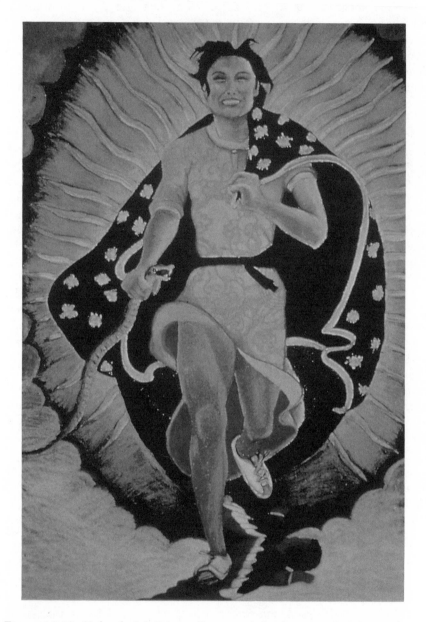

Figure 11.10. Yolanda M. López, *Portrait of the Artist as the Virgin of Guadalupe*, 32" × 24", oil pastel on paper, 1978. Collection of the artist. Reprinted with the permission of the artist and the Armand Hammer Museum of Art and Cultural Center, University of California, Los Angeles.

of becoming sacrifice like their female ancestors of Tenochtitlán (in reenactments of myth), whose sacrificial heads were discovered at Templo Mayor?[101] Is the *Portrait* a representation of Tonantsi offering the bird as sacrifice to enhance her ability to defend her people of Mexican descent, or is it a depiction of López smashing American democracy and hypocrisy (in the form of the red, white, and blue cherub) and throwing off Chicano patriarchy and machismo, as she continues her run toward freedom? Does López subvert and appropriate La Virgen to reconstruct her iconology in correspondence to Chicanas rejecting subjugation?

López's iconography appears to subvert the mythology and religious icon that is revered by Chicano/as. Sorell, however, calls attention to Angie Chanbram-Dernersesian's rejection of the removal of the mantle as meaning anything other than better movement, as she sees woman's role of endurance still in place in López's strong, nurturing, working women.[102] Interpretation opens interesting debates, for I disagree. The *esplendor/mandorla* allows greater movement, and the movement appears to be toward self-determination wherein Chicanas would control their own bodies and destinies.

López offers insight into this discussion. She observes that, though "La Virgin" is a religious and spiritual force, her power resides in her symbolism of Chicano/a national pride; and in her serenity, passivity, lifelessness in the realm of "magical mythology sanctified" within religious tradition; the Great Mother; a plastic representation.[103]

By embodying La Virgen in real lives of Chicanas, López calls attention to idealized representations of women whom she sees as meriting the kind of passion and honor bestowed upon the Virgin.[104] She commands respect through her self-portrait in her activism to take control of her life and her environment. López, as La Virgin, dismantles myth and moves as a real-type, rather than as a religious icon. As she subverts the latter, so does she intend to convert the eye to see the dignity in Chicanas' material lives and production.

The monumental quality of the figure and its stance in arrested motion effects a dynamic composition that is intensely excited by the brilliant pinks, reds, gold, and contrasting blues and blue-black. Within the compositional arrangement of symmetrical, organic, and decorative form, the subject iconographically defies the stability of formal arrangement, yet successfully effects order. López/La Virgen spans borders in hybridity, both saintly and earthly, smiling and killing, enclosed yet free; moving from past to present, from Mexico-Spain to California; from mysticism to feminism.

López's images, like those of Chicana writers, poets, and other artists, inscribe representations of women and others that offer perspectives of their own "realities." They correspond with poetic and theatrical work of Chicanas that, as Yolanda Gonzalez observes, go beyond the three or four female

roles found in Chicano representations of Chicanas: mother, grandmother, sister, or wife/girlfriend in the image of virgin or whore.[105] López's work also corresponds to Mesa-Bains's observation that Chicana artists culturally project subject-positions in inventive ways that go beyond the specificities of masculinist ideals.[106] And this action corresponds to the works of African American women who enunciate gender in diverse iconography, which in turn corresponds to their perceptions.[107]

López's work, like that of Torres, Barbara Jones, Chandler, and others, that circulates in galleries, community centers, homes, and museums projects subject-positions of individuals who move in flux with the shifting currents of time, never dislocated from cultural signifiers, always negotiating representation. Those works circulate as visual cultural media, analogically "a space of representation," that actively produce meanings through "social, semiotic, and symbolic procedures and imperatives"; they are critical aspects of a social discourse wherein exchanges among subjects are constituted and functioned.[108] Like other cultural forms of the sixties and seventies, they mediated beliefs, morals, customs, and vision through their cultural projection of perceptions of identity through self-representation. Given the intersubjectivity, intertextuality, and effectiveness of those forms in the epoch under discussion, in meanings, values, and functions, their multidirectional flows spearheaded, and were spearheaded by, the activism of a youth on the move for social change.

CONCLUSION

During the turbulent period of political activism in the 1960s and 1970s, memory, visuality, and activism mediated the sociality of art, and the sociality of art mediated memory, visuality, and activism in the art of African American and Chicano/a political struggle. Art and politics shifted in chiasmus as the post–World War II youths of the two dominant "minority" ethnic groups of the United States initiated action to reclaim their bodies, histories, images, rights, and destinies. Art was not separate from political struggle during that era, but was in struggle, as struggle was in art, reverberating nationally in *one* monumental phenomenon: a multipolitical/cultural renaissance that circulated visual form as struggle in sites of struggle to offer insight, in a call to fight. That renaissance was self-affirming and resistant, moving in flux as enunciation, as hybridity; always in transition and translation; processing identity and representation in borders, as borders, and across borders to dismantle oppression in the racialized, capitalist regime of power that subjected African Americans, Chicano/as, and other people of color globally.

In reviewing the dynamics of that epoch, it is clear that struggle occurred through memory, through signs of identity (past and present), in

human action, and in object action. Visual culture circulated as paintings, posters, sculpture, performances, and other media in the discourse of struggle for political change. The similarities in the development of Chicano/as and of African Americans that occurred during that time were not coincidental, but were the consequences of phenomena related to similar heritage and socioeconomic positions in the United States, affected by frustration with the failures of legalism and by a self-preserving drive to remake the self and a society for that self according to self-defined ideals.

In retrospect, some of those commonalities can be clearly delineated: (1) Members of both groups were nurtured by specific cultural traditions and aesthetics in the form of oral, musical, and visual culture, which they retained through memories' memories and which they engaged with didactic theatricality, rather than distancing; (2) members of both groups experienced oppressive social conditions relative to their identities within a hierarchical, racialized, capitalist economy; (3) many members of both groups were committed to collaborating in political strategies to change their conditions; (4) many in both groups reclaimed, reinscribed, and reinvented ancient mythology, flowing through the process of "becoming" from past to present, via indigenous heritage "memory places," to an array of conditions that they mediated through vision and representation—a hybridity in flux; and (5) members of both groups, through their consciousness and bodies, perceived that they were "tied to a certain world"[109] that required an aestheticized struggle.

In general, such developments marked the twentieth-century peak of a monumental "cultural war" that has been ongoing in North America and Mesoamerica since the invasion of the Americas by Europeans; that is, since Christopher Columbus entered Florida in 1492, since Hernán Cortés entered Tenochtitlán (Mexico) in 1500,[110] and since the Dutch brought the first Africans to the British Virginia colony in North America in 1619 (twenty black "indentured servants").[111] The cultural projections of the sixties emerged nationally through rupture, circulating collective struggle against an oppressive dominant system that constantly pulled African Americans and Chicano/as into domains of subservience within the capitalist system. Art in struggle and struggle in art, chiasmus, constructed new possibilities for the potential reconstruction of a democracy wherein both groups could articulate desires and representation in the negotiation of new spatial-temporal orders. African American and Chicano/a activism of the 1960s and early 1970s made a resounding impact at the voting booths, in the school systems, in the challenge to labor practices, in the reconstruction of words and texts indicative of the self, as defined by the self. Murals, posters, paintings, and performances—visual culture—constructed mental power through material permanence; they announced political struggle as struggle to dismantle

marginalization, disenfranchisement, and fragmentation of peoples on the move for processing the ideals of democracy. The divergent materials and subjects represented in the arts enunciated those ideals, and those ideals enunciated those works.

NOTES

The research for this paper began under the tutelage of Professor Tom Cumins (Latin American specialist), Professor of Art History at the University of Chicago, during the winter quarter of 1995, subsequent to a course that I took with him on the imperial art of the Aztec and Inca in autumn 1994. I continued the research for this paper during the spring quarter of 1995 under Professor Cumins and art historian Professor Victor Sorell (Chicano/a specialist), during which time I studied Chicano art with Professor Sorell (in a course of the same name) that he taught at the University of Chicago as a visiting professor. Professor Sorell is also Professor of Art History at Chicago State University. I wish to express my utmost appreciation to both professors whose expertise critically challenged my thought about contemporary Chicano art, the ancient Aztec and Mexican heritage, and critical theories of modernism and postmodernity. I also wish to extend my appreciation to Professor W. J. T. Mitchell and Professor Reinhold Heller, also art history faculty of the University of Chicago. With the former, I studied theories of visual culture and postmodernism, and with the latter, I studied modernism. All four professors have significantly offered me regimes of knowledge within critical approaches that have refreshingly stimulated and expanded the boundaries of my thought; and to each one, I am indebted. Any errors or lack of depth in this chapter, however, are entirely of my own making. Special thanks to Afro-American Studies, University of Wisconsin-Madison (Ford Foundation Grant), University of Chicago (Special Trustee Grant) and American Association of University Women (Retraining Grant).

1. Homi K. Bhabha, *The Location of Culture* (London: Routledge, 1994), p. 224.
2. Addison Gayle, *The Black Aesthetic* (Garden City, NY: Doubleday & Co., 1971); Mary Schmidt Campbell, ed., *Tradition and Conflict: Images of a Turbulent Decade, 1963–1973* (New York: The Studio Museum, 1985.)
3. Patricio Chavez, "Multi-Correct Politically Cultural," *La Frontera/The Border: Art About the Mexico/United States Border Experience* (San Diego: Centro Cultural de La Raza/Museum of Contemporary Art, 1993), p. 7.
4. Richard M. Merelman, *Representing Black Culture: Racial Conflict and Cultural Politics in the United States* (New York: Routledge, 1995), p. 3. In discussing "cultural projection" in relation to black culture, Merelman defines it as the conscious or unconscious "effort" of a social group and its allies to present "new" images of itself before other groups and the public. Self-fashioned images of cultural projection place positive representation within and beyond the "borders" of the group. Its agency is self-affirming and negates stereotypes. Cultural projection, according to Merelman, does not represent the culture of the entire group since it does not contain the complexities, nuances, and conflicts within a culture. It does, however, project a simplified, selective, cultural representation as defined by the collaborators on the projection.
5. Joseph Childers and Gary Hentzi, eds., *Columbia Dictionary of Modern Literary and Cultural Criticism* (New York: Columbia University, 1995), p. 42.

6. See W. J. T. in Mitchell, "*Ut Pictura Theoria*: Abstract Painting and Language," in *Picture Theory: Essays on Verbal and Visual Representations* (Chicago: University of Chicago, 1994), pp. 213–239. In elaborating the theoretical problems of literature and modern art, Mitchell explains that in addition to expunging literal representation, modern art also sought to exclude any reference to literary ideas; its objective was pure form. This goal differs from the historical tendencies of the art of African Americans and Mexican Americans, though there are many exceptions.

7. Ibid., p. 217.

8. See August Meier, Elliott Rudwich, Francie L. Broderick, eds., *Black Protest Thought in the Twentieth Century* (New York: Macmillan, 1971). Also see, Carlos Munoz Jr., *Youth, Identity, Power: The Chicano Movement* (London: Verso Press, 1989).

9. Griselda Pollock, *Vision and Difference: Femininity, Feminism, and Histories of Art* (London: Routledge, 1988), p. 160. Pollock reminds us that "within specifiable conditions of production and consumption," art is influenced by and intervenes in its conditions; that art is constitutive of active agency relative to its spatial and temporal materiality and sociality.

10. Tomas Ybarra-Frausto, "The Chicano Movement/The Movement of Chicano Art," in Ivan Karp and Steven D. Lavine, eds., *Exhibiting Cultures: The Poetics and Politics of Museum Display* (Washington, D.C.: Smithsonian Institution Press, 1991), p. 128.

11. William L. Van Deburg, *New Day in Babylon: The Black Power Movement and American Culture, 1965–1975* (Chicago: University of Chicago Press, 1992).

12. Carlos E. Cortes, "Mexicans," in Stephan Ternstrom et al., eds., *Harvard Encyclopedia of American Ethnic Groups* (Cambridge, MA: Belknap Press of Harvard University Press, 1980), p. 717.

13. Elizabeth Martinez, ed., *500 anos del Peublo Chicano/500 Years of Chicano History in Pictures* (Albuquerque, NM: Southwest Organizing Project, 1991).

14. John Hope Franklin and Alfred A. Moss Jr., "The Black Revolution," in *From Slavery to Freedom: A History of Negro Americans* (New York: Alfred A. Knopf, 1988), pp. 436–470.

15. Adam Fairclough, *To Redeem the Soul of America: The Southern Christian Leadership Conference and Martin Luther King, Jr.* (Athens: University of Georgia Press, 1987), p. 251.

16. Kwame Ture (Stokely Carmichael) and Charles V. Hamilton, *Black Power: The Politics of Liberation* (New York: Vintage Books, 1992); first printed in 1967. Rodolfo "Corky" Gonzales, *Yo Soy Joaquin/I Am Joaquin* (New York: Bantam Books, 1972). (Gonzales's poem by the same title was published in 1967.)

17. Matt S. Meier and Feliciano Rivera, *Readings on La Raza: The Twentieth Century* (New York: Hill & Wang, 1974); Juan Gomez-Quinones, *Roots of Chicano Politics, 1600–1940* (Albuquerque, University of New Mexico Press, 1994); Fairclough, *To Redeem the Soul of America*; Franklin and Moss, *From Slavery to Freedom*.

18. Ignacio M. Garcia, "Los Cinco De Mayo," in *United We Win: The Rise and Fall of La Raza Unida Party* (Tucson: University of Arizona, 1989), pp. 15–33.

19. Meier and Rivera, *Readings on La Raza*, p. 219.

20. Franklin and Moss, *From Slavery to Freedom*, p. 439. This date has been debated by some who say that there were other sit-ins before this date. If that is

the case, perhaps it would be safer to say that this one had a national impact (perhaps with the aid of the media) that stimulated the drive to heighten such activity.

21. Meier, Rudwick, and Broderick, eds., *Black Protest Thought*, p. 439.
22. SNCC, "Nonviolence Is the Foundation," in Meier, Rudwick, and Broderick, eds., *Black Protest Thought*, p. 307.
23. Roy Wilkins, "The Conservative Response," in Meier, Rudwick, and L. Broderick, eds., *Black Protest Thought*, p. 316.
24. David R. Maciel, "Mexico in Aztlan and Aztlan in Mexico: The Dialectics of Chicano-Mexicano Art," in Richard Griswold Del Castillo, Teresa McKenna, and Yvonne Yarbro-Bejarano, eds., *Chicano Art: Resistance and Affirmation, 1965–1985* (Los Angeles: Wright Art Gallery, University of California, 1991), p. 115.
25. Eugene Perkins, "The Black Arts Movement: Its Challenge and Responsibility," in E. Barbour, ed., *The Black Seventies* (1970), p. 87.
26. In Campbell, ed., *Tradition and Conflict*, p. 9.
27. Ibid., p. 10.
28. Hoyt W. Fuller, "Toward a Black Aesthetic," in Gayle, *The Black Aesthetic*, p. xvii.
29. Del Castillo, McKenna, and Yarbro-Bejarano, eds., *Chicano Art*; Samella Lewis, *African American Art and Artists* (Berkeley: University of California Press, 1990).
30. Luis Valdez and Stan Stiener, eds., *Aztlan: An Anthology of Mexican American Literature* (New York: Alfred A. Knopf and Vintage Books, 1972), p. 197.
31. Munoz, *Youth, Identity, Power*, p. 54.
32. In Victor A. Sorell, "Articulate Signs of Resistance and Affirmation in Chicano Public Art," in Del Castillo, McKenna and Yarbro-Bejarano, eds., *Chicano Art*, p. 141.
33. In Martinez, ed., *500 anos del Pueblo Chicano*, p. 160.
34. Shifra Goldman and Tomas Ybarra-Frausto, "The Political and Social Contexts of Chicano Art," in Del Castillo, McKenna, and Yarbro-Bejarano, eds., *Chicano Art*, p. 85.
35. Gloria Anzaldua, *Borderlands/La Frontera: The New Mestiza* (San Francisco: Aunt Lute Books, 1987), p. 30.
36. Ibid., p. 30.
37. Alphonso Pinkney, *Red, Black, and Green: Black Nationalism in the United States* (Cambridge: Cambridge University Press, 1978), p. 99.
38. Ture (Carmichael) and Hamilton, *Black Power*, pp. 98–120.
39. Fairclough, *To Redeem the Soul of America*, p. 313.
40. Van Deburg, *New Day in Babylon*, p. 160. Huey P. Newton, who was the minister of defense of the Black Panther Party in Oakland, was jailed on charges of being involved in a shooting altercation. Given that the Panthers were a highly visible and active vanguard, they were constantly under surveillance and subject to harassment by the police. Harassment accelerated as they gained increasing support from African American communities and other organizations. The Panthers organized community activities such as voter-registration drives, gave some 20,000 bags of groceries to communities nationwide through its Angela Davis People's Free Food Program, organized a Free Busing to Prisons Program, began a People's Free Plumbing and Maintenance Program, and organized an Intercommunal News Service (all staffed by volunteers and supported by local businesses).

41. See Goldman and Ybarra-Frausto, "The Political and Social Contexts of Chicano Art," p. 85.
42. Chloe Sayer, ed., *The Mexican Day of the Dead: An Anthology* (Boston: Shambhala Redstone Editions, 1994), p. 26.
43. Norman Bryson, "The Gaze in the Expanded Field," in Hal Foster, *Vision and Visuality: Discussions in Contemporary Culture* (Seattle, WA: Bay Press, 1988), p. 94.
44. Griselda Pollock, "Feminism/Foucalt/Surveillance/Sexuality," in Norman Bryson, Michael Ann Holly, and Keith Moxey, eds., *Visual Culture: Images and Interpretations* (London: Weslyn University Press, 1994).
45. Ibid.
46. Not all Chicano/a and African American artists produced overtly political or cultural works; some worked in abstraction. My discussion, however, focuses on the prevailing tendencies of the period.
47. David J. Weber, ed., *Foreigners in Their Native Land: Historical Roots of the Mexican Americans* (Albuquerque: University of New Mexico Press, 1973); Robert C. Toll, *Blacking Up: The Minstrel Show in Nineteenth-Century America* (New York: Oxford University Press, 1974). These sources reveal extremes of cultural projections of African Americans and Mexican Americans as stereotyped by others. Such representations differ markedly from self-representations of those ethnic groups.
48. Mitchell, *Picture Theory*, p. 192.
49. Ibid.
50. Ibid.
51. See Mitchell, *Picture Theory*.
52. Shifra M. Goldman, "How, Why, Where, and When It All Happened: Chicano Murals of California," in Eva Sperling Cockcroft and Holly Barnet-Sanchez, eds., *Signs from the Heart: California Chicano Murals* (Albuquerque: University of New Mexico Press, 1990), p. 55.
53. Sorell, "Articulate Signs of Resistance and Affirmation," p. 148.
54. Timothy W. Drescher, *San Francisco Murals: Community Creates Its Muse, 1914–1994* (San Francisco: Pogo Press, 1994), p. 7.
55. Eva Sperling Cockcroft and Holly Barnet-Sanchez, "Introduction," in Cockcroft and Barnet-Sanchez, eds., *Signs from the Heart*, p. 10.
56. Jacinto Quararte, *Mexican American Artists* (Austin: University of Texas Press, 1973), p. 32.
57. "David A. Siqueiros (1896–1974), et al.: 'A Declaration of Social, Political, and Aesthetic Principles,'" in Charles Harrison and Paul Wood, eds., *Art in Theory, 1900–1990: An Anthology of Changing Ideas* (Oxford, England: Blackwell, 1993), pp. 387–388.
58. "Diego Rivera (1898–1957): 'The Revolutionary Spirit in Modern Art,'" in Harrison and Wood, eds., *Art in Theory*, pp. 404–407.
59. Luis Leal, "In Search of Aztlan," in Rudolfo A. Anaya and Francisco Lomeli, *Aztlan: Essays on the Chicano Homeland*, trans. Gladys Leal (Albuquerque: University of New Mexico Press, 1991), p. 11.
60. Amalia Mesa-Bains, "Indigenismo," in Marta Moreno Vega and Cheryl Y. Green, eds., *Voices from the Battlefront: Achieving Cultural Equity* (Trenton, NJ: Africa World Press, 1993), p. 26.
61. Dana Leibsohn, "Primers for Memory: Cartographic Histories and Nahau Identity," in Elizabeth Boone and W. Mignolo, *Writing Without Words: Alternative*

Literacies in Mesoamerica and the Andes (1994), p. 166.

62. Eduardo Matos Moctezuma and Leonardo López Lujan, "Teotihuacan and Its Mexican Legacy," in Kathleen Berrin and Esther Pasztory, *Teotihuacan: Art from the City of the Gods* (New York: Thames & Hudson, 1994), p. 158.

63. Esther Pasztory, *Aztec Art* (New York: Abrams, 1983), p. 71.

64. Frances F. Berdan and Patricia Rieff Anawalt, eds., *Codex Mendoza*, vol. 2 (Berkeley: University of California Press, 1992), p. 10. *The Codex Mendoza* was prepared after the Spanish conquest with the assistance of Indian informants. (Most sources indicate that he ruled 1391–1404.)

65. Esther Pasztory, "The Aztec Tlaloc: God of Antiquity," in J. Kathryn Josserand and Karen Dankin, eds., *Smoke and Mist: Mesoamerica Studies in Memory of Thelma D. Sullivan* (Oxford: Oxfordshire, 1988), p. 289.

66. Leal, "In Search of Aztlan," p. 8.

67. Munoz, *Youth, Identity, Power*, p. 15.

68. Tomas Ybarra-Frausto, "Arte Chicano: Images of a Community," in Cockcroft and Barnet-Sanchez, eds., *Signs from the Heart*, p. 55.

69. Octavio Paz, *Mexico: Splendors of Thirty Centuries* (New York: Metropolitan Museum of Art, 1990), p. 9.

70. Ture (Carmichael) and Hamilton, *Black Power*, pp. 34–56.

71. Mesa-Bains, "Indigenismo," pp. 41–66.

72. Alan W. Barnett, *Community Murals: The People's Art* (Philadelphia: Art Alliance Press, 1984), p. 17.

73. Cockcroft and Barnet-Sanchez, "Introduction," p. 9.

74. Cortes, "Mexicans," p. 717.

75. Ybarra-Frausto, "The Chicano Movement/The Movement of Chicano Art," p. 129.

76. Ibid.

77. Ron Karenga, "Black Cultural Nationalism," in Gayle, ed., *The Black Aesthetic*, p. 33.

78. Maurice Merleau-Ponty, *Phenomenology of Perception*, trans. Colin Smith (London: Routledge and New Jersey: Humanities Press, 1992), p. 21.

79. Amiri Baraka, "The Black Aesthetic," *Negro Digest* (September 1969): 5–6.

80. Jeff Donaldson, "Upside the Wall: An Artist's Retrospective Look at the Original 'Wall of Respect,'" in Jeff Donaldson, ed., *The People's Art: Black Murals 1967–1978* (Boston: African-American Historical and Cultural Museum, 1986).

81. "The Wall of Respect: Artists Paint Images of Black Dignity in Heart of City Ghetto," *Ebony*, vol. 23, no. 2 (December 1967): 48.

82. Ibid., p. 49.

83. Ibid.

84. In Barnett, *Community Murals*, p. 52.

85. Ibid.

86. Ibid.

87. Goldman, "How, Why, Where, and When," p. 27.

88. Pollock, *Vision and Difference*, p. 30.

89. Barbara Jones Hogu, *Afri-COBRA III* (Amherst: University of Massachusetts, 1973).

90. Clement Greenberg, *Art and Culture: Critical Essays* (Boston: Beacon Press, 1961), p. 139.

91. Freida High W. Tesfagiorgis, "Afrofemcentrism and Its Fruition in the Art of Elizabeth Catlett and Faith Ringgold," in Norma Broude and Mary D. Garrard,

eds., *The Expanding Discourse: Feminism and Art History* (New York: HarperCollins, 1992), pp. 475–485.

92. Leal, "In Search of Aztlan," p. 8.

93. Sorell, "Articulate Signs of Resistance and Affirmation," p. 145.

94. Amalia Mesa-Bains, "El Mundo Femenino: Chicana Artists of the Movement— A Commentary on Development and Production," in Del Castillo, McKenna, and Yarbro-Bejarano, eds., *Chicano Art*, p. 137.

95. Ibid.

96. Anzaldua, *Borderlands*, p. 27.

97. Victor A. Sorell, *Her Presence in Her Absence: New Mexican Images of La Guadalupana* (Albuquerque, NM: Southwest Hispanic Research Institute, 1994), p. 16.

98. Cecelia Klein, "Rethinking Cihauacoatl: Aztec Political Imagery of the Conquered Woman," *Smoke and Mist* (Oxford: B.A.R., 1988), p. 241.

99. Eduardo Matos Moctezuma, *The Great Temple of the Aztecs: Treasures of Tenochtitlan*, trans. Doris Heyden (London: Thames & Hudson, 1988), pp. 40–42.

100. H. B. Nicholson, "The New Tenochtitlan Templo Mayor Coyolxauhqui-Chantico Monument," in *Indiana*: (Gerdt Kutscher), *Part 2* (Berlin: Gebr. Mann Verlag, 1985), p. 82.

101. Eduardo Matos Moctezuma, "Symbolism of the Templo Mayor," in Elizabeth Hill Boone, ed., *The Aztec Templo Mayor: A Symposium at Dumbarton Oaks* (Washington, D.C.: Dunbarton Oaks, 1983), p. 200.

102. Sorell, *Her Presence in Her Absence*, p. 16.

103. Shifra M. Goldman, *Dimensions of the Americas: Art and Social Change in Latin America and the United States* (Chicago: University of Chicago Press, 1994), p. 198.

104. Ibid.

105. Yolanda Broyles Gonzalez, "Toward a Re-Vision of Chicano Theatre History: The Women of El Teatro Campesino," in Lynda Hart, ed., *Making a Spectacle: Feminist Essays on Contemporary Women's Theatre* (Ann Arbor: Univeristy of Michigan Press, 1989), pp. 290–338. Gonzalez refers to the general problem of typecasting women, reflecting upon the plays of El Teatro by Luis Valdez.

106. Amalia Mesa-Bains, "Feminist Visions," in Del Castillo, McKenna, and Yarbro-Bejarano, eds., *Chicano Art*, p. 322.

107. I have discussed this point elsewhere. See Tesfagiorgis, "Afrofemcentrism and Its Fruition," pp. 475–485 (also in *Sage: A Scholarly Journal on Black Women*, vol. 4, no. 1 [spring 1987]: 26–29). See also, Freida High W. Tesfagiorgis, "In Search of a Discourse and Critique/s That Consider the Art of Black Women Artists," in Stanlie James and Abena Busia, eds., *Theorizing Black Feminisms* (London: Routledge, 1993).

108. Pollock, "Feminism/Foucault/Surveillance/Sexuality," pp. 1–41.

109. Merleau-Ponty, *Phenomenology of Perception*, p. 148.

110. Richard Townsend, *State and Cosmos in the Art of Tenochtitlan* (Washington, D.C., and Dumbarton Oaks: 1982), p. 12.

111. Franklin and Moss, *From Freedom to Slavery*, p. 53.

12 / Interview with the Artist Sana Musasama

Phoebe Farris-Dufrene

This interview with Sana Musasama took place over a four-month period during the summer and fall of 1995. We talked on the phone, met in Washington, D.C., and communicated by letters and faxes. I would like to begin this chapter with an opening statement by Sana, in which she explains her background, before proceeding to the actual interview.

I have studied and worked in clay in Helena, Montana; Tuscarora, Nevada; Sierra Leone, West Africa; Bizen, Shigaraki, Japan; Paris, France; Hertogenbosch, Holland; southern Greece; and northern Thailand. Currently, I am fascinated with the pottery and baskets of the hill tribes in Vietnam and southeast China. I have explored and mastered various techniques, firing atmospheres, and surfaces. Primarily, I am a hand-builder, although I use the wheel and mold-making techniques to help me with expressing my ideas.

I have taught clay for over twelve years, both in traditional and nontraditional settings. I enjoy teaching—exchanging and sharing technical information, ideas, and perceptions. Further, I enjoy the interchanges that take place in the studio, which I view as a community. I encourage an environment in which a positive attitude toward change, risk taking, learning, and growing is nurtured in each individual. As a teacher, I function somewhat as a guide, leading my students on a journey through various steps and stages, exposing them to the rich and diverse history of the material. I encourage each individual to find, create, and develop their own unique path. I regard creative thinking as a necessary ingredient of intellectual development.

PF-D: Sana, our friendship goes back to the seventies when we were both fine arts majors at City College in New York. We met in the ceramics studio and have been friends and art colleagues ever since. During the past twenty-five years, we have both been through numerous

166

cultural, ethnic, and artistic transformations. Can you elaborate on some of your experiences at City College that led to your choice of ceramics as your medium of preference? Can you discuss your name change and your travels to West Africa in the seventies? Were there any particular professors, art movements, political movements, and/ or family circumstances in the seventies that impacted on your artistic development?

SM: As you mentioned, Phoebe, we went through our numerous cultural, ethnic, and artistic transformations. One of my many transformations was a name change for me in 1974. Without elaborating, I simply outgrew my previous name. It didn't fit anymore. My name "Musasama" is really two different people. Musa was a soothsayer in Gambia, West Africa, and Sama was a female paramount chief in Liberia, West Africa. Sama was a robust woman who spoke English perfectly and possessed a lot of energy and passion. I stayed in her village for a week and worked the rice farms in the evening. Sama would tell stories about her childhood. She was suffering from arthritis, and I shared my Ben-Gay with her and gave her a massage. The next morning, she felt like a new person. I was a heroine in her eyes. The day I left the village, Sama asked me to take a part of her name and put it in mine. I did just that, responsibly and with respect.

At City College in New York, there were two instructors, Paul Chaeff and Walter Yorish, who were artist/teachers. They were both enthusiastic, focused, highly creative, and ambitious. Their style of teaching was improvisational. Every time I registered for a ceramics class, it was closed, full! Finally, I approached Paul and had him sign me in. That was three semesters before graduation. I had a natural facility with clay. It didn't take long to discover that clay was my medium of expression. I had a voice with clay. Clay is one of the most abundant substances on earth. It can be found all over the world. Nature makes it. I love the fact that it comes in as many colors, textures, and personalities as people and that almost every race and class of people have pushed their thumbs in this humble material. I respect clay's anatomical composition of earth, air, water, and fire.

With my eyes freshly opened to this new world of clay, and with only a few months until graduation, I decided to be adventurous and create a hands-on travel/education experience for the next phase of my education. Experiencing other cultures, their clay objects, processes, the meaning of art and ritual in their lives was an alternative for me, a route to graduate work. At that moment, whether I chose clay as a question I have pondered a great deal. Perhaps we chose

each other. I started working in clay twenty-two years ago at City College in New York, and the very same magic and excitement I felt then, I still feel. I remember those early days at Eisner Hall majoring in art and minoring in education. I was mesmerized by the presence of the ceramic studio. As you remember, Phoebe, the clay room was centrally located on the ground floor. Every time I passed it en route to another studio, it pulled me in. I loved the smell of the room, the warmth of the kiln, and the toasty brown color of the clay body.

Also important, and something that has had a tremendous impact upon me as a world traveler and clay teacher, is that unlike the other studios, the ceramic studio had a breath and energy of its own. It was a community. I observed the students engaged in rich dialogue about their travels, the Vietnam War, alternative lifestyles, exhibits, graduate schools, etcetera, as their hands formed the most thoughtful forms I had ever seen. There was a noncompetitive feeling.

As I researched through magazines and art reference books, I came across the clay cultures of the world that would guide me through the next twenty years of pushing my clay around. I began my travel education in Ghana, West Africa, in 1974. I traveled the coastal countries from the Gold Coast to Mauritania, settling in Mende land, Sierra Leone, where I lived and worked for several seasons. The seasons dictated the lifestyle. Clay making and blacksmithing came after the rainy season. It seemed so commonsense. The Mende people believed that God beat the soil away with the heavy rains and exposed the clay for them. They asked permission as they removed the clay from the earth. The making of pots was a community effort. Many hands formed a vessel's decisions, such as the angle of an incised cut, all dictated by traditions hundreds of years old that had served the people well. Market day was my favorite day. We would dress in our best and walk miles with our ceramic pots elegantly balanced on our beautiful heads. My time in Africa in a magical and intuitive way altered my sensibilities, redirected my aesthetic, stimulated the senses, and aroused my intellect. Reawakening my personal echoes, Africa became my wellspring, engendering me fearless and unstoppable. The world was on my agenda, and Africa was my reservoir.

Dennis Parks continues being my most influential instructor, or guide, as he would say. He built an alternative and innovative school in the mountains of Tuscarora, Nevada, twenty-two years ago. He introduced me to the crankcase oil firing, single firing, salt, brick making, sage brushing, glazing, ice fishing, hunting, kiln building, farming, and animal husbandry. Dennis invited students from all over

the United States and abroad to help build the facilities. Dennis exposed me to a lifestyle and ideology intertwined and committed to creativity, respect for the environment, and people power. Dennis got me thinking about community as I had lived it in Mende land. The Vietnam War was the war that removed my male classmates from the studios. I suffered casualties as close as my next-door neighbor who I grew up with. Also, Black Nationalism permeated the Black community and the campus. Also, women's issues surfaced. There were a lot of issues to embrace and lives to change. I floated among all the groups and was active in the war issues. Needless to say, I was affected and influenced by all the issues of the time. My mother was dying at the time from a long sickness (diabetes). As I reflect back, my strength and commitment to school and school life was defused by her sickness.

PF-D: During the seventies, what I admired about you the most was your commitment to being an artist and not a nine-to-five person/educator. At that time, I was married and the mother of a small child. Worried about financial security, I chose careers in art education and art therapy at the expense of focusing more seriously on my own creativity, especially my photography and printmaking. What gave you the courage to take the financial risks of pursuing art full-time?

SM: What gave me the courage? An inner voice told me I found myself in clay. I have always been economically self-sufficient. I started working at the age of fourteen, and my dear mother taught all five of us the value of saving. My first job at the five-and-ten-cent store where I earned $35 a week was carefully divided into family contributions, savings, transportation, and a shopping treat for me. I only wish now my money only had to be divided four ways. With money in the bank and an extremely low cost of living, a tremendous amount of energy, and courage/belief in myself, I pushed my art with all my life and still am. I felt then, and still do, that I have a special gift of being beyond normal talent, and with this gift is a responsibility. The voice gave me the courage, and I made the commitment.

PF-D: How did/does your family feel about your career choice? Were/are they supportive? Are any other family members involved in the arts?

SM: As a young child, my parents recognized and encouraged my creativity. I was placed in art classes after school and during the summers. In the classroom, I was labeled as the artist. However, when I chose the arts as a profession, it frightened them, and they tried to discourage me. It took many years to understand this. Both my parents

aspired to offer their children exposure to a wider range of opportunities than they received. Perhaps to draw, sculpt, write, or sing was one of their dreams deferred. When they spotted talent in us, they pushed it. We took piano, violin, singing, and dance lessons. Interestingly, my parents saw these creative choices as practical occupations. They summed up in their minds that if you don't succeed as a professional in any of the above, you could always domesticate these professions and earn an honest living—one can always teach piano from the home, open your own dancing school, teach voice and/or violin from your very own living room.

My Aunt Finny was a dressmaker (she attended the New York Art & Design High School in the fifties). She created for a New York City firm and created on her own. Her dining room was her studio. It was fascinating as a child visiting her apartment on 155th Street in Harlem. Aunt Finny supported herself and family from her art form. But—selling sculptures? My family didn't know if this was possible. They came to my sales and exhibitions. They invited family and friends. They assisted me setting up and taking down shows. They helped me crate and uncrate numerous sculptures. They saw me make lots of money on some occasions and zero on others. My choice worried them.

Now, after years of work, travel, grants, reviews, exhibitions, and awards opportunities, I have held their hands through every event and written them love letters from almost every part of the world. They understand and respect without an explanation. They adore me and believe in me. My sisters and immediate family have lived and grown through me. Unfortunately, both my parents died too soon in my career. I have two naturally gifted sisters. The oldest, Vicky, has played the piano all our lives. Bonnie, next to the youngest, could draw with incredible detail the most beautiful landscape scenes. As young children, neither wanted to be artists. My youngest nephew, Warren, is a natural artist. He draws, paints, does assemblage, and works in clay. It's beautiful to observe him and see through his eyes. He's fresh air in my studio. I will encourage his creativity.

PF-D: As you know through visits with my family, ours is a multicultural background (Native American and African American). My cultural references include visits to relatives on the Pamunkey/Powhatan Indian Reservation and associations with people on the other two Powhatan reservations, exposure to Native American pottery, my family's Oriental rug collections, and interaction with numerous aunts, uncles, and cousins who have careers in the arts and mass media. Have other cultural ethnic influences outside of the African American

experience affected your work? Before multiculturalism became a fad, what diverse cultures influenced the direction of your work?

SM: I have been greatly moved and inspired by the pottery and art of early civilizations, i.e., prehistoric pots from China, Africa, South America, the Middle East, Japan, the Nok culture, Jomonware, the early work of Native Americans, Eskimos, have all excited me and moved me to tears.

These early ware all hold the pulse of life in their forms, weaved of common experience. These pots speak a cross-cultural and panoramic language as they enter into the ceremonies of peoples' lives. They glow of times past and present and stand with the right to be. It is this essence, "heartbeat," pulse, truth that I'm in search of when creating my sculptures.

PF-D: During the eighties, while I was living in Washington, D.C., we did not see each other that much. You were traveling around the world, the recipient of many fellowships. What countries did you visit? What grants did you receive? How did you incorporate travel into your work?

SM: I traveled to Japan, India, France, Italy, Montana, and Nevada. At that time, I was winning what I call baby grants—$600–$1,000 here and there. It is only recently that I've received larger-scaled grants. In the very recent past, I have received a New York Foundation for the arts grant, a Pollack-Krasner, a Mid-Atlantic, two Craft Alliances, and many funded residences, national and abroad. Travel became a part of the work. It's how I learned about clay. I sculpt to find out what I know. I travel to learn and know how I feel about something.

PF-D: During most of your extensive travel you were alone. How are single women traveling alone perceived in various countries? Did you interact with many women artists abroad?

SM: I usually travel alone, although once abroad, I attract other travelers. In most countries I'm Western, which means available and sexually free, rich or richer than the nationals. As an African American, too often I become an ambassador for the entire race. My blackness is both a burden and a blessing. I attract many women artists who get a sense of my freedom and want a taste of it if only for a day of travel and/or exchanges.

We talk more about our lives and the quality we seek on a human level than we talk about our actual artwork. Often these women help to operate a family business. We talk a lot about business and what we can do together. I export/import baskets from such a woman artist friend in Da Lat, Vietnam. We both agree that to paint or to

make sculpture is our purest performance. Like food or water, we must do it, and it doesn't matter if no one ever sees it, really (although we'd love public acknowledgment). But we create because we have to. We simply must.

PF-D: Western art makes distinctions between crafts and fine arts, craftspersons and artists. Clay works and other "crafts" that are usually created by women have a lower status in Western art. However, you define your ceramic pieces as sculptures. How do you as a ceramic sculptor deal with these Western distinctions between "art" and "craft"?

SM: I have become bored with this issue of craft versus art and now ignore it. However, when applying for grants, I always apply in the category of crafts. My medium has a strong history in craft. That history cannot be ignored and should not be. I approach all kinds of art galleries. I produce sculpture always. Occasionally, the question "What is art?" surfaces. I sometimes answer, "It is power, magic, a gift." It can occur in a five-year-old's painting, or in the work of an untrained folk artist, or in a tribal setting where someone who has never gone to an art academy makes a wonderful piece. I feel/think if a work has the quality to call and to evoke emotion of some kind in the observer as well as the artist, it's "art." It can be constructed of any material and be produced by either sex.

PF-D: During the nineties, you have had two write-ups in *Essence* magazine, as well as Leslie King-Hammonds's *Gumbo Ya Ya: Anthology of Contemporary African-American Women Artists*. The September 1992 issue of *Essence* discusses your *Maple Tree Series* and your *Hummingbird Series*. You gave me one of your ceramic hummingbirds. What is the meaning behind the bird series? Can you discuss some of the technical aspects, such as the firing and glazing? Your knowledge of chemistry is impressive.

SM: They are not hummingbirds. The series is called *Echoes & Excavations*. The bird icon was an important symbol for these works. The work is autobiographical. The bird is me. They are Raku, a Japanese technique/style. *Echoes & Excavations* is a series of work reflecting my personal journey in clay. I was looking at the work of sixteen years for a "voice." I needed this to continue at that time in my work. Family unhappiness, depression, family responsibilities, and the pressures of working full-time by teaching while still trying to create were affecting me. The bird symbol is full of meaning, as well as being a metaphor for myself. This period in my life is too painful to discuss further.

As far as technique, I do multiple firing, mostly low-fire temperature range. Although I also fire at cone levels 5 to 10, if I want that range. I do a lot of inlay, underglaze painting, and *sgraffito* (pushing fired clay objects into wet clay). My palette consists of a wide range of intense color and varied textures.

PF-D: I am fascinated by your *Maple Tree Series*, especially your one-person show at the June Kelly Gallery in New York. The *Essence* article and June Kelly Gallery brochure mention that the *Maple Tree* sculptures were inspired by an abolitionist movement involving Native Americans, indentured black servants, and Dutch colonialists that espoused maple syrup tapping as an alternative to using African slaves in the West Indies to harvest sugarcane. This is a piece of history that was totally new to me. I knew that the Shinnecock Indians on Long Island let runaway slaves use their land as a stop on the underground railroad, on their way to Canada. But I was unaware of other Native American involvement in the abolitionist movement. Please enlighten me on this.

SM: My current work is inspired by the reading of early abolitionist movements in our country's history. I was deeply moved by the story of the Maple Tree movement that existed in the 1790s; a movement that was embraced by three races—the Native Americans, the Dutch, and the indentured African servants. I decided to devote my creative energy to reinterpret this history in the form of ceramic sculptures. I began this body of work in 1991 and still feel imbued with passion and power to continue pushing my clay to retell our collective story.

I first learned of the Maple Tree movement in Slippery Rock, Pennsylvania. This movement was linked to sugarcane plantations. Native Americans taught the early settlers how to tap the trees. The *Maple Tree Series* are a group of ceramic sculptures that reinvent and reinterpret a story I read in a news journal. The story was fascinating to me. Unfortunately, little is written about it. The tree was used as a social/economic/humanist symbol. Friends of the movement marched through the streets with tree branches in their hands. Learning more about the movement and sugarcaning led me to studying trees and their mythologies. The maple tree is a female tree. Gender issues and environmental issues surfaced. In Iroquois oral traditions, there are stories about maple tree tapping and the early European settlers.

PF-D: In addition to the historical references in the *Maple Tree Series*, please explain your aesthetic concerns. Tell me about the formal qualities

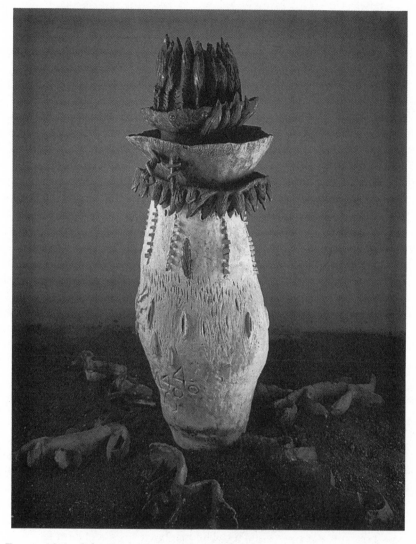

Figure 12.1. Sana Musasama, Slippery Rock, Pennsylvania, *Maple Tree Series*, 61″ × 34″, ceramic, 1991.

of the trees and the technical processes involved in the execution. Does each tree have a separate title, etcetera?

SM: My aesthetic concerns at first were centered on using icons or symbols that were representational of the three individual groups (Native Americans, European settlers, and African indentured servants). Later, my concerns focused on the tree as a symbol, the sugarcane process, and gender issues. Finally, the trees became a fusion of all the above. In addition, they possess the character of the maker, the trees stand from three and one-half feet to sixteen feet. They are hand-built forms utilizing various techniques and processes and firing atmospheres to achieve the heavily textured surfaces that I love. I fire the cone level .04. I use a matte textured glaze. I've been working on these trees for five years. I made them in France, Holland, New Jersey, Maine, Pennsylvania, and Mexico. Each piece is titled the *Maple Tree Series* and is named after the place where it was created.

PF-D: What is the public reception to this series? Any critical reviews from the exhibit? Are the trees in any important public/private collection?

SM: *Edgeomb, Maine*, was reviewed in *Coven* magazine. It's too soon to judge the public. Only six of the twenty-eight trees have been shown and that was at June Kelly in May [1995]. The trees really have not had much public attention or interaction. (I spent five years in studios both in the United States and Europe making them.) I am presently seeking one-women exhibitions. The six that were seen were received well. The trees are not in any important public/private collections as yet.

PF-D: What is your exhibition record? Are you represented by a gallery? Does being a woman of color interfere with being represented in mainstream galleries? If so, how?

SM: No, I am not represented by a gallery. I need gallery representation. I am currently showing one of the trees in Europe at Galler SBI Norway. I also have a piece at an exhibit called "Women Sculptors of the 90's" in Staten Island, New York. In October 1997, I will have another one-woman show at the June Kelly Gallery, New York.

PF-D: On a recent visit to the 1995 Nubian exhibit at the Smithsonian Museum of African Art, we both commented on some of the similarities between the geometric designs in African and Native American pottery. Later, while viewing Zulu beadwork in Howard University's collection of African art, we remarked on the resemblance to Plains Indian beadwork. What are your theories on the reasons for these similarities in women's art on two different continents?

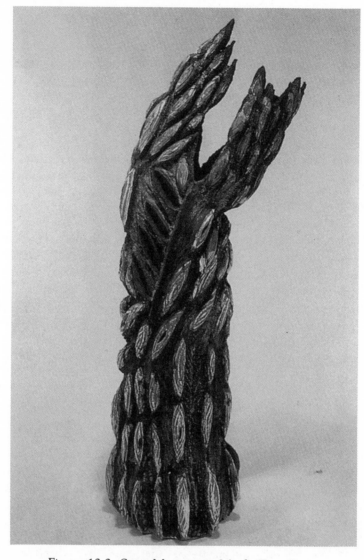

Figure 12.2. Sana Musasama, *Maple Tree Series* #4, 62" × 33", ceramic, 1991.

After your 1995 visit to Vietnam, you gave me some beautiful handwoven cloth from various indigenous mountain-dwelling people. You gave it to me because you thought it looked like the weavings made by native peoples in the southwestern part of the United States. Once again, we have examples of artists in faraway locations using similar design patterns. Jack Forbes (Powhatan), director of Native American Studies at the University of California, Davis, and author of *Africans and Native Americans*, as well as Ivan Van Sertima, professor at Rutgers University and author of *They Came Before Columbus*, document travel and trade before Columbus got lost in 1492. Are you familiar with their writings? Do you think the history of design should be more fully investigated by artists and scholars?

SM: Yes, I am familiar with these writers. Artists and scholars working together would be great. In China, I saw some antique textiles that looked completely African to many of us. As artists/historians/scholars, there is a need for more research that attempts to establish definitive ties, sources, and cultural relationships. I have certainly seen enough evidence to suggest that there is some linkage/exchange/cross-cultural borrowing/sameness. A Neolithic Japanese pot and a Neolithic African pot look like siblings. It is a fascinating thing to see. But what is not known enough about is the fact that African traders traveled the silk route in China and so did many other cultures. Exchanges on different levels developed. It was unavoidable. Why? Perhaps these early cultures were faced with the same issues: survival, food, sun, water, fire, earth, God/gods, death, and life. On the sides of their pots, these ancient peoples carved lips, bellies, and handles. Their reality was the rain, the landscape, the hunt, ritual, etcetera.

PF-D: What does the future hold for you? Recently you have taught at the Maryland Institute College of Art, City College, and Hunter. What would be the ideal position for you in academia? Have you encountered racial and/or gender discrimination in seeking tenure-track positions? Does college teaching help or hinder your ability to be prolific?

SM: The future? Time. Time to create. Time to live, love, and develop. Time to give something back. To be honest, tenure-track jobs have never been a focus. Something about tenure seemed too stationary for my type of personality. I am always looking for replacement opportunities, sabbatical replacements, part-time residencies, travel exchanges, teaching abroad, etcetera. However, looking toward the future, a secure college teaching position is ideal. It would give me

Figure 12.3 Artist posing with her sculptures in her studio.

health coverage, a steady income, and time to work in my studio. My time in the classroom doesn't eat away at my studio time. They are two different times, and I treat them differently. I work in seasons, like in Africa. Usually when teaching is demanding, it is usually the time of year when I've just successfully completed an intense work period and produced a large amount of work. No, teaching doesn't hinder me. I welcome a college teaching job now and then.

PF-D: As a black person who grew up in a middle-class black suburban community in Queens, how did your racial identity impact on your work, art themes, and so on? People in the dominant culture often erroneously assume that all African Americans have had an urban, "inner-city" experience of "deprivation" or a rural southern segregated experience. Can you elaborate on this?

SM: My racial identity is carefully weaved into everything I do. My racial identity has had a tremendous impact on the personality and human being I am. My parents, both from South Carolina, migrated to New York in the mid-1930s, both seeking opportunities, perhaps a better view of the world. When we were growing up, class was never a discussion. We never considered ourselves middle-class. We were working-class, my entire community. Moms stayed home, dads worked. It wasn't that we didn't need Mommy to work; it's not that my dad made a lot of money. Mommy needed to be home when we returned from school. We made do with what we had. My family believed in extended family. Always relatives and cousins lived with us. They, in return, took on a responsibility; perhaps it was teaching us a foreign language, or taking one of us on a trip, or buying our first pair of back-to-school shoes.

People in my community seemed to have the same support systems. My neighbors were Aunt Ming, Aunt Lolly, Miss Gabindon, Aunti T—not relatives by blood, but relatives by community. My community seemed to have love and respect for the same things. They valued human life, the environment, God in the sky, and education. All had *dreams* and goals. Is this only middle values?? No. It's human values regardless of class. My family, my community were full of hope and the future. (Sometimes false hope; they wouldn't look at racism straight in the face—they ran from it.) They raised their five daughters with a mixture of the South and North. We were dark-skinned brown people and grew up not too far from a naval base. My father made a career of the military, the Navy. People were from all over the world. I remember the exotic aromas from different kitchen windows, also the different accents so beautiful to

Figure 12.4. Artist displaying sculptures.

my ears. Always people spoke of "my country, my people." My parents spoke of the South as though it was another country. The South was the country where the stories of killings, lynching, and rapes were rampant. My father promised himself that none of his children would ever see a colored-labeled water fountain, as he and my mother had seen (we did not; however, we heard). We grew up with race, pride, and respect. We listened carefully to the stories full of painful, unfair lessons to live by. My parents taught us the beauty of full lips, kinky hair, dark skin, and African features. Mommy never explained the mixture her mother obviously was. We will live a black experience. My love of my family, community, ancestry, and racial identity has empowered me and made me a survivor. It allows me to travel all over the world fearless and to mingle with all people. It is my wellspring, my reservoir.

PF-D: As a woman of color, how do you define "feminism"? How does feminism relate to your work? Can you elaborate on the many ways feminism is defined in other countries? How does feminism relate to art in the countries you have visited?

SM: Feminism, like racism, doesn't show up on the surface of my sculptures. I see them both as forms of energy that can be used to empower, to change, alter, improve, and enhance lives. Feminism provides me with a personal map, a global plan, a past and future. The ideology system gives me a role model for alternative solutions, a belief that it is necessary that we all develop to our fullest personal potentials as women. Feminism is a digested attitude for me. It's in my walk, my speech, my smile. It's my overcoat. It's unconsciously and consciously in everything I do and create. Feminism is love of our female selves. It's power.

PF-D: I would like to close on a spiritual note. As a firm believer in Native American spirituality, I think any success I have in life should be acknowledged by recognizing and thanking my spirit guides and the Creator. And when negative events happen, it is partly because the spirit world is trying to teach me a lesson, sometimes painful lessons. As an artist, a creator of beautiful objects and concepts, what role does spirituality play in your creative development?

SM: My approach . . . my work is usually about an experience that triggers an emotion, sometimes a place or a particular time. I then submerge myself with information that enriches and nurtures these ideas. I often travel. When I feel this big, big presence, which I call an "extra heartbeat," I pick up my clay and begin to build.

I weave all my life experiences into my daily activities and approach

teaching from a global perspective. I live and love by a basic universal and humanistic law. In all the places I have lived, worked, and traveled, I have arrived open. I always leave full. I am in a constant state of questioning, giving, creating, and reinventing. That is why I make my art.

In closing, I will share the following story. One of my students once asked, "Musasama, where is Africa in your pots? Where is India, France, Montana, Nevada, Thailand, and Vietnam?" I smiled deep inside myself and began to explain: "The exchange of information from one source to another doesn't always happen so literally. Under the powerful pressure of creative metamorphosis, these initial images grow, transform, cross paths, intersect, and finally speak a common language." All of my travel and educational experiences have been digested, and like good food, they have permeated every pore, nourishing my entire self. Professionally, these experiences have created and propelled within me the desire, ambition, and skill to be a great artist, a stimulating teacher, a supportive colleague, and a contributing member of various institutions. Further, these experiences have enhanced my development as an understanding sister, an adventurous auntie, a loving daughter, and hopefully a more compassionate and understanding human being.

CONTRIBUTORS

NADEMA AGARD (a.k.a. Winyan Luta and Red Woman) is an artist, educator, author, and consultant in multicultural and Native American arts and cultures. She has served as the project director of the Native American Arts Program of the Museum of the American Indian in New York City and spent a year as Scholar in Residence at the Phelps Stokes Institute of New York. Agard previously taught at Bemidji State University and recently accepted the position of Repatriation Director for the Standing Rock Sioux Tribe in North Dakota.

ANA MAE BARBOSA is Professor of Art Education at the University of São Paulo, coordinator of the Nucleus of Promotion of Art in Education of the University of São Paulo, and vice president of the International Society for Education Through Art (former president). Dr. Barbosa also served as the director of the Museum of Contemporary Art of São Paulo from 1986 to 1993. A researcher on the history of art, Professor Barbosa's art education work emphasizes social and political influences, postcolonial issues, and iconology.

CARL E. BRISCOE JR. is currently a visiting scholar in African-American Studies at Purdue University and activist who specializes in political theory as it relates to the African American community. He has taught elementary and secondary education in alternative schools and universities and is the former director of African American Studies at Western Illinois University. At present, Dr. Briscoe is working on three books: *Racial Erasure*; *The Normalization of Racism*; and *Criminalizing the African American Male: Pretext for a New Growth Industry*.

ROBIN M. CHANDLER, a Boston-based collagist, has been teaching sociology of art, African American art history, and Latin American studies courses at Northeastern University since 1989. Dr. Chandler's work has been exhibited at Western Maryland College Gallery, Westminster; University of Wisconsin Union Art Gallery, Milwaukee; Boston City Hall Galleries, Harriet Tubman House Gallery, The Gallery, and Simmons College—all in Boston; and Rose Art Museum, Waltham, Massachusetts, among other places. Her poetry and writings on multicultural education have appeared in select publications, and she has received grants from the National Endowment for the Arts and the Artists' Foundation, as well as purchase awards.

PHOEBE FARRIS-DUFRENE is Associate Professor of Art and Design at Purdue University and an art therapist in private practice. She is the founder and

faculty advisor of Purdue's Native American Student Association and is a member of the Powhatan-Renape Nation, as well as a consultant on Native American art and culture. Dr. Farris-Dufrene has received a Fulbright grant to Mexico, a National Endowment for the Humanities grant, and research/travel grants to Cuba and Brazil, establishing an international reputation in multicultural and feminist art. She has published extensively in journals, has conducted numerous lectures and workshops at conferences, and has exhibited her work in national and international galleries. Dr. Farris-Dufrene is currently interim director of the Women's Studies Program at Purdue University.

FREIDA HIGH (WASIKHONGO TESFAGIORGIS) is Professor of Afro-American Studies (Art and Culture Area) at the University of Wisconsin-Madison and is currently enrolled in the art history doctoral program at the University of Chicago. An artist and art historian, her work has been published in various texts and periodicals including: *Theorizing Black Feminism/s; Expanding Discourse: Feminism and Art History; African Arts; Sage: A Scholarly Journal of Black Women;* and *Black Women in the United States: An Historical Encyclopedia.* Professor High has also exhibited widely at the Milwaukee Art Museum, Grand Rapids Art Museum, Elvehjem Museum of Art, and Leigh Yawkey Museum of Art (Wisconsin); National Center of Afro-American Art (Massachusetts); Fine Arts Museum of the South (Alabama); National Arts Club (New York); National Gallery (Senegal); Museo Arte Contemporanea di Gibellini (Palmero); and Haus Emsen-America House (Berlin), among other places.

MICHI ITAMI is Associate Professor in the Department of Art at City College of New York, CUNY, where she is also the director of the Studio Graduate Program. On the board of the College Art Association where she serves as chair of the Committee on Cultural Diversity, as well as a member of the steering committee for Godzilla: Asian American Art Network, Professor Itami is an artist who specializes in printmaking. Her current work concentrates on computer-generated and multimedia computer-based prints.

JAN JAGODZINSKI is a Professor in the Department of Secondary Education at the University of Alberta in Edmonton. Dr. jagodzinski has served as coordinator for the Caucus on Social Theory in Art Education (an affiliate of the National Art Education Association), as executive editor for the *Journal of Social Theory in Art Education,* and as president of the Culture, Media, and Curriculum Social Interest Group. He is the author of *The Anamorphic I/i* (Duval Press, 1996) and of a two-volume work on art education: *Postmodern Dilemmas: Outrageous Essays in Art Education* (volume 1) and *Pun(k) Deconstruction: Experiential Writings in Art Education* (volume 2).

CLIFF JOSEPH is a visual artist (painting and drawing), community activist,

and registered art therapist who has taught a variety of art-related topics at Pratt Institute, Adelphi University, and for the New York City Board of Education. Former president of the New York Art Therapists Association, co-chairperson of the Black Emergency Cultural Coalition, and founding member of Art Against Apartheid, Mr. Joseph is presently a member of the American Art Therapy Association (AATA) and appears frequently as lecturer, presenter, and/or exhibitor at a wide array of national and international art, cultural, and educational events. He is co-author of *Murals of the Mind: Image of a Psychiatric Community* (International Universities Press, 1973) and editor of *Art Therapy and the Third World*, the published proceedings of an AATA conference.

SANA MUSASAMA is a ceramic artist. Her teaching experience includes Professor of Ceramics for Hunter College of New York, City College of New York, and the Jamaica Art Center in New York. Musasama was awarded a grant from the New York Foundation for the Arts in 1995, and her work was commissioned by the Seagram's Award in 1996.

JANICE D. TANAKA currently teaches at the University of Florida. An accomplished corporate and public relations video producer, Professor Tanaka has garnered several awards for her work, most recently, the International Television Association Award for an orientation video she produced for the Japanese American National Museum. She divides her time between teaching in Gainesville, Florida, and Burbank, California.

REGINA VATER is a Brazilian artist whose extensive international career as an installation and video artist prompts her lecturing tour to various U.S. and Brazilian universities. Her work—which is associated with ecological issues and the philosophical lessons inherited by American cultures from African and Native American civilizations—has been exhibited by the Royal Museum of Fine Arts in Belgium, the Clock Tower Gallery-P.S1 Museum, New York, the Venice Biennial, and the Museum of Contemporary Art of São Paulo.

INDEX

aboriginal peoples, 92–93
Adams, Ansel, 21
aesthetics: of Afri-COBRA, 148;
 Native American, 17; nonelitist, 13
affirmative action, 25, 70
African American art: Afri-COBRA,
 124, 125, 148, 150; art and politics
 in activism of 1960s and 1970s,
 118–65; as art of theatricality, 122;
 blues, 49; Catlett, 150, 151;
 Chandler, 142, 143, 144, 146;
 Chicano/a art compared with, 119;
 Donaldson, 135, 141; freedom call
 projected by, 122; jazz, 49–50, 52;
 Jones, 148, 149; muralism, 132–47;
 Organization of Black American
 Culture, 134, 140, 141; political
 dimensions of, 49–52; political signs
 and posters, 126–32; rap music, 3, 6,
 8; as source of postmodernism, 121.
 See also Musasama, Sana
African Americans: activist
 organizations of, 123, 124; African
 heritage of, 146; Afrocentrism, 89;
 Baraka, 102–3, 140, 141; black
 ethnicity in pastiche
 multiculturalism, 101; Black Panther
 Party, 124, 131–32, 162n. 40; in
 Brazil, 72–77; Carmichael, 124, 131,
 141; Chicano/as compared with,
 119–20, 159; as between dichotomy
 of East and West, 49; ethnicity
 embraced by black youth, 93;
 Freedom Rides, 124; hegemony
 within racial groups, 102; identity
 politics of, 91; irony of being
 American, xi; Jackson, 113n. 52;
 King, 5, 51, 123, 145; Lee, 2, 102–3;
 Malcolm X, 102, 124, 140, 142, 145;
 occupying borderlines, boundaries,

and interstices, 118; reasserting race
 as primary social category, 89;
 sit-ins, 124, 161n. 20; Student
 Nonviolent Coordinating Committee
 (SNCC), 124, 131; television and
 movie depictions of, 6; vanguard role
 in 1960s and 1970s, 120; Vietnam
 War criticized by, 127, 128; whites
 as honorary, 94; youth activism of,
 122–25. See also African American
 art
Afri-COBRA, 124, 125, 148, 150
Afrocentrism, 89
Agard, Nadema, 55–64; *Blue Night
 Turtle Moon Birth Amulet of the
 West*, 58, 59; *Corn Mother Box*, 58;
 *Earth Mother and Her Children of the
 Four Directions*, 56, 57; *Grandmother
 Moon and Her Corn Moon Daughters*,
 61, 63; *Heaven's Door*, 58, 60; *Honor
 Thy Father and Thy MOTHER*, 58;
 Native American women in work of,
 16; *She Is the Four Directions—
 Transformational Crosses as Sacred
 Symbols of Life*, 55; *The Virgin of
 Guadalupe Is the Corn Mother*, 58,
 61, 62; wholeness emphasized by, xi;
 *Yellow Day Lizard Sun Birth Amulet
 of the South*, 58, 59
Alo, Foe, 34
Amaral, Tarsila do, 65, 109
Americas: cultural war in, 159;
 multicultural scene in, ix. *See also*
 Brazil; Canada; Native Americans;
 United States
Ang, Ien, 107
Angelou, Maya, 23
Ani, Marimba, 4, 7
Anior, Aracy, 71n. 1
antiessentialism and hybridity, 102–10

187